Happiness Always,

Ronnie

12-25-74

DALI...DALI...DALI...

Text by Max Gérard
Introduction by Dr. Pierre Roumeguère

Harry N. Abrams, Inc., Publishers, New York

Abridged Edition
Standard Book Number : 8109-0223-0
Library of Congress Catalogue Card Number : 74-4169
Copyright 1974 in France by Draeger, Imprimeurs, Paris
All rights reserved.
No part of the contents of this book may be
reproduced without the written permission of the publishers
Harry N. Abrams, Incorporated, New York
Printed and bound in France

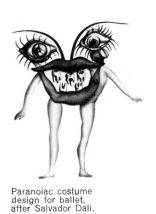

Paranoiac costume
design for ballet,
after Salvador Dali.

CANNIBALISM AND AESTHETIC

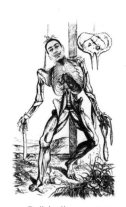

Dali in the process
of softening and
disintegration.

From the Paranoiac Cannibalism of Gastro-Aesthetics toward a BIOLOGICAL AESTHETIC

Orality, imperial way of access to the Dalinian universe.

Megalomaniacal cannibalism : " *to eat everything,* " meaning cosmic cannibalism through the frenzied mechanisms of the Paranoiac-Critical Method in a biological aesthetic of hard and soft, or softening structures : such seems to us to be the imperial way of access to the most prodigious personality of our time.

THE COSMIC DALI.

The best guide, the surest and truest, by which to approach the Dalinian universe is still Dali himself. So we will be content to follow and note his own thoughts, comparing them rigorously and systematically, just as Dali always does, to the most specific and pertinent scientific data.

Let us therefore follow Dali :

" *My work is a reflection, one of the innumerable reflections of what I accomplish, write, and think.*
" *All my painting is only a portion of my cosmogony.* "

Here then is our point of departure : the system of the world, cosmogony and cosmogenesis according to Dali.

To approach his secret is to approach the mystery of genius and of madness, of love and death, of art and life, of all that is essential for man : man himself. A " perverse polymorph, " Dali also shows himself to be the most authentic " polymorphic genius, " a Leonardo da Vinci of the twentieth century. Paradoxically, along with Picasso and like him, Dali, the most

renowned and representative man of our time, is the most misunderstood and unknown. His work as a poet, a philosopher, and an aesthetician has made its mark on our sensibility, and still remains to be discovered.

Let us therefore try to unveil the secret, then to approach, to use Dali's own expression, " *le secret re-secret,* " the secret of the secret : the well-hidden secret and re-secret, unknown to himself, in his whole life, his behavior, his works, his conscious and especially his unconscious thought, and very explicitly hidden in *The Secret Life of Salvador Dali* and in his aesthetic writings and works of the period 1931-36.

The royal way of access to this secret is indicated in our " The Cosmic Dali, " the preface to *Dali by Dali* of 1971 : it is the neuropsychiatric concept of the " Image of the Body, " from which proceeds in Dali a fundamental Platonic nostalgia for the recovery of his lost half, his feminine double, incarnated in Gala since 1929.

The preface to *Les Diners de Gala* discreetly broached the secret of this secret, what is hidden behind this secret and lies at the origin of Dali's creative genius : the orality of the nursling, the unweaned infant that was Dali.

DALI'S SECRET.

It was after a long series of tape-recorded interviews made between 1954 and 1958 that we came to discover, and then to reveal to our truly patient " patient " — for neither of us knew where we were going in those four years — the secret : the Dioscuric nature of his personality.

Elsewhere we will relate in detail the circumstances and results of this revelation, which we only sketched in the introduction to *Dali by Dali*.

Despite the emotional and dramatic paroxysms of the recalled and reactivated events, this revelation immediately produced in Dali a state of jubilant exaltation, in which he remained for several years. He centered part of his thoughts and activities on his "tragic myth," the Dioscuric myth of Gala-Dali, Pollux and Helen, Castor and Pollux, the Cosmic Twins.

At that time he never stopped recounting this myth to everyone and in every circumstance, in Spain, in France and America, on the radio, on television, in the course of countless private interviews or during his press conferences. To his house in Port Lligat he added a new construction, surmounted on the outside by two enormous eggs, and containing within the "Salon of the Egg," dedicated to the symbolism of the Divine Twins — the true altar of this Dioscuric temple.

In 1965, Dali himself offered us a marvelous account of this dramatic "lived experience" in Alain Bosquet's *Entretiens avec Salvador Dali* :

"*June 5, 1958, the day on which our mutual friend Doctor Pierre Roumeguère read me his thesis on the Dioscuric myth of Dali. I felt an incomparable thrill at hearing the absolute truth for the first time : a psychoanalytic thesis revealed to me the drama that lies at the base of my tragic structure. It had to do with the ineluctable presence, in the depths of myself, of my dead brother, whom my parents had so adored that at my birth they gave me the same first name, Salvador. The shock has been violent, like that of a revelation. It has also explained the terrors to which I was prey each time I penetrated into my parents' bedroom and when I looked at the photograph of my deceased brother — a very beautiful child, all dressed in lace, whose face had been retouched to the point where by contrast, all night long, I pictured this ideal brother in a state of total putrefaction. I only went to sleep at the thought of my own death and by accepting the idea of finding myself in the coffin, at rest at last. Thanks to Pierre Roumeguère, I have been able to ascertain that an archetypal myth like that of Castor and Pollux had a sense of visceral reality for me. The gut experience justified the mental structure of my being... It is the physical proof of a discovery made explicit, with every necessary guarantee, by a scholar.*"

A COSMIC ORALITY : "*To eat everything.*"

The Secret Life of Salvador Dali gives a masterly analysis, in admirable formulas of scientific precision, of the point of departure and genesis of his whole personality, located exactly in the center of centers that is orality and the oral stage, origin and foundation of this :

"*Awareness of reality by means of the jaws.*"

At the outset, a frenzied and constant craving, an essential need, fundamental, irrepressible, fatal as an instinct, to eat, to eat anything whatsoever, always, everywhere and completely.

"*Everything that is edible excites me...*
I would bite into everything — sugar beets, peaches, onions..."

Everything must also be made edible. Thus :

"*That house in Cadaqués where we lived, I dreamt of building its walls of bread. I wished that all the chairs were of chocolate. Even today I have still not given up the idea.*"

It is essential to note the reversible, reciprocal character of this relation, which, projected on others, establishes the persecuted-persecutor mechanism of paranoiac psychosis. Thus, would Dali like to cash a check? He thinks that the teller is going to eat his check, and refuses to give it to him :

"*What do you think he's going to do with that check?*" Gala asks him.
"*He might eat it... and we wouldn't be able to eat...*"

And elsewhere :
"*I'm surprised that a bank teller doesn't eat a check.*"

A PARANOIAC ORALITY.

But if the drive grows, becomes violent and irrepressible, edibility itself will no longer place either limits or restraints on this "devouring" orality : it will want to eat everything. Now this is exactly what Dali describes in explaining the dynamics of this drive. First the disappearance of limits :

"*There is nothing that cannot be eaten : at that time this was already my favorite expression.*"

Then the excitement mounts in an extending crescendo :

"*My edible, intestinal, and digestive productions were intensified... I wanted to eat everything and planned... to construct a large table of hard-boiled eggs that could be consumed...*"

To eat everything! There lies the most precocious and essential obsessional phantasm of the Dalinian experience, what Heidegger calls *Dasein*, being-in-the-world, and *Mitsein*, being-with, origin and invisible web of the individual, of the lived experience, assumed as fate.

Then Dali superbly concludes :

"*All my awareness was transformed into gourmandism and all my gourmandism into awareness.*"

Let us consider and admire this extraordinary formulation, a lightning flash of concision and expressive power that strikes to the heart, the very center of a lived dynamic, thought and felt by an implacably lucid and analytically logical mind that separates from chaos or nothingness the most forgotten memories of childhood — the essential generator and creator of the personality :

"*Awareness of reality by means of the jaws.*"

But let us admire especially this presentation of the genetic mechanism in terms of "transformations," moreover of *reversible* transformations, thereby unveiling a precocious, foremost, fundamental, definitive union between the "lived" and the "felt" of "gourmandism," "transformed" in consciousness according to a magnificent and typical closed and circular relationship, the operative model of narcissism :

gourmandism → consciousness → gourmandism → consciousness

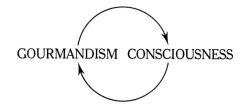

GOURMANDISM CONSCIOUSNESS

which itself will lead to the last boundary of thought and of the Dalinian mystique, as of any mystique, and will place alongside the anarchic monarchy and revolutionary conservatism of the Tradition, of the Baroque-Classical Aesthetic, a materialist Spiritualism and a spiritualist and mystical materialism so akin to the spirit of secret and alchemist societies.

"*To the degree that I am a Spanish mystic, I am a hyperrealist, starting from the concrete in order to come back to it.*"
Which means a new circular reaction :

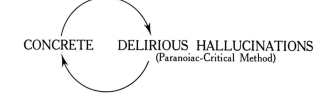

CONCRETE DELIRIOUS HALLUCINATIONS
(Paranoiac-Critical Method)

A COSMIC CANNIBALISM.

If the oral relation is the basis of the relation with the outer world, just as Dali, from whom nothing escapes, notes :

" *My worldly fixation was accordingly formed by the triumphal path of my mouth,* "

then his relations with others, deliberately neglected up to this point, will be fundamentally " cannibal. " And this is effectively what happens.

" *The greatest gastronomical refinement is that of eating 'cooked and living' beings.* "

— Dali speaks of young girls...

" *Young girls have exquisite insides... they blush when you try to make them edible.* "

— He mentions Napoleon :

" *I am especially anxious to draw attention to Napoleon's trousers (good to eat)...* "

— He evokes the Pope :

" *Personally I much prefer a pope like John XXIII. He looked terribly edible!* "

— Spirituality :

" *What does this spirituality consist of? Is it edible?* "

— Or his own religion :

" *The sublime fundamental law of our Catholic, apostolic, Roman, and Roumanian religion : to swallow the living God.* "

— He considers a king :

" *A king should be like a good cheese : very ripe, to the limits of deliquescence.* "

— Does he wish to define himself? He will say :

" *Gruyère cheese is my personality.* "

— In the same way, he will explain Cézanne by the edibility of his apple, or Le Corbusier by the inedibility of his cement, which makes him :

" *Sink and die of drowning.* "

— But, in return, reciprocally, others can eat him :

" *Captain Moore is a very nice person. There's no reason why he shouldn't start biting me one day.* "

This is the reversible aspect of the cyclical reaction :

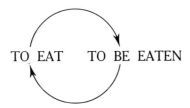

TO EAT TO BE EATEN

A DIOSCURIC AND AESTHETIC CANNIBALISM : " *Les ' Je mange Gala* ' "

Logically this cannibalism will then exist — and to the maximum — with one's companion spouse. If Dali's alimentary behavior seems to have nothing in common with the rest of the world, revealing itself as extremely complex, sophisticated, and saturated with the imaginary, it is exactly the same with his conjugal behavior, and Dali often explains it, tirelessly and at length.

Thus the tenth chapter of *Dîners de Gala*, devoted so significantly to " aphrodisiac dishes, " is entitled " Les ' Je mange Gala.' "

This chapter was called, no less significantly, in the first rejected version, " Les Saveurs cosmiques " (The Cosmic Flavors), suggesting the extension of this frenzied craving to the whole cosmos, which thus acquires the same flavor as the glorious and sublime body of his spouse-twin.

Now, this is exactly what Dali develops from the first line of the first chapter, " Gala, " in his *Les Passions selon Dali*, in a veritable festival of gastro-aesthetic cannibalism entitled :

" *How I put my father to gastronomical use.* "

Dali describes at length the mole on Gala's " divine ear, " exactly identical with that of Picasso, an " *expression of the Divine Proportion,* " and therefore :

" *The signature of divine architectures. It assumed a sacred value; it linked, through Picasso, my love to the passion of my father and to the aesthetic passion.* " Thus :

" *Under the form of that sacred pastille... consecrated wafer of the paternal communion... Gala became a sublime and delectable representation of my father.* "

And Dali goes on with the most fantastic and symptomatic precision. On one side we find the reversible relation " to eat — to be eaten. "

" *Thus I had the possibility of tasting my father in Gala in small succulent mouthfuls, while at the same time agreeing to be devoured by Gala...* "

and on the other this cosmically extended cannibalism, expressed in a circular relation :

" *Finally as the Dalinian unconscious makes Leda, the cosmic mother of the Divine Twins, appear behind Gala, I can close my mouth and allow myself to possess (eat) in all legitimacy my father, my brother, my mother, and beauty.* "

But what does this reversible relation " to eat — to be eaten " then mean? A phantasm too charged with anxiety neutralizes and secures itself by reversing itself, and Dali, from whom nothing escapes, does not fail to explain to us further :

" *and let our passions be devouring, but let's have a still greater appetite to live in order to devour them!* "

or again, apropos of death :

" *the wish to know devours me, but I devour that wish.* "

CANNIBALISM AND FUNEREAL RITUAL :

" *To eat is always to die a lot.* "

With the theme of death, it too devouring but devoured, and thus linked to the orality whose occult face it is going to reveal, there appears a whole new dimension, seemingly the most incomprehensible, of the Dalinian gastro-aesthetic. For our initiatory quest is unending : scarcely is one level attained before another appears and disappears. Scarcely is one question answered before another emerges.

Why this cannibalistic fixation? What duality is hidden behind the Dioscuric phantasm? The answer is suggested by the last piece of this gastronomical puzzle, the mystical marriage of orality with death.

In the first chapter of *Les Dîners de Gala*, in the very first sentence, Dali makes this astonishing and solemn proclamation :

" *Dali says that, without any doubt, to eat — especially gastronomical repasts — is always to die a lot.* "

And having thus posed the relation : Eating → Dying, Dali immediately goes on to pose the reverse and reciprocal formulation : Dying → Eating, so strong and essential are the reversible and reciprocal relations that are linked to orality.

" *The specter of Death creates supreme delights, salivary expectations.* "

Elsewhere he develops this theme according to the implacable logic of reversibility : first the relation Dying → Eating, then the reciprocal Eating → Dying :

" To say that I think unceasingly of death is not enough. I carry in myself its fabulous presence. Even more strongly at the moment of eating. The reality of death appears to me at every meal and imposes itself... As soon as the odor of fried sardines reaches my nostrils, I turn toward the cemetery, and my gastronomical happiness is increased by the awareness of death. My appetite topples the tombstones. In tasting the cleanest flesh that comes from the sea, I say to myself : 'I am not dead, I live, I live,' and I doubly salivate, also tasting this dazzling evidence."

It is on the basis of this relation, and its reversibility, that Dali, who decidedly omits nothing, lucidly and logically goes on to establish a cathartic and prophylactic ritual, successively formulated according to the two senses of reversibility.

First the direct sense :

" Henceforth I will taste any sardine with particular relish if at the same time I am thinking of all my friends who are dead, preferably shot or martyred."

Then he immediately pursues the reverse sense, lucidly underscored :

" In return, if I eat the sardine with a good appetite, it is because I do so in the name of the dead. In the name of the dead, I eat it greedily."

The two guiding principles of the Dalinian gastro-aesthetic, each reversible by reciprocity, thus seems to us irrefutably established by Dali himself.

— On the one side, the Dioscuric principle : - Dali - Eats - Gala — also valid in the sense : Gala - Eats - Dali -.

— On the other, the oral principle : Eating ➞ Dying, and Dying ➞ Eating; the two circular reactions being :

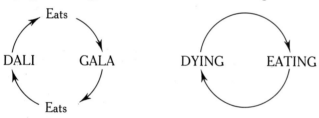

CANNIBALISTIC AND AESTHETIC ORALITY.

We cannot in these few pages consider the " secret of the secret " of Dali, hidden behind his orality, and in any case our purpose is to set forth Dali's aesthetic, by which to " explain " the strangest and most irrational aspects of the Dalinian universe.

Let us begin by mentioning the qualitative and quantitative importance of the writings of Dali the art critic : there we always find orality, the underlying point of departure and arrival for the whole appreciation of plastic values, as well as for his pictorial technique. As early as 1936, he wrote : *When Salvador Dali speaks of his Paranoiac-Critical discoveries on the subject of the pictorial phenomenon... that kind of frenzy that consists of wanting to touch everything with the hands, worse still, of wanting to chew and eat everything...*

His most recent written work, *Dix Recettes d'immortalité* (Paris, Audoin-Descharnes, 1973), repeats this obsessional motivation :

" When I knew that a molecule of holographic emulsion contained the entire image in three dimensions, I exclaimed immediately : I want to eat it! By so doing, I was able to realize, at least figuratively, one of my dearest wishes : to eat the adored creature Gala, to ingest in myself, in my organism, molecules containing smiling holographic Galas swimming at Cape Creus."

Like his technique as a painter, Dali's judgments as an art critic proceed wholly and always from the same delirious

and obsessional orality. In 1933, he completed an admirable analysis :

" Of the Terrifying and Edible Beauty of Modern Style Architecture " — title of the article — subtitle : *" Appearance of the Cannibal Imperialism of Modern Style."* In 1936, he returns to the same subject at length :

" The Pre-Raphaelite painters bring forth and illumine for us the most desirable and at the same time the most frightening women that exist, for they are beings that we would feel the greatest terror and anguish in eating."

— Elsewhere he studies :

— *" François Millet, whose erotic cannibalism... "*

— *" This appetizing aspect of the Meissonier variety... "*

— *" This digestive hallucinatory aspect of the Gustave Moreau variety... "*

— *" This grandiose and cannibal aspect of the Millet variety... "*

— Apropos of Gaudi's architecture :

" This aspect, the triumphal meat of salivary expectations, Modern Style of the Barcelona variety."

— About Picasso he tells us :

" The biological phenomenon that constitutes Picasso's Cubism has been the first great imaginative cannibalism."

Each of his writings on Surrealism proceeds from the same aesthetic vision — we should say hallucination — wherein is revealed either the edible aspect, that is to say to be eaten — or the " glutton," " voracious," " cannibal " aspect, which means to eat.

At first he analyzes :

" The colossal nutritive and cultural responsibility of Surrealism... "

" The Surrealist object... under the sign of eroticism, exactly as with the love object, first we want to set it in motion, then we want to eat it."

" After the appearance of Surrealist objects that functioned symbolically, the question was rather of knowing how we could, for example, make a table edible, for the at least partial satisfaction of the imperious wishes of the " cannibalism of objects."

At the end, even the Surrealists themselves are drawn into the whirl of the circular reaction : to eat — to be eaten.

" Salvador Dali suggests that one try also to eat the Surrealists, for we Surrealists, we are good quality food... because we Surrealists... we are caviar..."

AESTHETICS AND IMAGE OF THE BODY.

In order to explain and justify in detail this aesthetic and all the works here presented that proceed from it, we would have to analyze at length this cannibal frenzy based on sensorial, visual " hallucinations " felt and developed in phantasms, then rationalized in technique by the famous Paranoiac-Critical Method.

Let us limit ourselves here to indicating the itinerary of this aesthetic frenzy according to the four " keys " of access to the Dalinian universe.

■ At first, orality, that " fixation on the world by the triumphal path of the mouth " — not, however, that of the child, but of the suckling infant.

■ Then this orality as felt and lived through the image of the body. Every being, normal or not, feels, lives, and acts only through his body and the image that he has of it, its reflection in his consciousness projected in the outside world onto beings and objects. The image of the body is the agent, the controller, the guiding principle of our actions and our personality, of the more or less harmonious cooperation of desire and pleasure of the imaginary — with reality. This image of the body is disturbed in the neurotic; completely

dislocated, shattered, and rebuilt according to an irrational and atypical pattern in the psychotic. We have a perfect illustration of this in Picasso's faces and bodies. Dali gives us not only an almost photographic illustration of it but also a lucid explication of the theory in the numerous articles published between 1931 and 1936, corresponding very precisely to the regression of his psychosis, to the return to reality, and to his recovery through his " transference " to Gala, as we have shown in *Dali by Dali*.

— Finally, third key, the projection of the body image, the expression of the subjectivity of our inner world, and hence its collision and conflicts with external objective reality. The normal person learns how to adjust and set the image of his body, the spontaneous and natural support of his actions, according to the outside world. The psychotic rejects the objective world, which he " invests " with his own body image, meaning that he totally projects it on the outside world, which then appears to him entirely and exclusively formed by his own body, encroaching and dilated to the absolute dimension of the cosmos, fanatically, rigorously, and without the least concession to any other reality except that of his body, or rather the delirious and cosmic image that he has of it. This is normally experienced by all of us at the nursing stage of the first four months of our lives. People keep the memory of it and express it clearly in those reservoirs of our infantile past that are mythologies. It is the universal myth of cosmic primordial man.

So now, starting from the whole world as a body, from this delirious and cosmic body image, we can understand the Dalinian aesthetic.

First of all, the dialectic of soft and hard as analyzed in *Dali by Dali* : it is necessarily the dialectic of the body, the architecture of flesh and bone, as Dali has been tirelessly repeating for forty years.

" *Salvador Dali has not stopped insisting on this hypermaterialistic aspect, first requirement for any process of knowledge of biology as linked to the flesh and bones of aesthetics.* "

" *Those who have not touched the bony structures and living flesh of the ornamental frenzy...* "

" THIS EXTRAVAGANT CUISINE OF SPACE. "

There is no aesthetic without a concept of space. Now we can understand why and how space for Dali is meat, a carnal and fleshy body.

" *Space, for Euclid, according to whom intersection, point, and plane were nothing but idealized material objects, could not reach a consistency superior to that of a light tapioca bouillon, perfectly utopian and chilled.*

" *It is with Descartes by the consideration of space as a three-dimensional content that the insipid juice starts to thicken, and also, and above all, to awaken the appetite to the salivary expectations that already produce this extravagant cuisine of space; this cuisine definitely finds all its nutritive weight and all its characteristic heaviness with Newton's apple. But up to Newton, space is offered to us less as meat than as the container for the meat; its role is passive and chronically masochistic... With the discovery of the undulatory theory of light and of electromagnetic bodies by Maxwell and Faraday, the thousand temporary ductilities of the ether were needed in order to reach the modern theory of relativity, where space has become this good and colossally enticing meat, voracious and personal, pressing at every moment... the bodies of the ' object-beings.' *"

" CANNIBALISM OF THE OBJECT-BEINGS...

...affectionate blackheads of space."

" *Pressing at every moment the bodies of the object-beings.* "
— Here is the fourth key, the one that opens wide the final doors of this universe. Thus not only space but the objects of space participate in this projection of the body : they are bodies themselves, bodies of flesh and bone, and in 1935 Dali himself developed this fourth key for us in detail in the course of an extraordinary article :
— " *Apparitions aérodynamiques des êtres-objets.* "

It is naturally a childhood memory, the voluptuous pleasure he took in extracting, " with a neurotic ritual, " blackheads from his nose. Henceforth space looked to him like a gigantic cosmic nose out of which emerged " object-beings " that had all become " blackheads of space. " — Let us limit ourselves to mentioning only the titles of the paragraphs :
— " *The Blackheads of Space* " — " *Blackheads! Blackheads! It's Slippery!* " — " *The Sphinx of the Blackhead* " — " *The Barbarity of the Blackhead* " — " *Examples of Blackhead-Objects* " — and two descriptions of this " *Aerodynamic appearance of object-beings* " :

" *All those aerodynamic, gelatinous, dented cars with supersmooth curves, massive salivary anatomy, fleshy thighs, and flabby stomachs of the 'Modern-Style-Mae-West' type, all those aerodynamic and atmospheric cars with fat, compressed, exuberant, and sticky viscera are nothing else — and this is what Salvador Dali tells you and guarantees — but real 'blackheads' that pop out, all slippery, solemn, atmospheric, and apotheosic from the very nose of space, the very meat of space.* "

Here now is the explanation of " The Sphinx of the Blackhead, " the strange mysteries of creation and birth, of the hard and the soft :

" *An important nose made of a ductile material — elastic (compact appropriate rubber); on the aerodynamic and supersmooth curves of the nose there would therefore be a multitude of 'strange bodies,' set into it so as not to break the homogenous and supersmooth continuity of the surface. A general compression by both hands would be enough for hundreds of minuscule objects — night tables, skulls, bottles, lampshades, etc. — to break by their ascension, as slow as the Paramount Theater orchestra, the surfaces that a moment ago were supersmooth. — It will be an artificial, concrete, and affectionate blackhead.* "

We cannot in these few pages reach what is most surprising and unusual, Dali's secret of secrets, nor can we comment on many of the works here presented, which reveal him to us while concealing him. We will probably some day be able to publish this " secret re-secret " : — " Dali as suckling nursling " — and " Dali — cosmic spermatozoid. "

We hope, however, that we have at least untangled the main lines of force of Dali's creation and aesthetic, and we will limit ourselves to reproducing faithfully, as a conclusion, what Dali himself prophetically wrote in 1933 for the study titled

" RETOUR À LA BEAUTÉ. "

Where the Venus of logic is being extinguished, the Venus of " bad taste, " the Venus in furs announces herself under the sign of unique beauty, that of real, vital, and materialistic agitation. — Beauty is nothing but the sum of total awareness of our perversions. — Breton has said : " Beauty should be convulsive or not at all. " The new Dalinian Surrealist age of the " cannibalism of objects " equally justifies this conclusion :

BEAUTY SHOULD BE EDIBLE OR NOT AT ALL.

Dar-es-Salaam — Paris, April 26, 1974 *SALVADOR DALI*

Dali

Dali, Dali, Dali

mad about attitudes that can bewitch a work

Dali, on what taut cord would you have engaged your perpetual will for anomaly

We will meet them in the course of these pages

They are called

By making use of them

Also

Thanks to it, you can disentangle, unravel, blindingly bedazzle

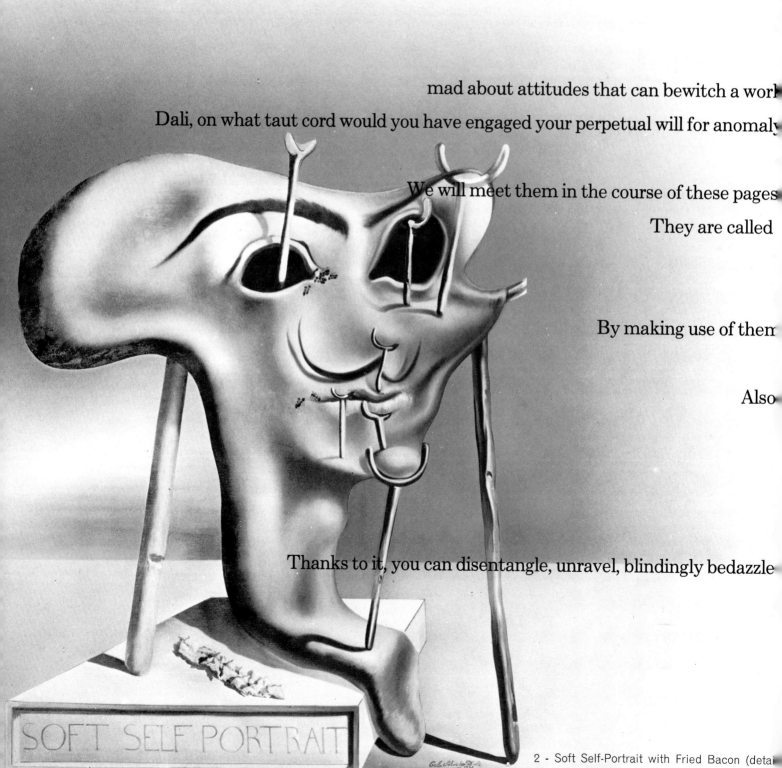

SOFT SELF PORTRAIT

2 - Soft Self-Portrait with Fried Bacon (detail)

nad about the craft of the artisan who develops his techniques,

nad about good practice in painting and drawing,

craft he possesses that centuries of civilization have perfected, disciplined, and strengthened!

nad about the craft of the old masters,

nad about their masterpieces and their tradition!

nad about searching to the frontiers of the absolute, mad about going to the furthest extreme,

nad about immoderation, mad about eternity,

or adorn someone's profile!

n threatening the equilibrium of your physical being,

of your psychic integrity, if you had not prudently found yourself some scrupulous switchmen?

hose who can check the Dalinian frenzy.

Gala. Paranoiac-Critical Method. Bourgeois sensibility.

Taste for material success. Fascination with ritual.

ve will try to discover when Dali is serious and when he jests,

while concluding besides that the difference has no importance for his work.

t is well to consider this volume as only a tool put in your hands.

t is up to you to use it to break down a barrier,

o force a passageway.

Thanks to it, you can progress to the very substance of his work,

breathe the essence of Surrealism, encircle the writing of an imagination.

Thanks to it, you can...perhaps?

War

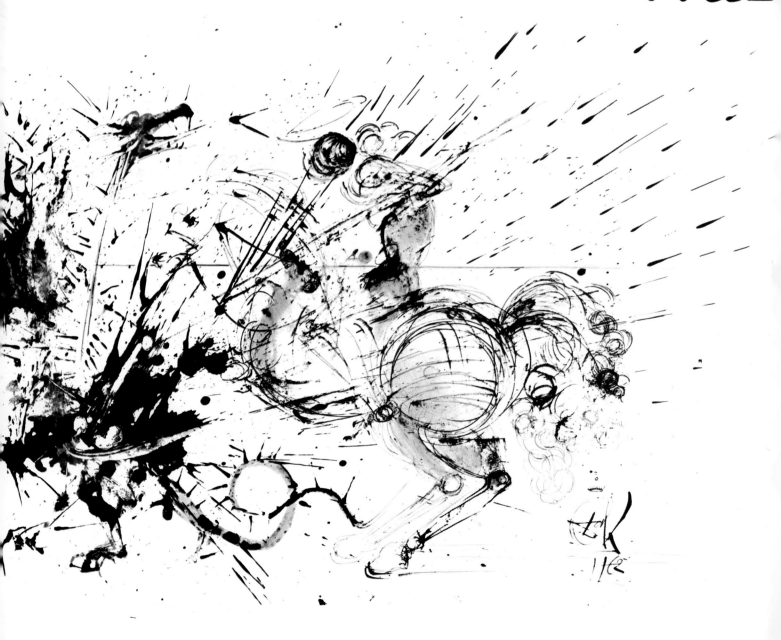

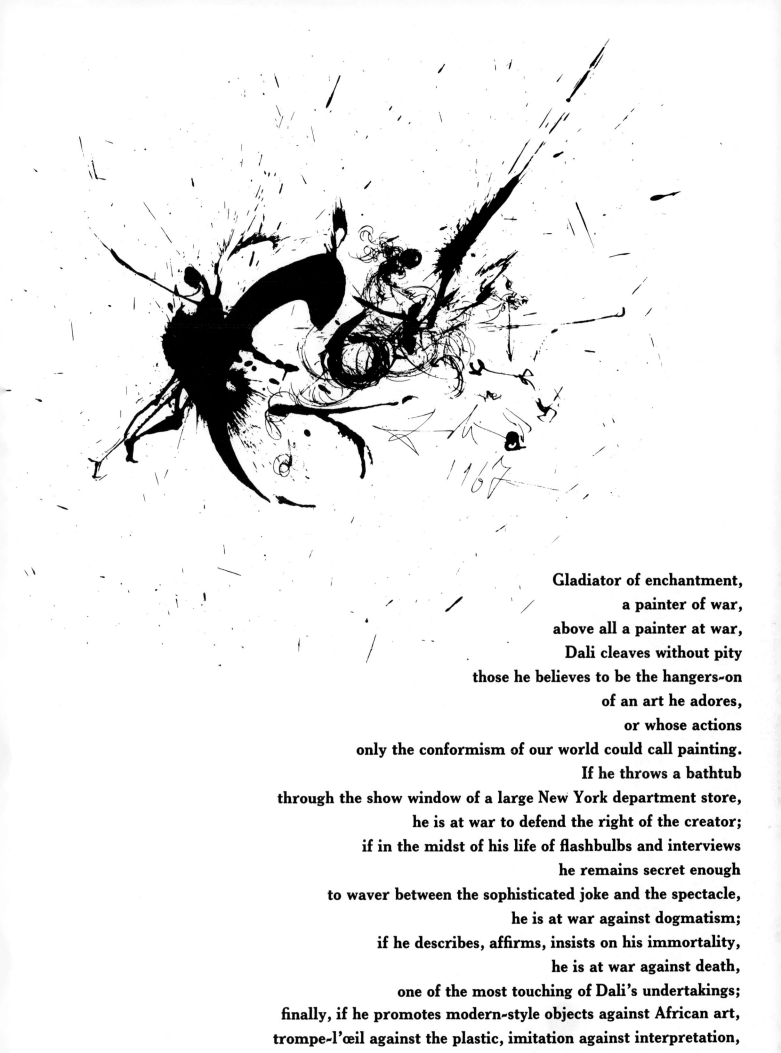

Gladiator of enchantment,
a painter of war,
above all a painter at war,
Dali cleaves without pity
those he believes to be the hangers-on
of an art he adores,
or whose actions
only the conformism of our world could call painting.
If he throws a bathtub
through the show window of a large New York department store,
he is at war to defend the right of the creator;
if in the midst of his life of flashbulbs and interviews
he remains secret enough
to waver between the sophisticated joke and the spectacle,
he is at war against dogmatism;
if he describes, affirms, insists on his immortality,
he is at war against death,
one of the most touching of Dali's undertakings;
finally, if he promotes modern-style objects against African art,
trompe-l'œil against the plastic, imitation against interpretation,
this is his most cherished war,
a war against forms of art that imitate his own painting.

3 - Saint George and the Dragon.

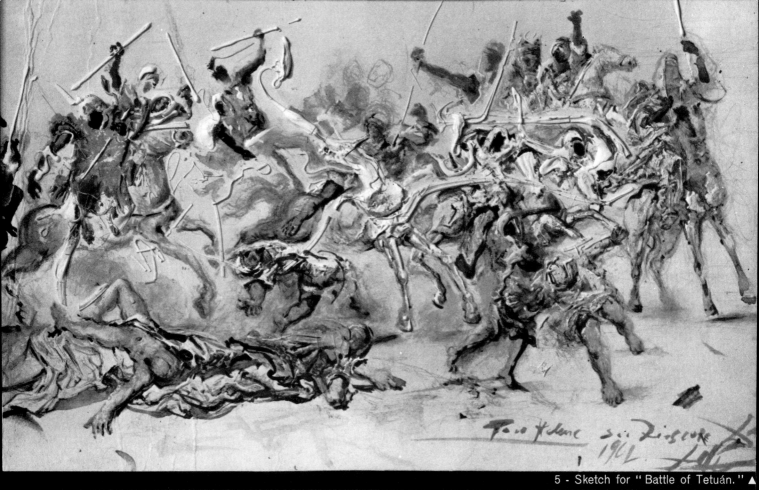

5 - Sketch for " Battle of Tetuán." ▲

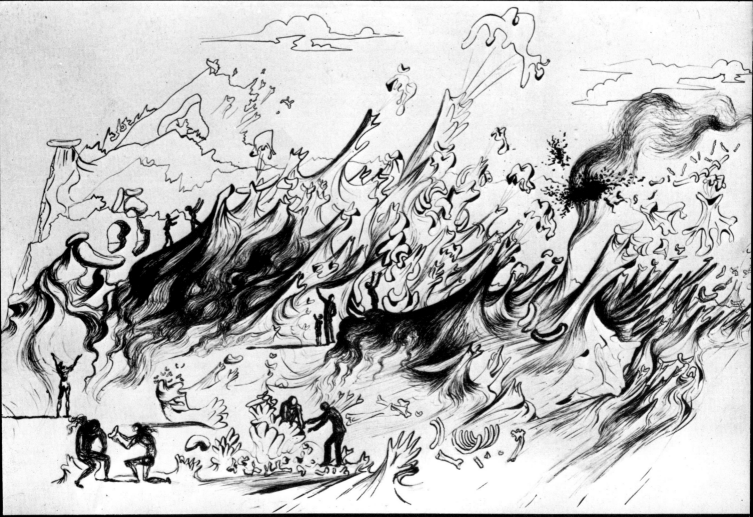

6 - Futuristic War. ◢

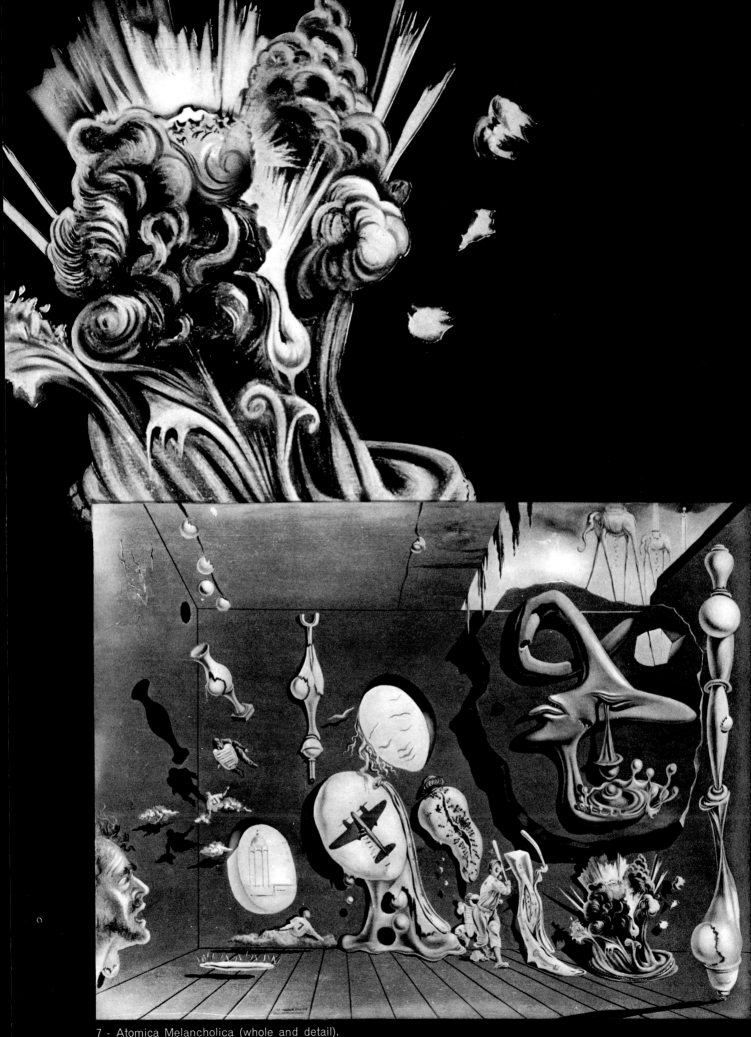

7 - Atomica Melancholica (whole and detail).

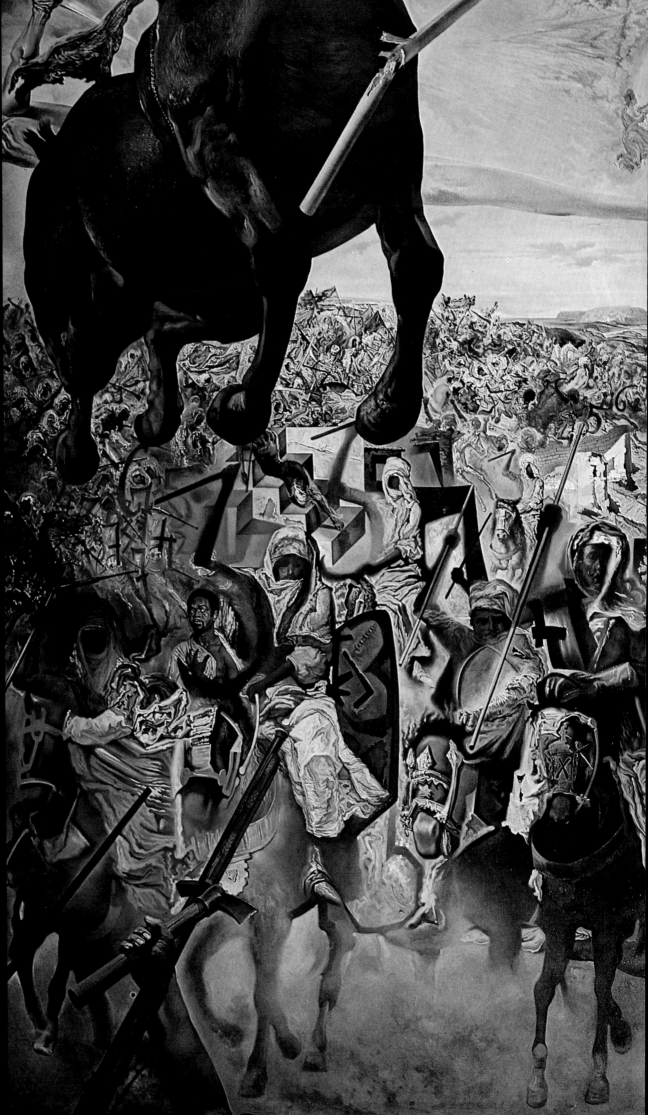

War
and love
are
the salt
of the
earth

Poem
by
Salvat
Papaseit
quoted by
Dalí

8 - Battle
of Tetuán.

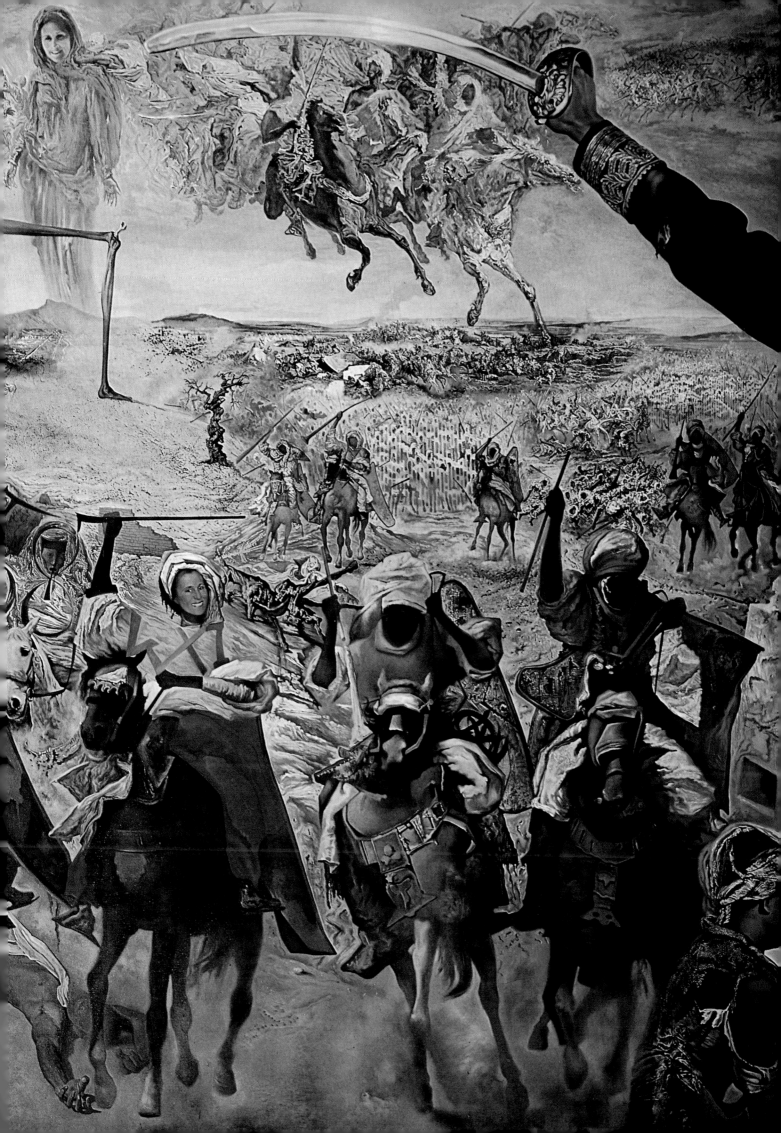

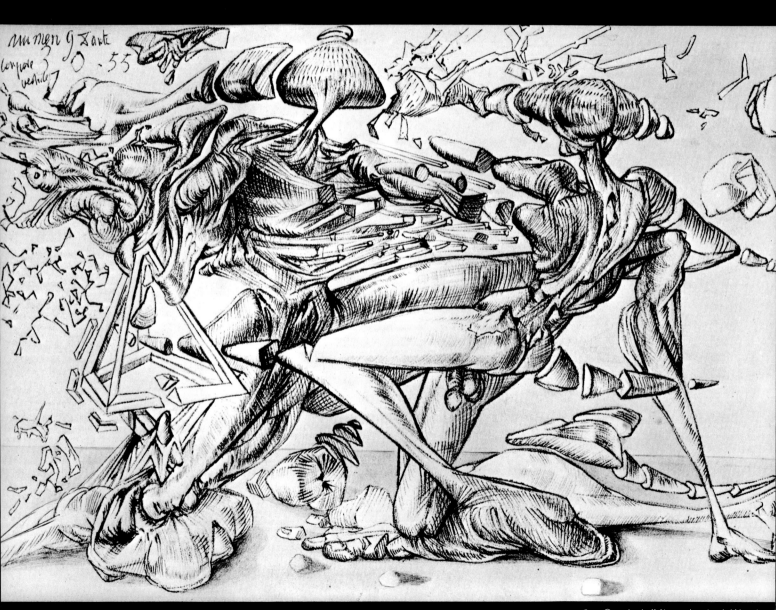

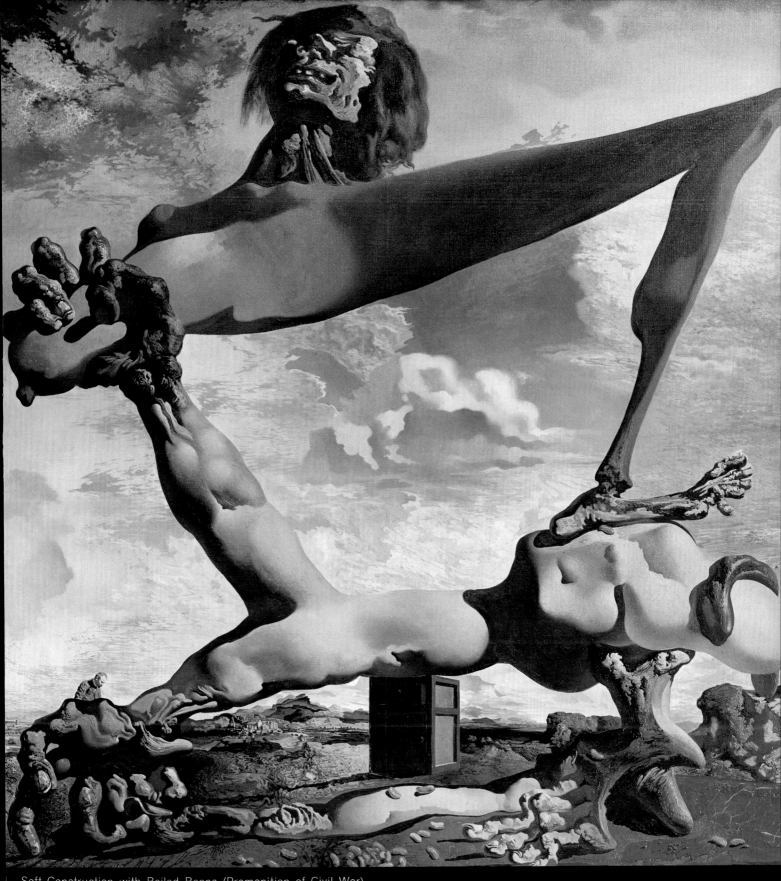

- Soft Construction with Boiled Beans (Premonition of Civil War).

the

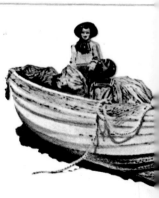

Landscape

Privileged partner of the canvas,
or laceration of a setting
opening to the horizon,
the Dalinian landscape delineates
the painter's passion
for a third dimension
whose developments the chapter " Space-Time " will discuss a little further.
Meticulous, while remaining more felt than represented,
landscape for Salvador describes the moment of a sentiment
or bends itself to the attitudes of the figures that haunt it.
But above all, with his landscape Dali breathes,
because he always encounters, and it is still the same,
that of his native land.
Dali is a Catalan, Dali is Mediterranean,
Dali is lord of one end of the Costa Brava,
thus no excess can disturb
the luminosity, the rhythm, the tranquil assurance
of this sea, these rocks, this plain of Ampurdan
which he does not tire of repeating,
which he does not tire of rediscovering, as though it had become
the petrified breast of a maternal harbor
where the wanderer can curl up in a kind of moist intra-uterine security.

11 - Paranoiac-Astral Image.

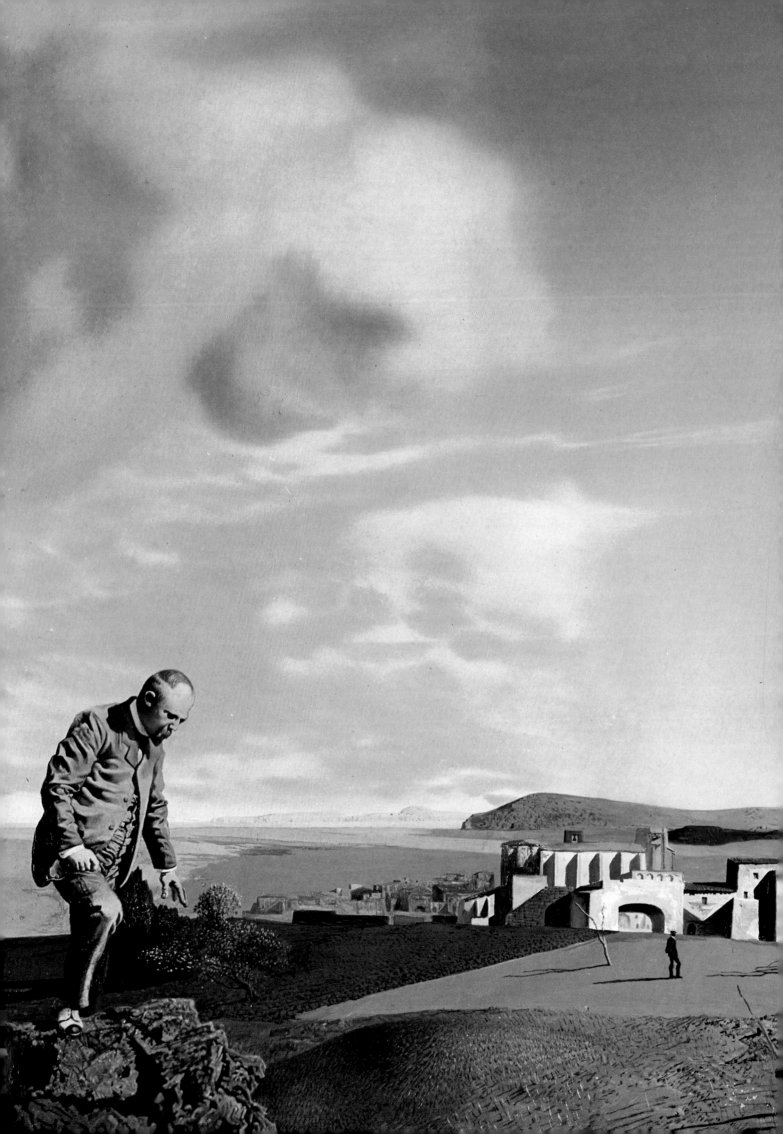

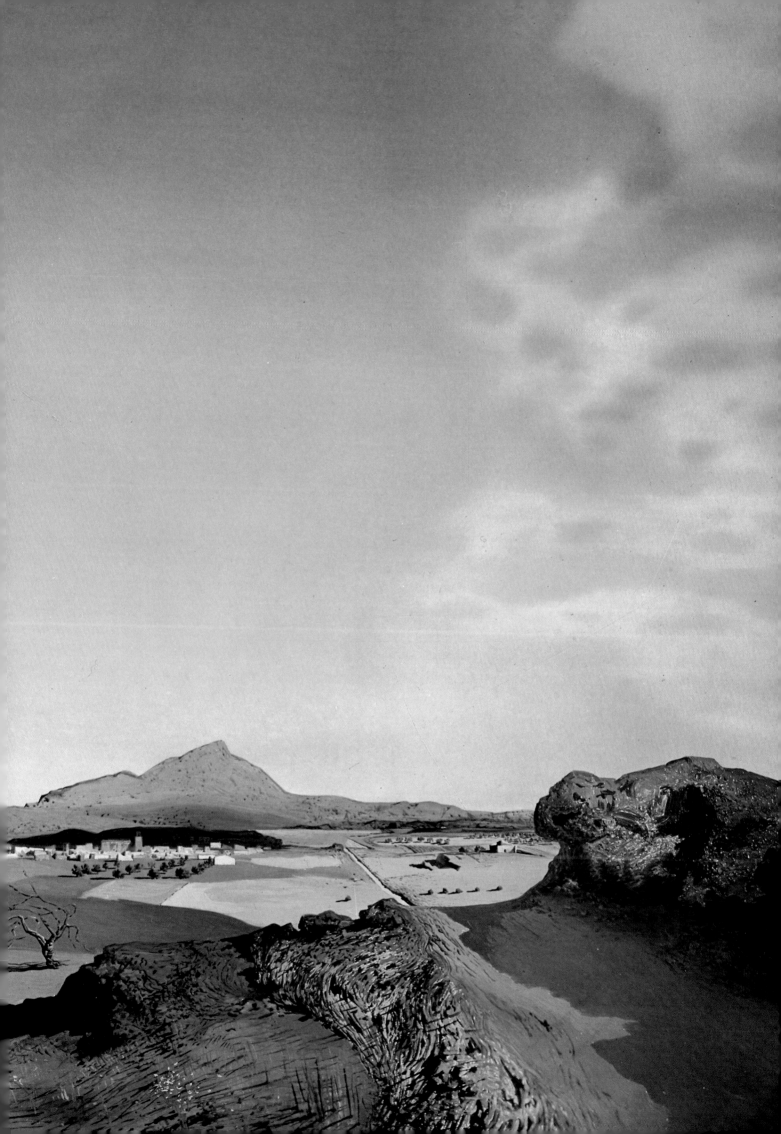

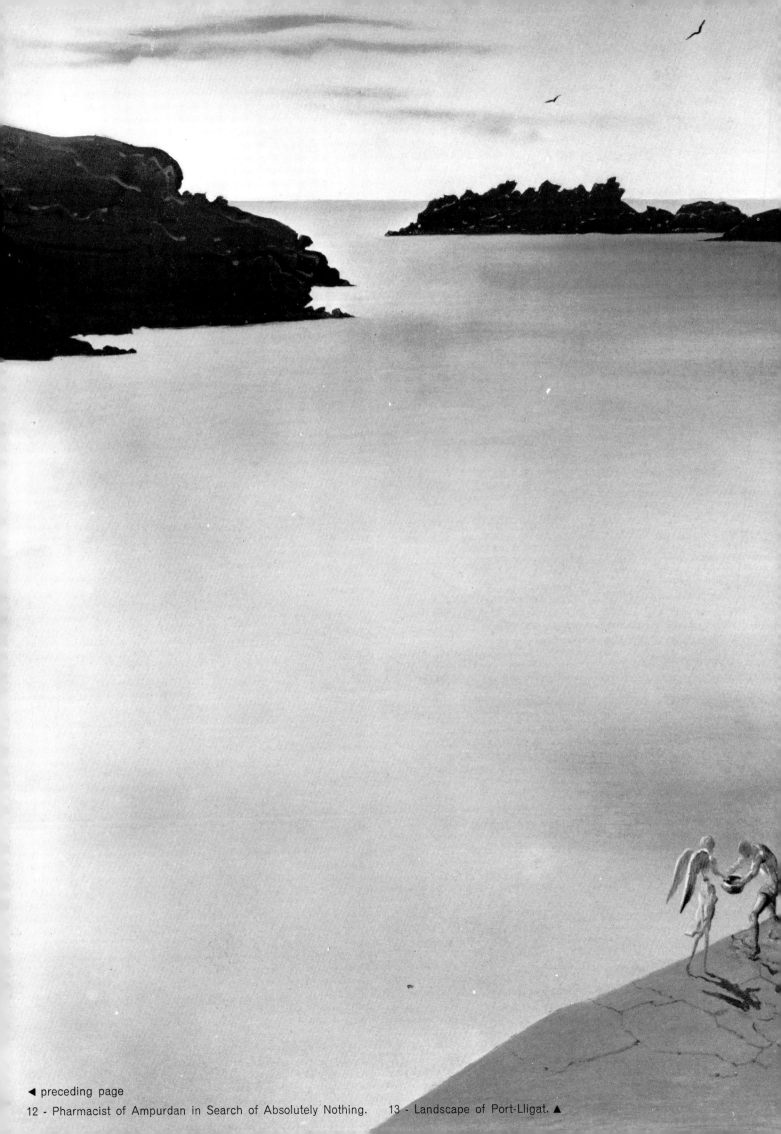

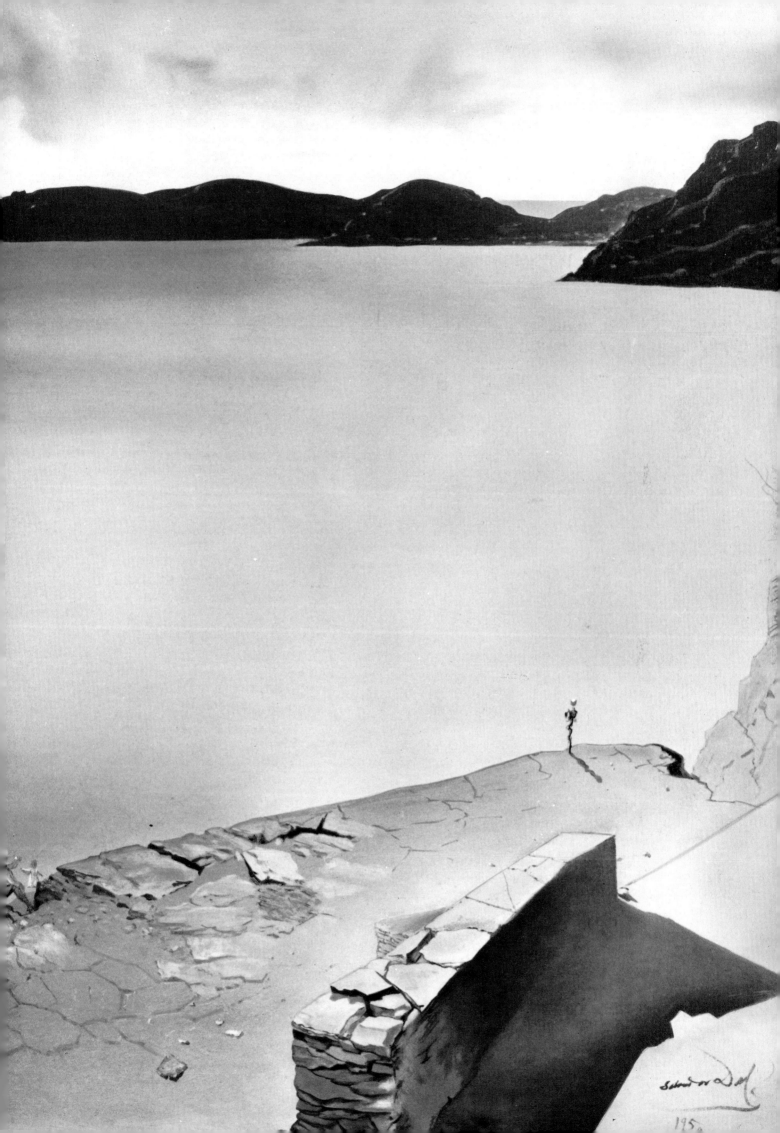

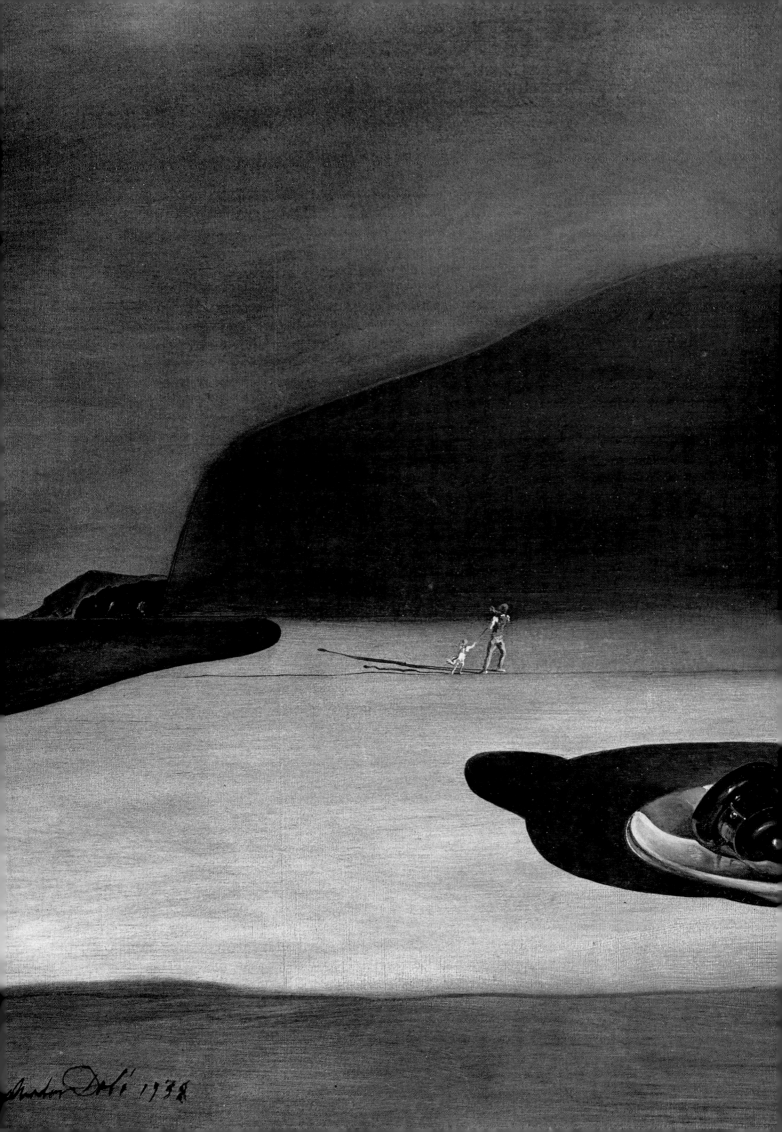

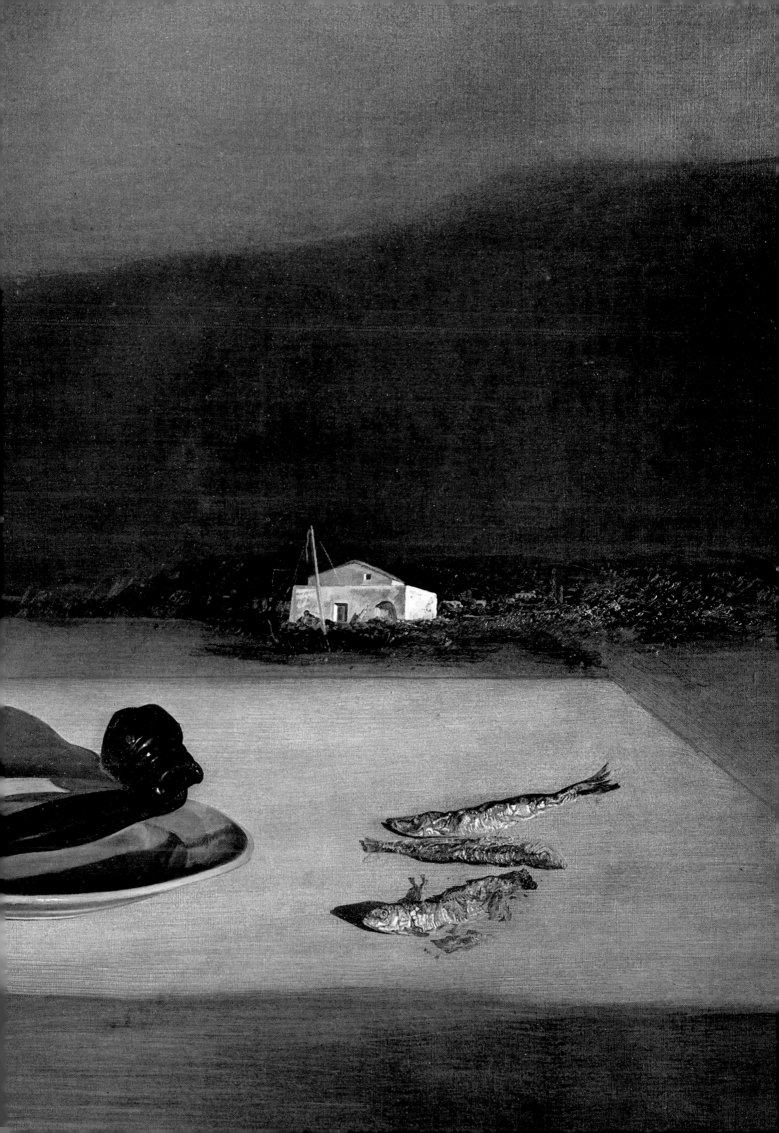

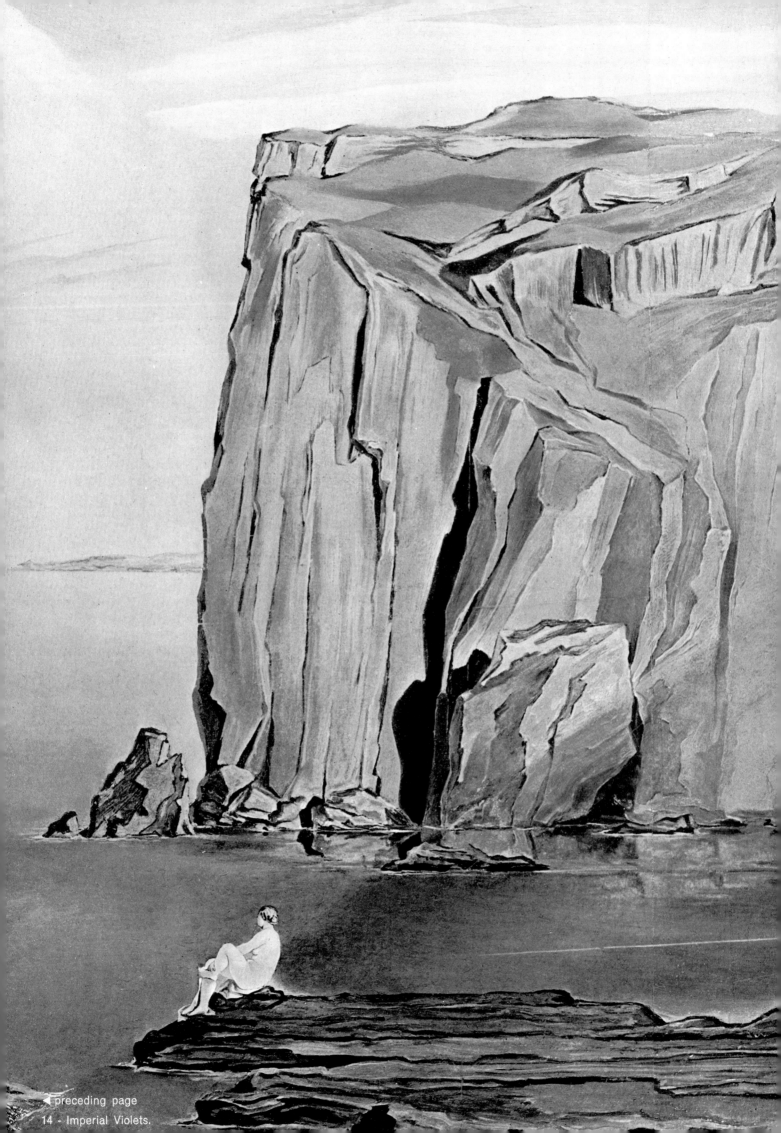

Figure on the Rocks. ▲

Gala

Thanks be rendered to her.
When Gala's path
crossed Dali's,
she brought with her at last
an intelligence capable
of enduring tirelessly the frenzy of a paranoiac monologue.
Essential counterweight to Salvador's ego,
faithful signpost among the nebulous bifurcations
of his undertakings,
Gala in the shadow thus assumes the complex labor
of a para-Dalinian life.
Having long freed Salvador from material needs,
she allows him to assume his selfhood
while remaining the barrier
against an environment greedily demanding still more
from a Dali who throws himself
into the most bizarre enterprises.
More than taking on her shoulders the burden
of the difficult years,
she remains the one who, with the final "No"
at the ultimate stopping place
knows how to put the brakes on a creator.

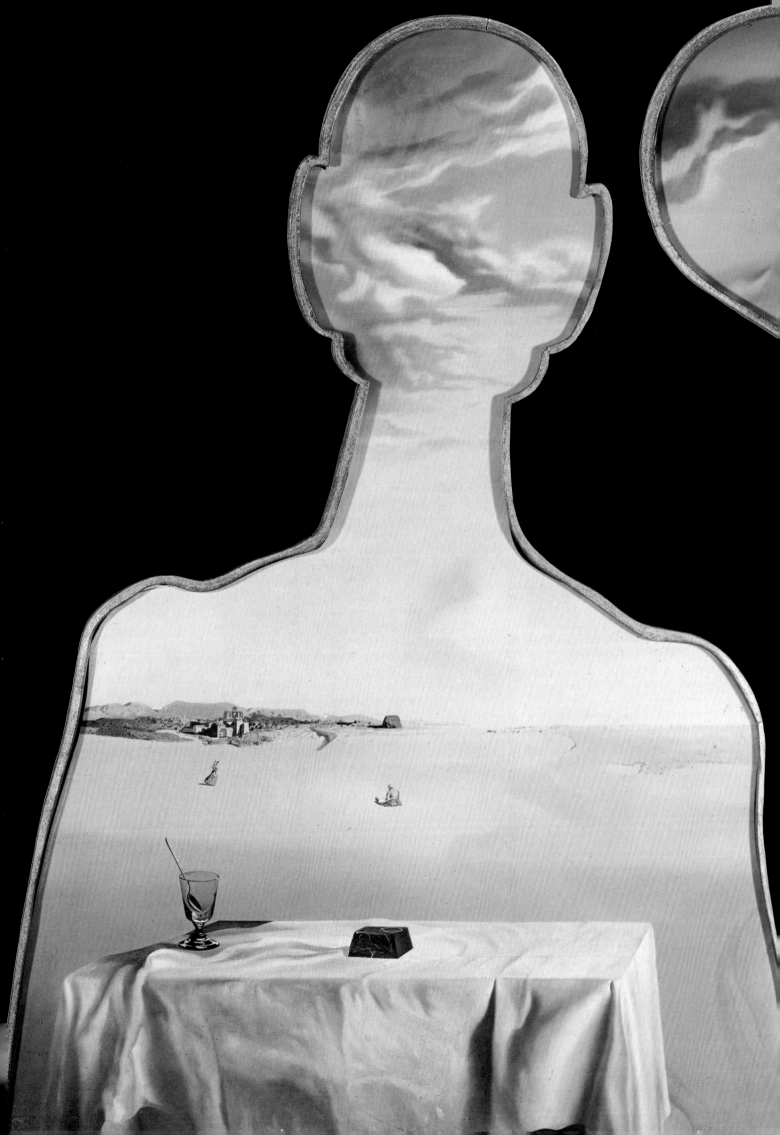

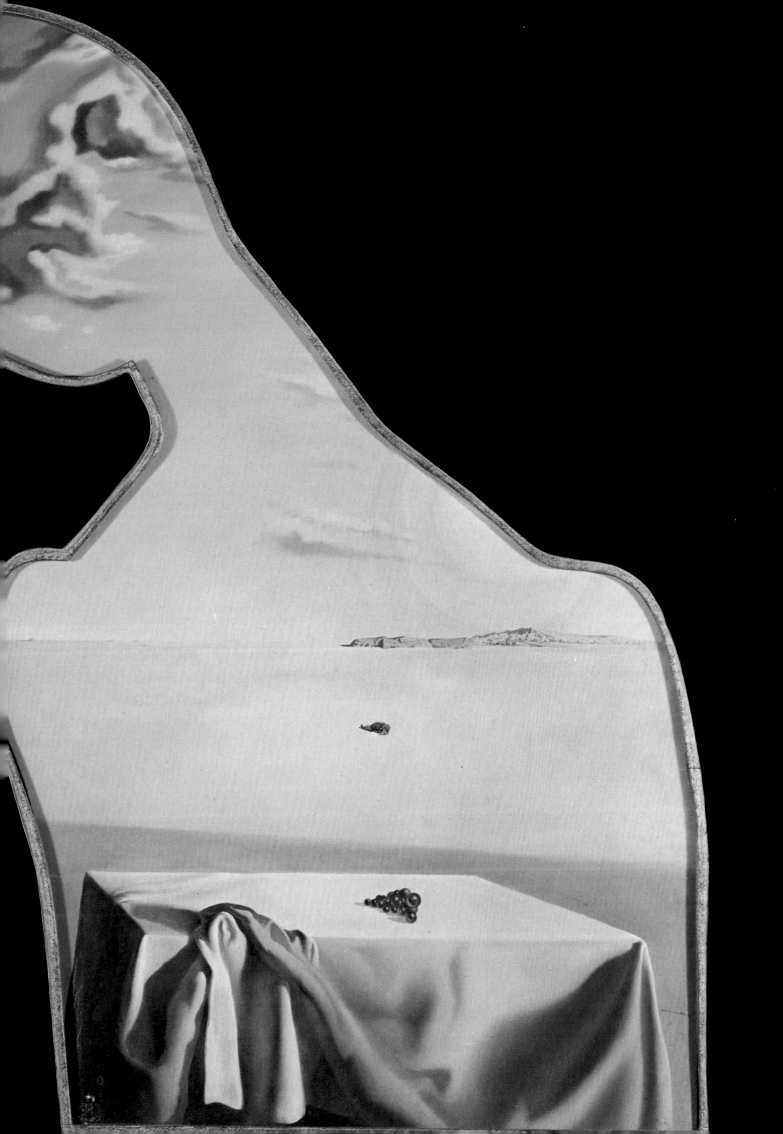

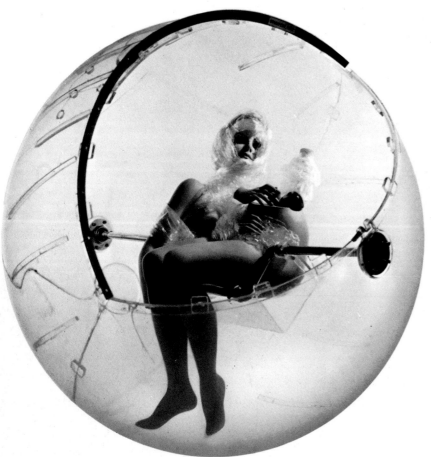

18 - Ovocipede.

◄ preceding page

17 - Couple with Their Heads Full of Clouds.

**Gala, my Olivette,
whom an atavistic hunger
impels me to bite,
to eat ourselves
to the very core of our beings**

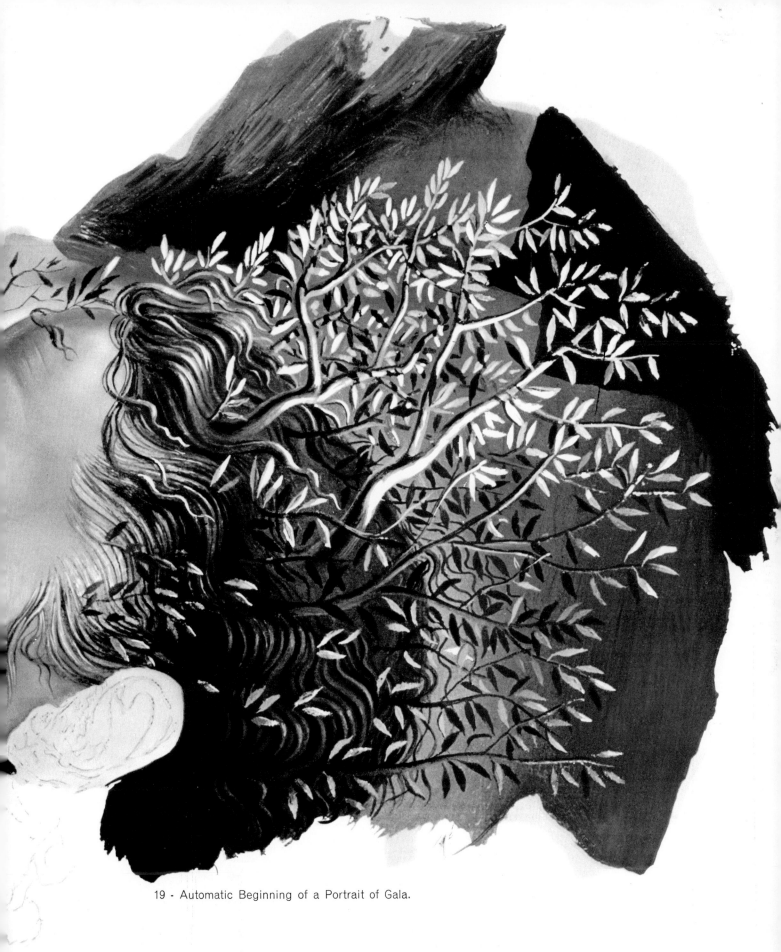

19 - Automatic Beginning of a Portrait of Gala.

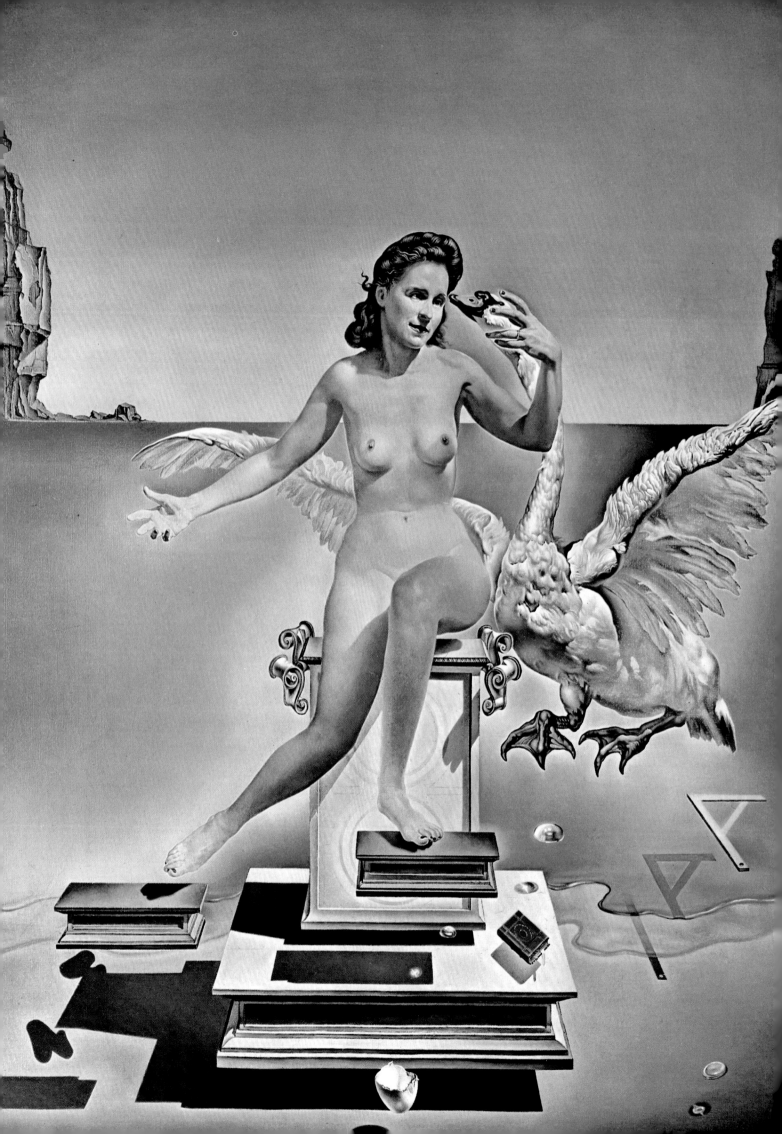

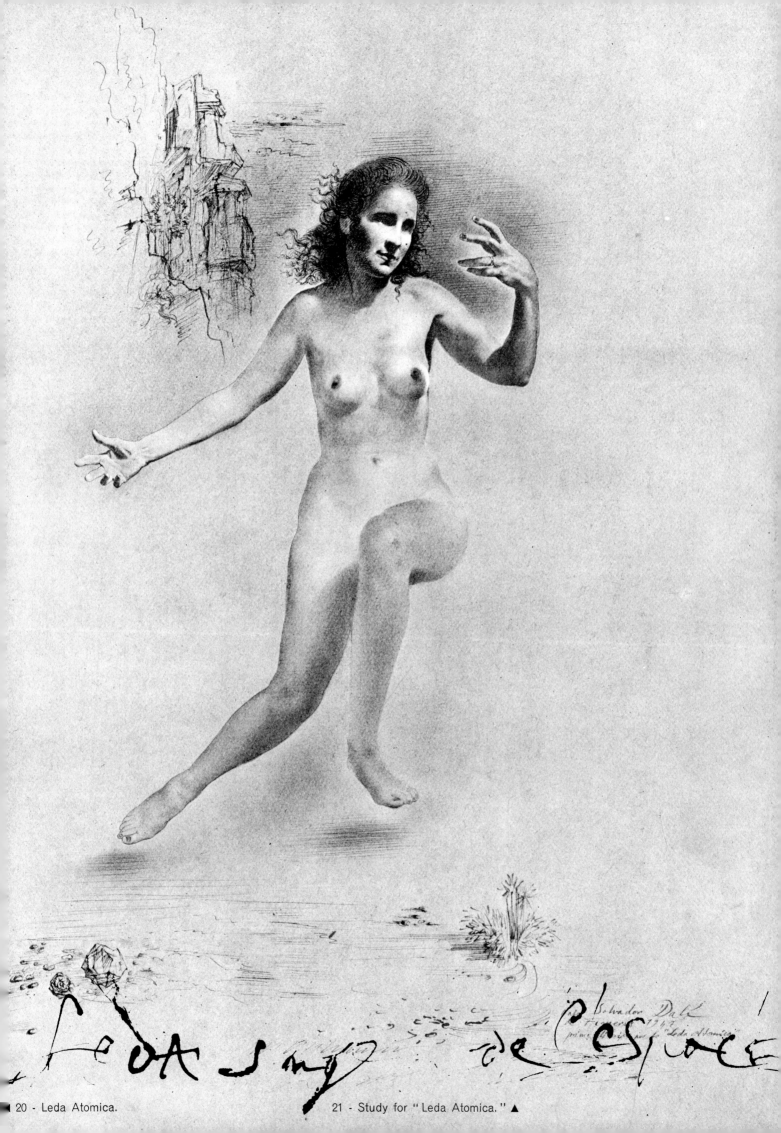

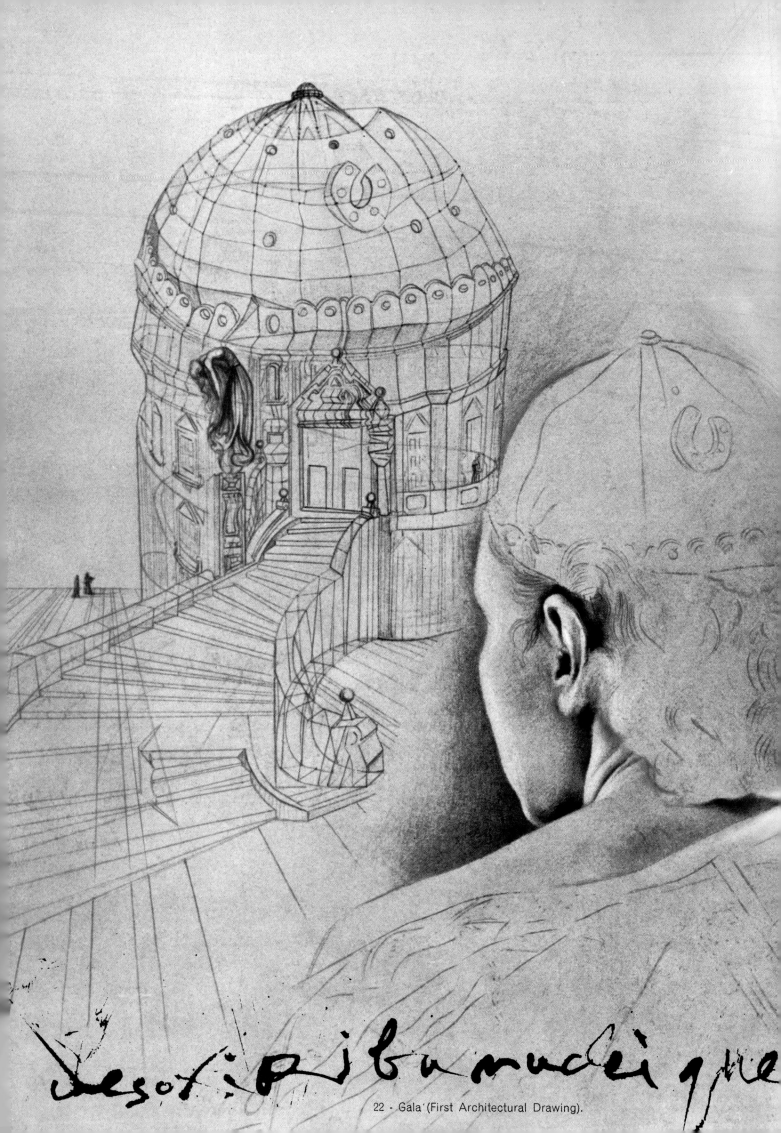

22 - Gala (First Architectural Drawing).

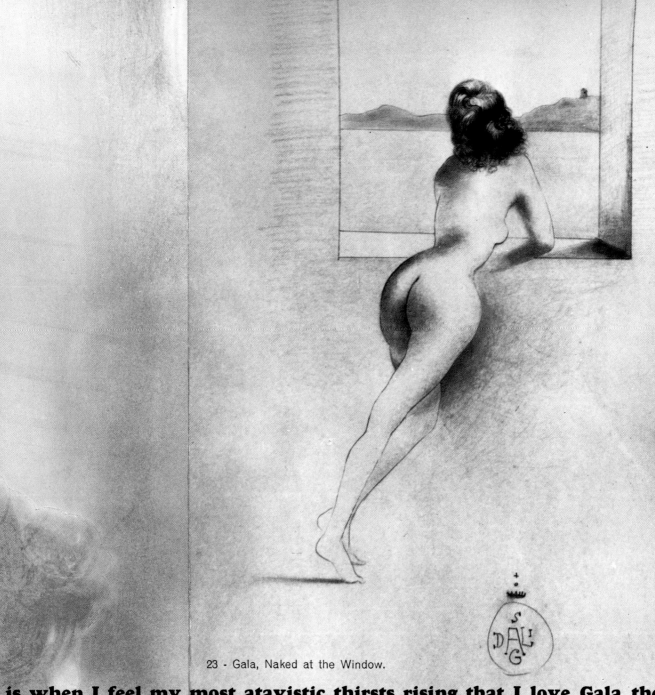

23 - Gala, Naked at the Window.

is when I feel my most atavistic thirsts rising that I love Gala the most.

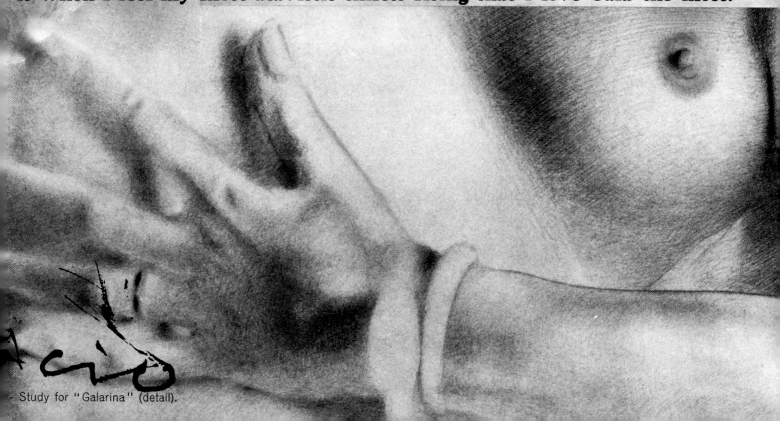

Study for "Galarina" (detail).

25 - The Flesh of the Décolleté of My Wife, Clothed, Outstripping Light at Full Speed. ▼

27 - Galarina. ▼

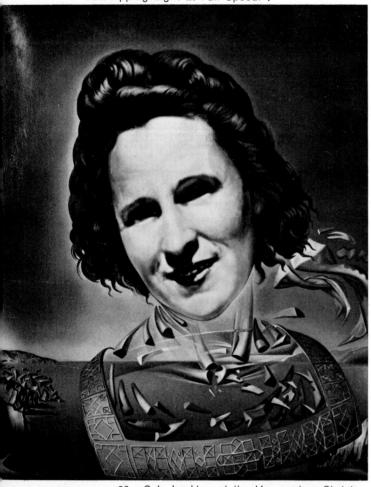

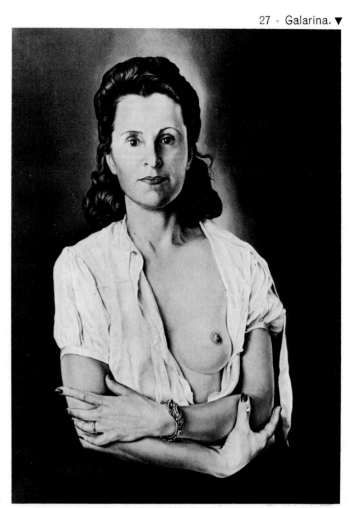

26 - Gala Looking at the Hypercubus Christ. ▼

28 - Gala with Two Lambchops in Equilibrium on Her Shoulder. ▼

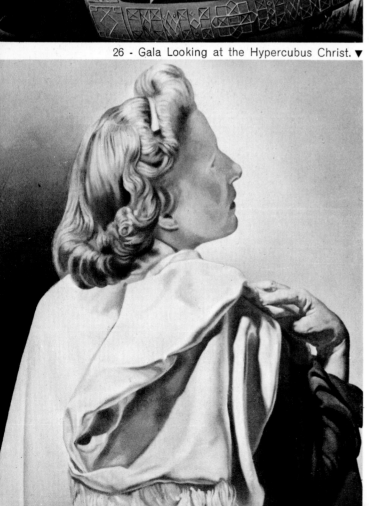

The lambchops on Gala's shoulder mean that Dali decided that day to eat two raw lambchops instead of eating Gala.

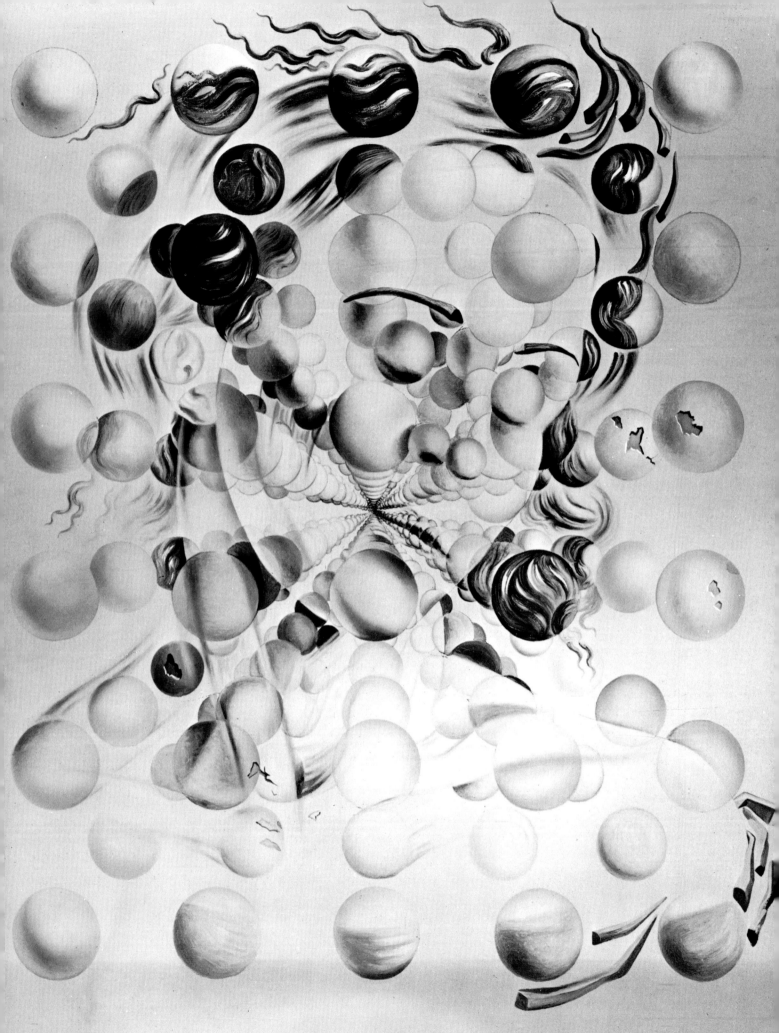

Dali, Dali, Dali loves Gala better than his mother, better than his father, better than Picasso, and even better than money.

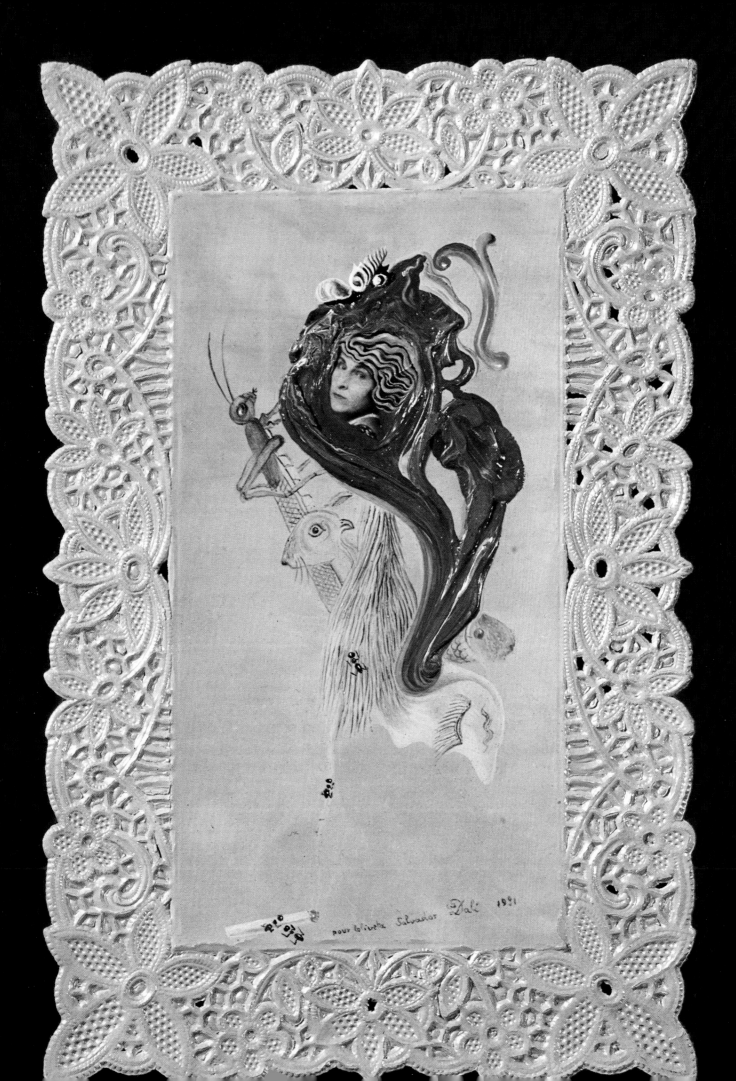

pour la vieille Salvador Dalí 1941

Nature
Still

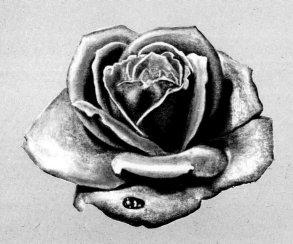

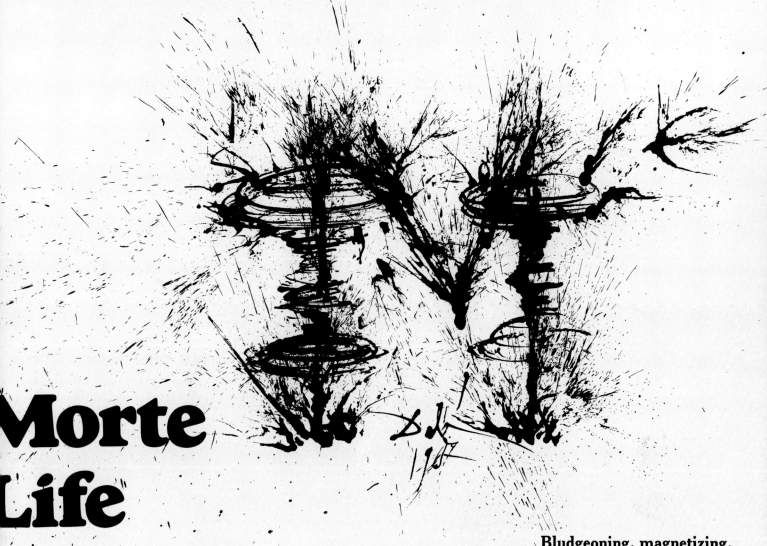

Morte
Life

Bludgeoning, magnetizing,
maltreating the expression itself,
in "Nature morte"
Dali retains only
the word :
Nature!
Death he will never cease to deny.
By the same token the objects, the Dalinian environment,
become vectors pantheistic enough to celebrate life.
For Salvador, the material breathes by giving a substance to space,
and so there is no reason for astonishment
when human figures participate in this transmutation.
Petrified figures,
pulsating objects,
the frontier between life and death oscillates on the picture plane
just as it seeks itself in the process of scientific experimentation.
To make this vital undertaking triumph,
Dali then invents objects
capable of gaining a victory over entropy.
Such is the case of Michelangelo's " Slave ", who,
taking advantage of an inclined plane,
rolls at accelerating speed downward across the following page.

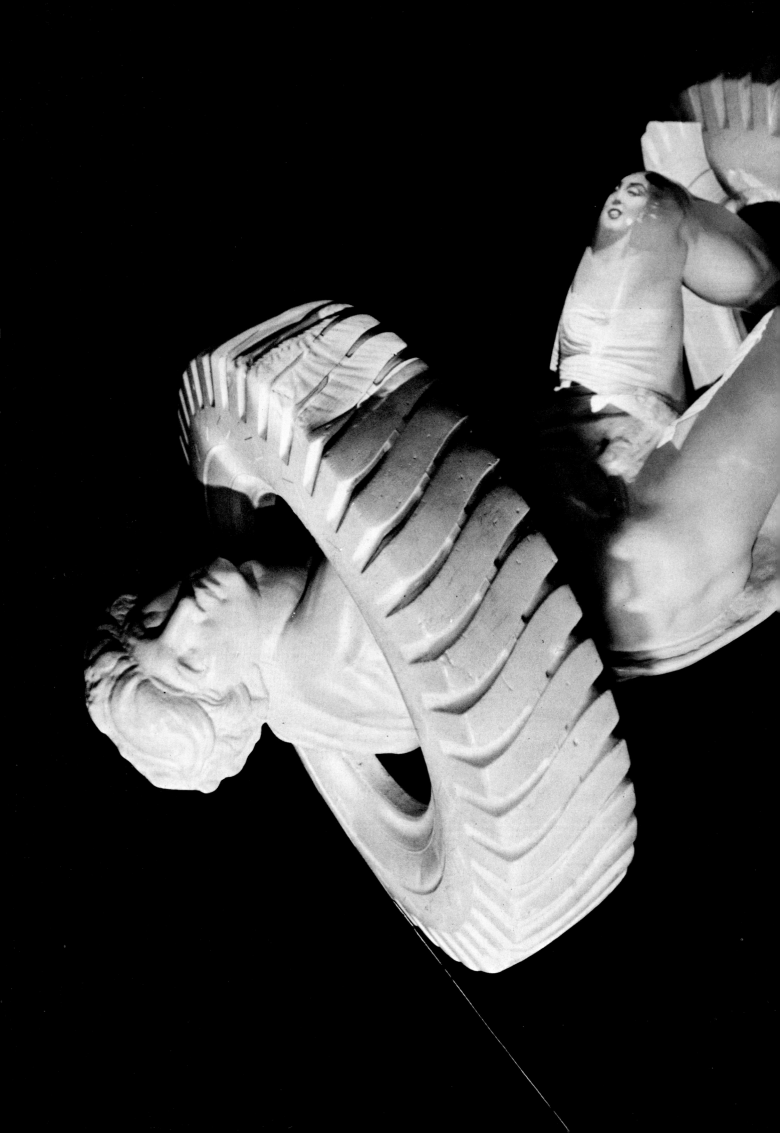

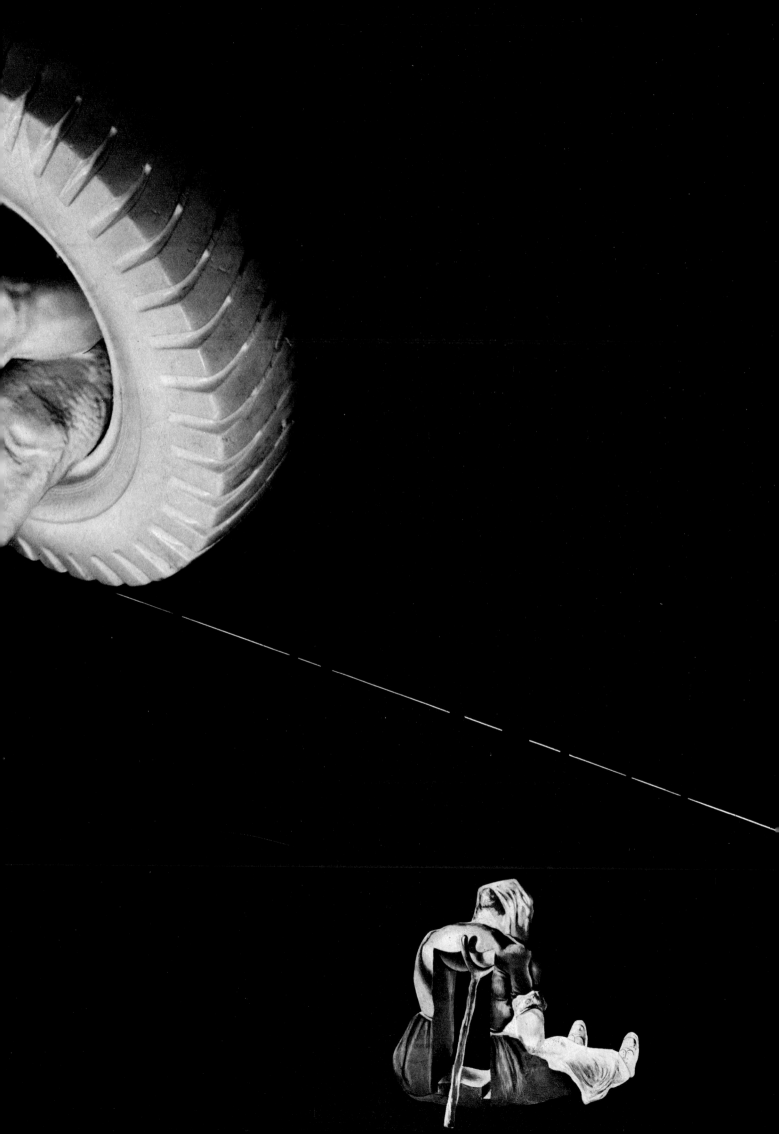

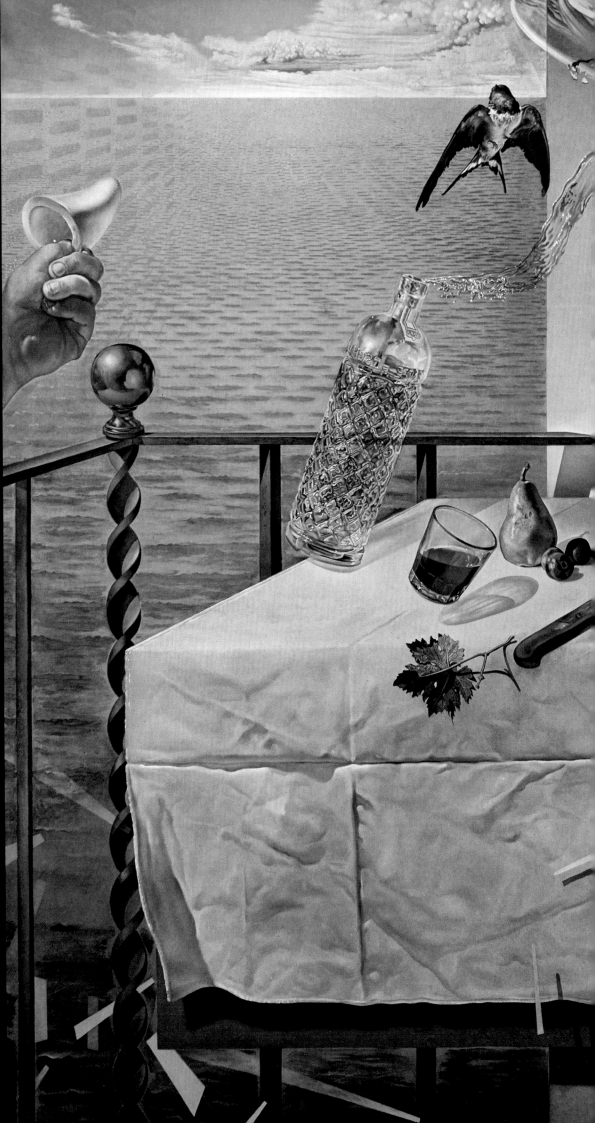

DALI...
DALI...

DALI...

penetrates
more and more
into the
compressed
magic
of the universe.

◀ preceding page

33 - The Slave
of Michelangelo.

33 a - The Weaning
of Furniture-Nutrition
(detail; see plate 63).

34 - Nature Morte Vivante
(Still Life Fast Moving). ▶

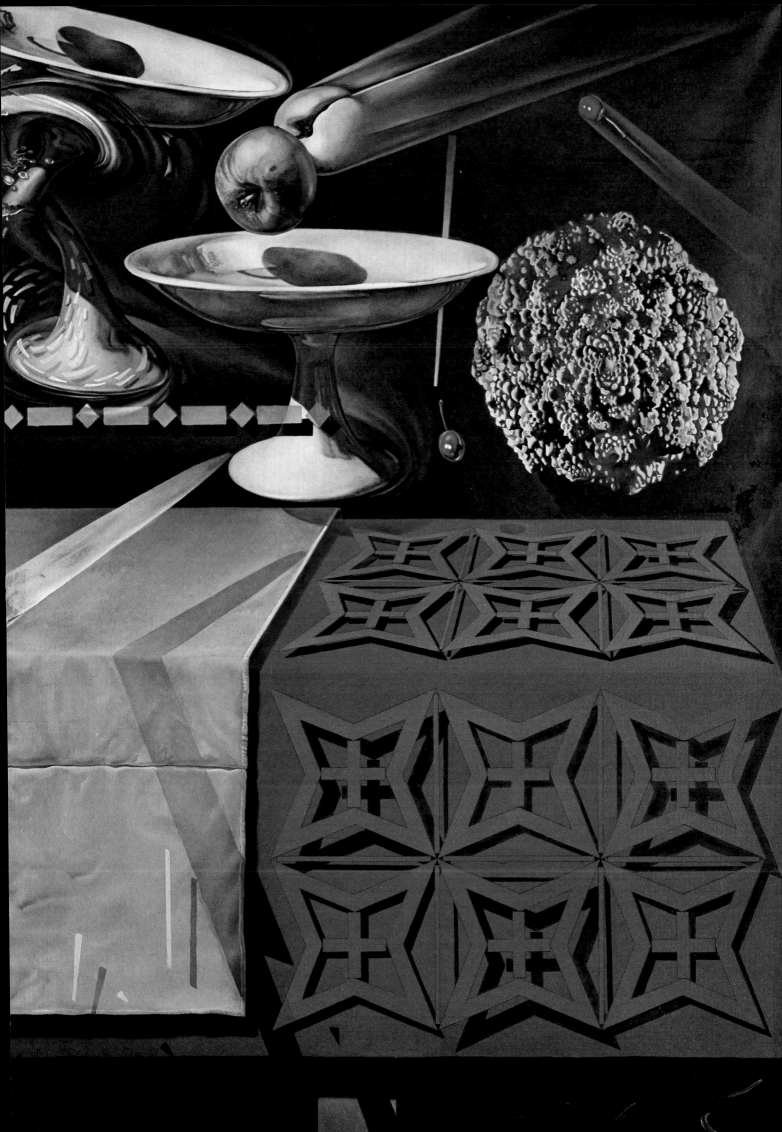

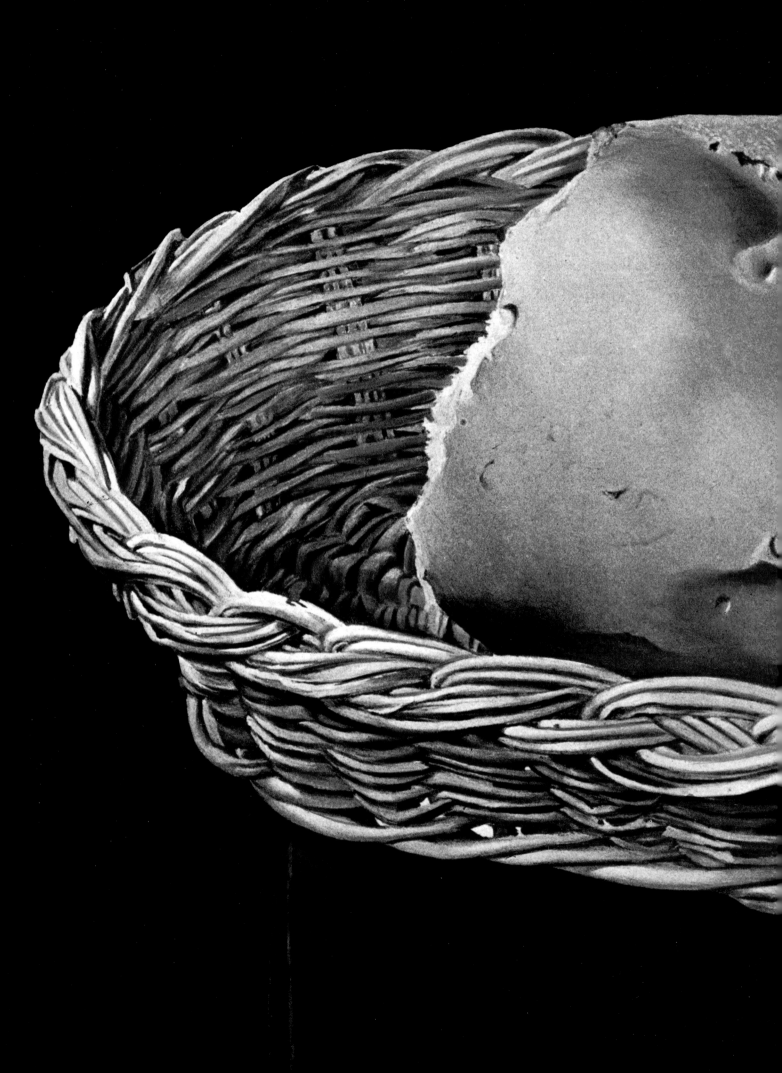

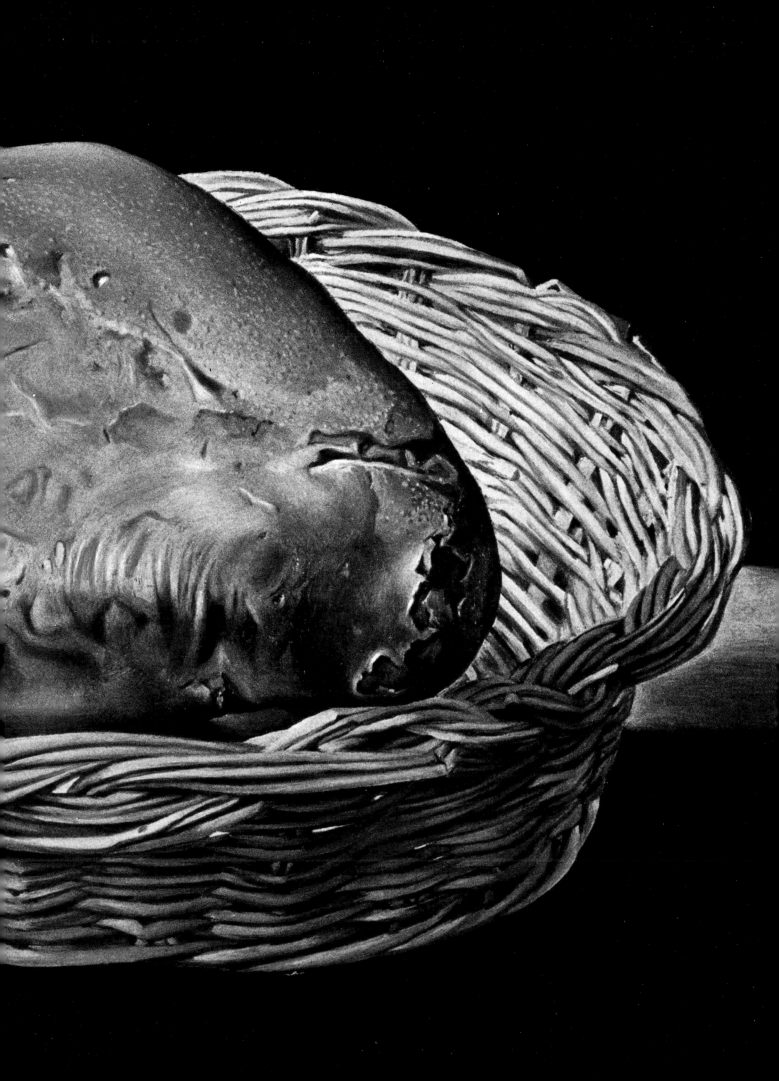

Basket of Bread, II.

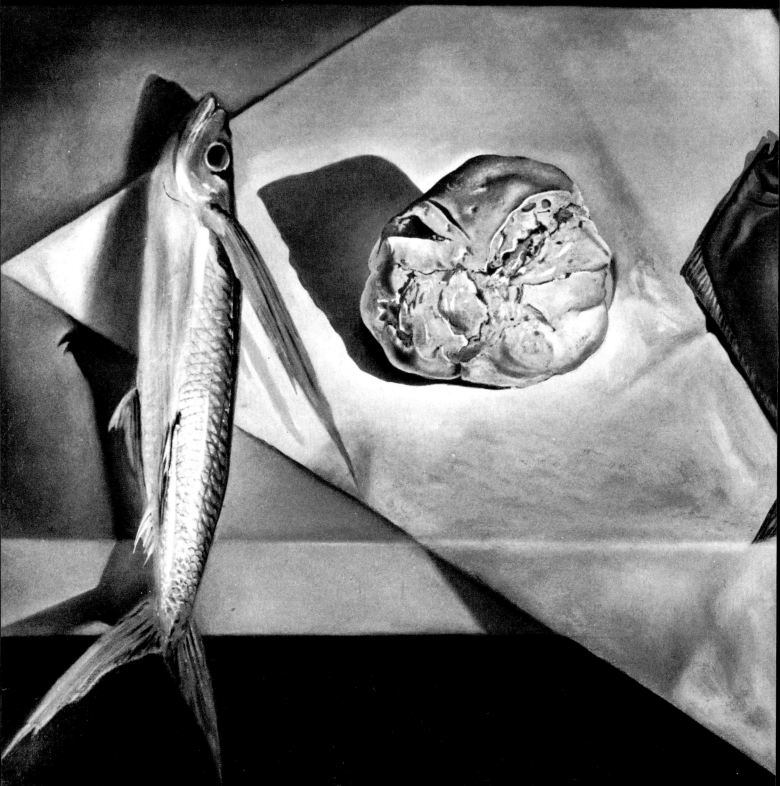

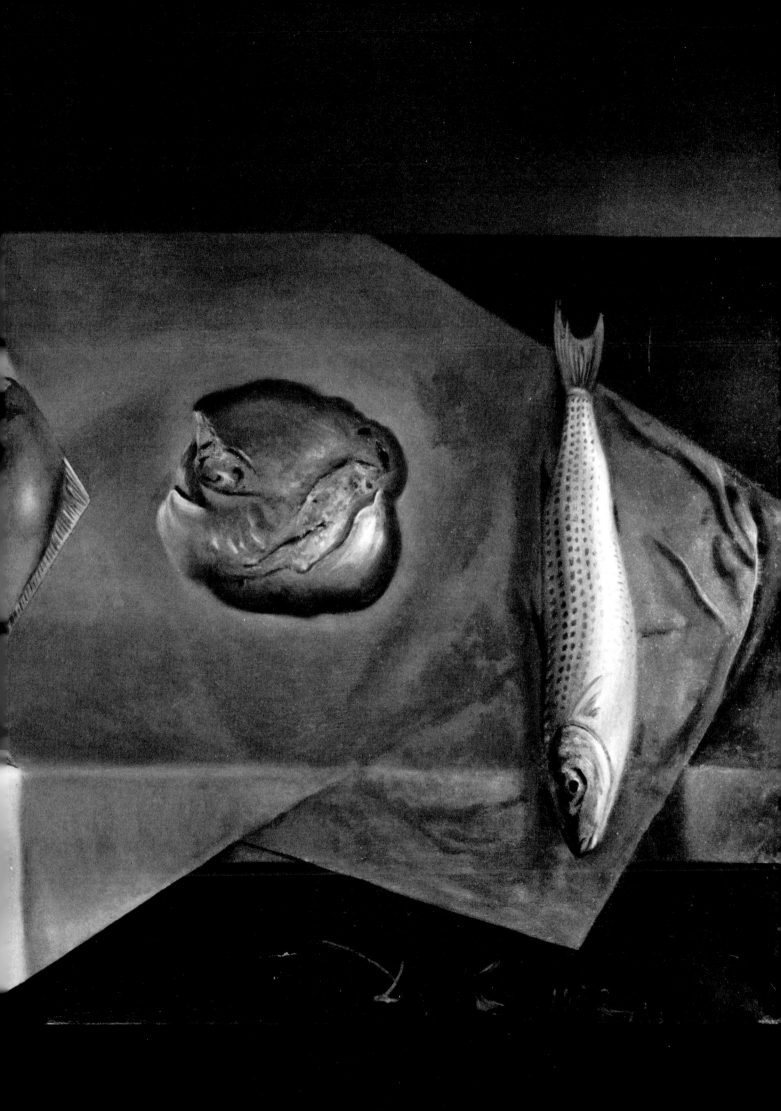

- Eucharistic Still Life.

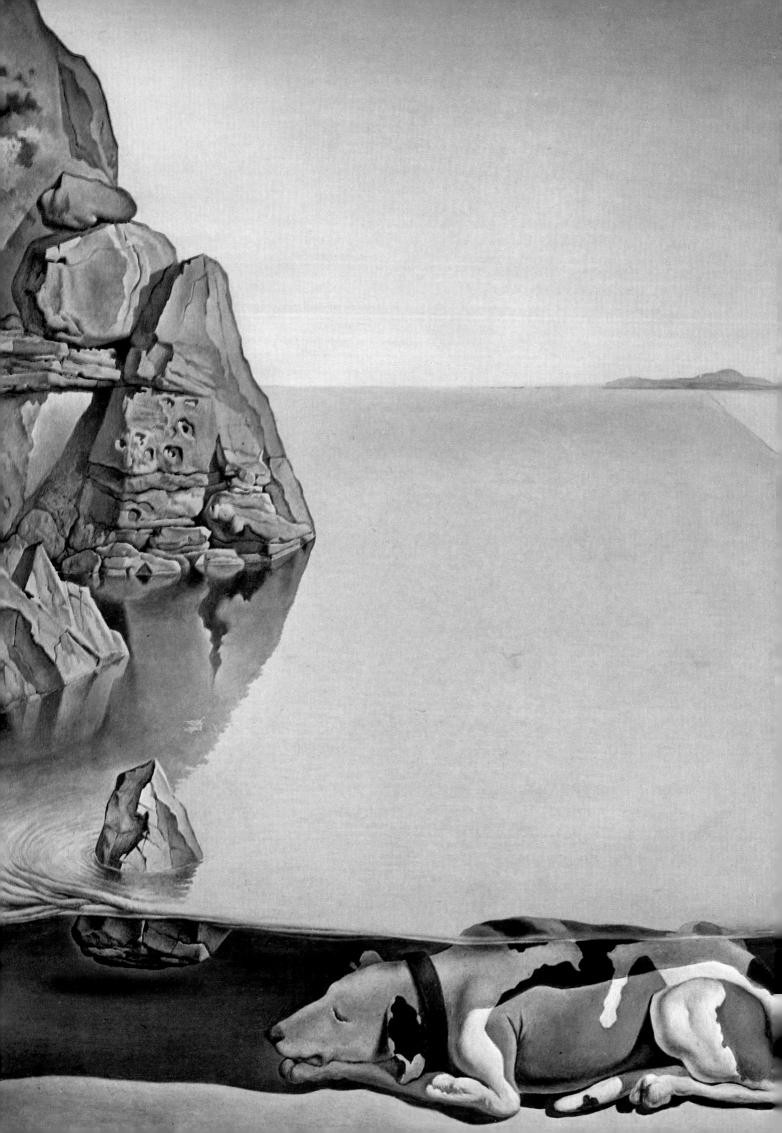

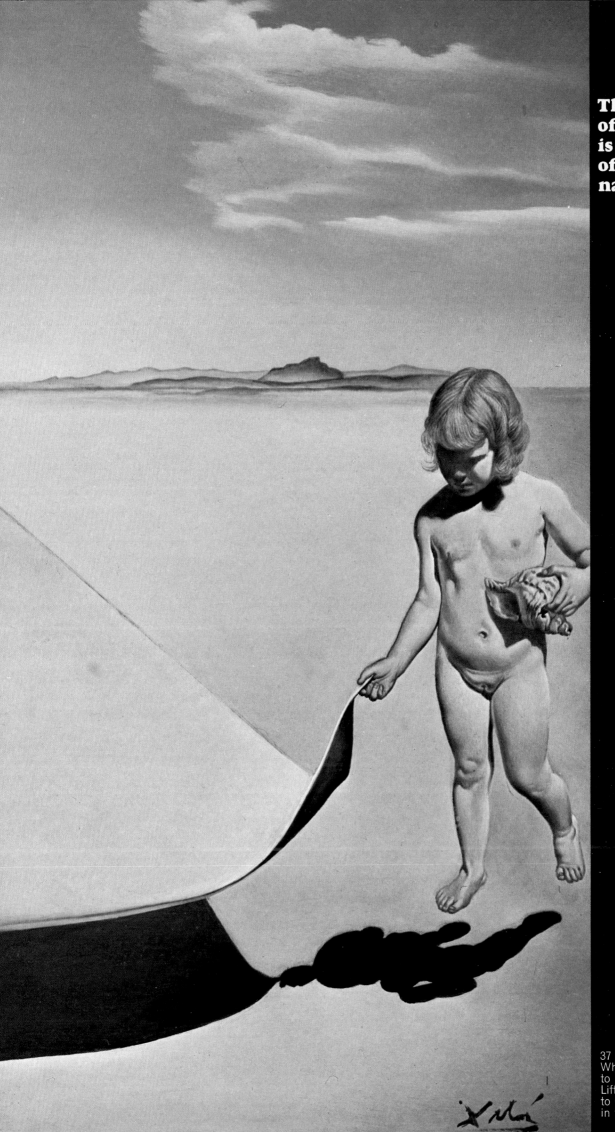

The entropy
of a still life
is a way
of amending
nature.

37 - Dali, at the Age of Six
When He Believed Himself
to Be a Young Girl,
Lifting the Skin of the Water
to Observe a Dog Sleeping
in the Shadow of the Sea.

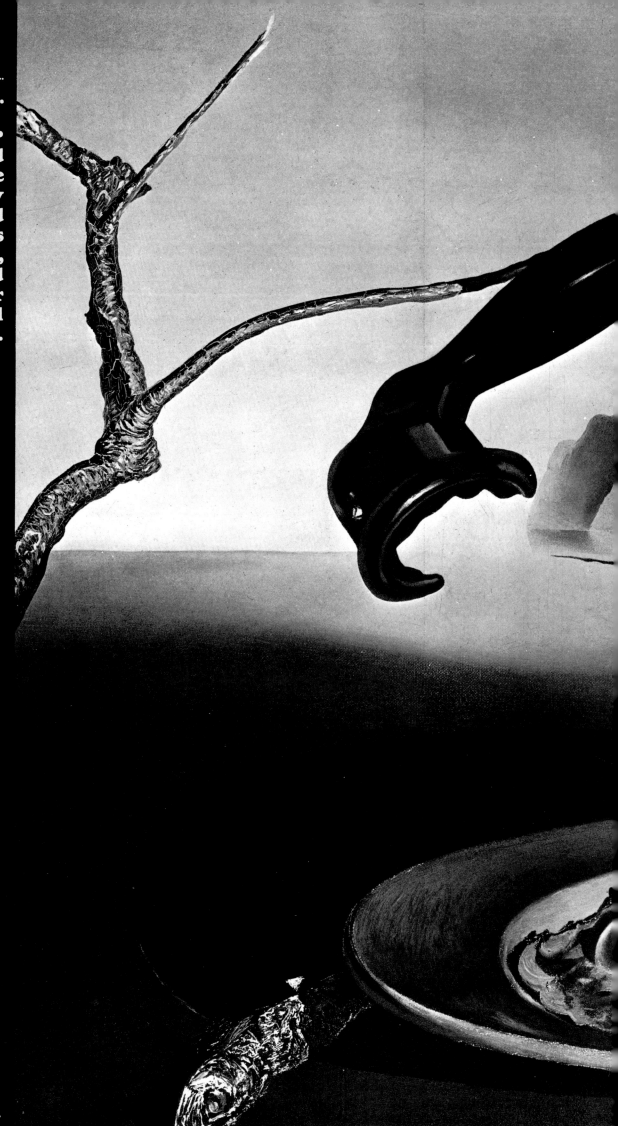

DALI...
DALI...
DALI...
**the need
to materialize
in reality
as frenzied
as it is
unknown,
the world
of our
irrational
experiences.**

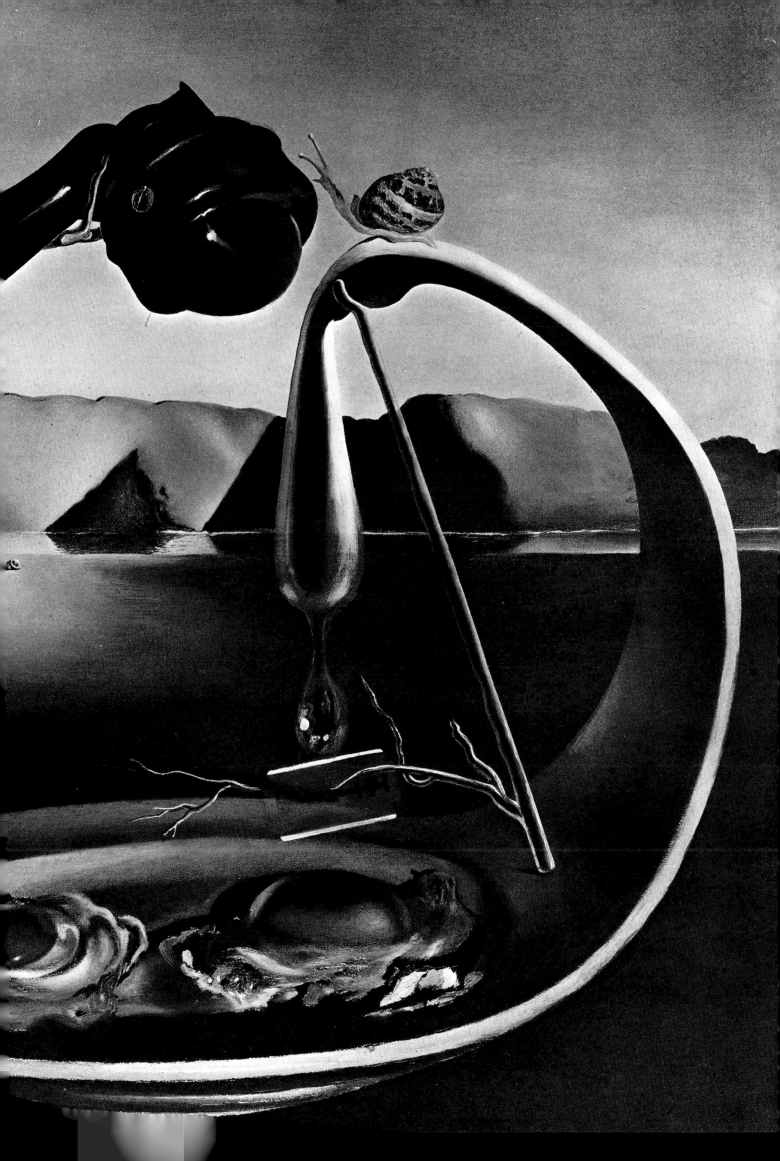

Eroticism

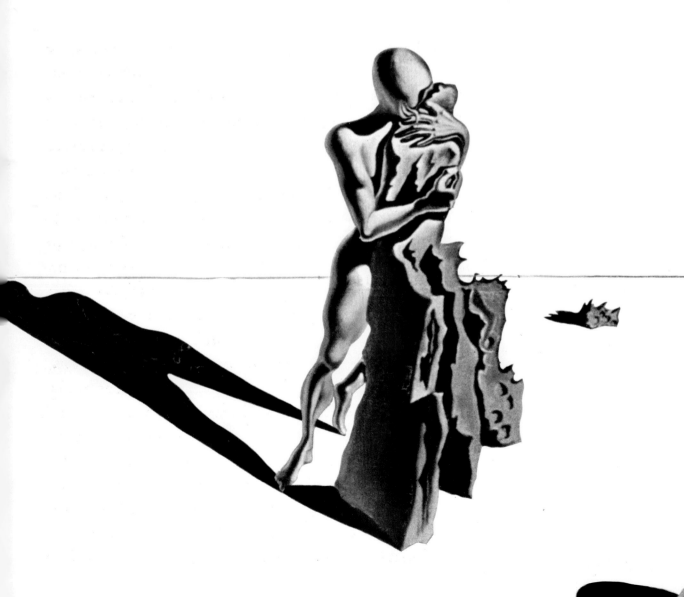

Skillful in playing
with his ideas,
Dali classifies in this way
the vital preoccupations of man :
the Sexual Instinct,
the Sentiment of Death,
finally the Anguish of Space-Time.
Placing the Sexual Instinct before that death
against which Salvador-the-Saviour
keeps polishing new weapons-
this is a peremptory way of enchanting the living.
Then, taking the offensive for life in the name of eroticism,
Dali mixes his appetites-
for sex, for contexts, for containers,
or for materials-
since even the petrifaction of a sexual embrace
does not conflict with his Dionysiac frenzy.
Superb combination wherein the objects themselves
participate in the joys of the orgasm when,
beyond the liberation of sexual appetites,
Dali's eroticism intones the most lyrical of songs
whether it be puerperal, visceral, mineral, or genital!

39 - The Great Masturbator (detail; see plate 46).

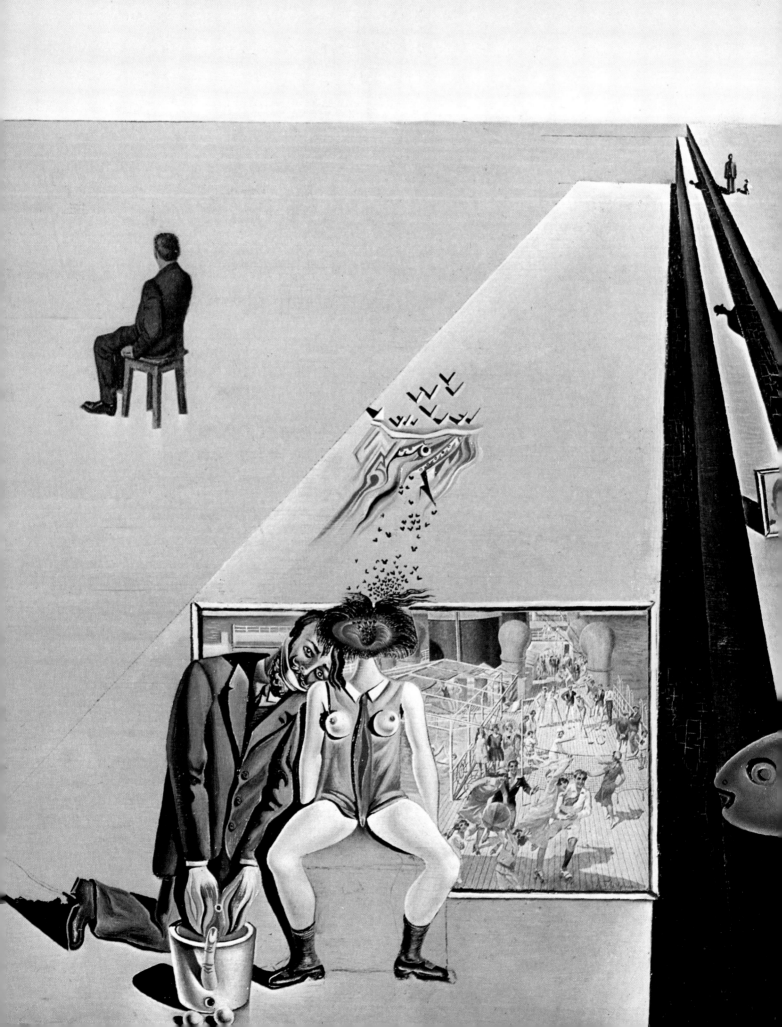

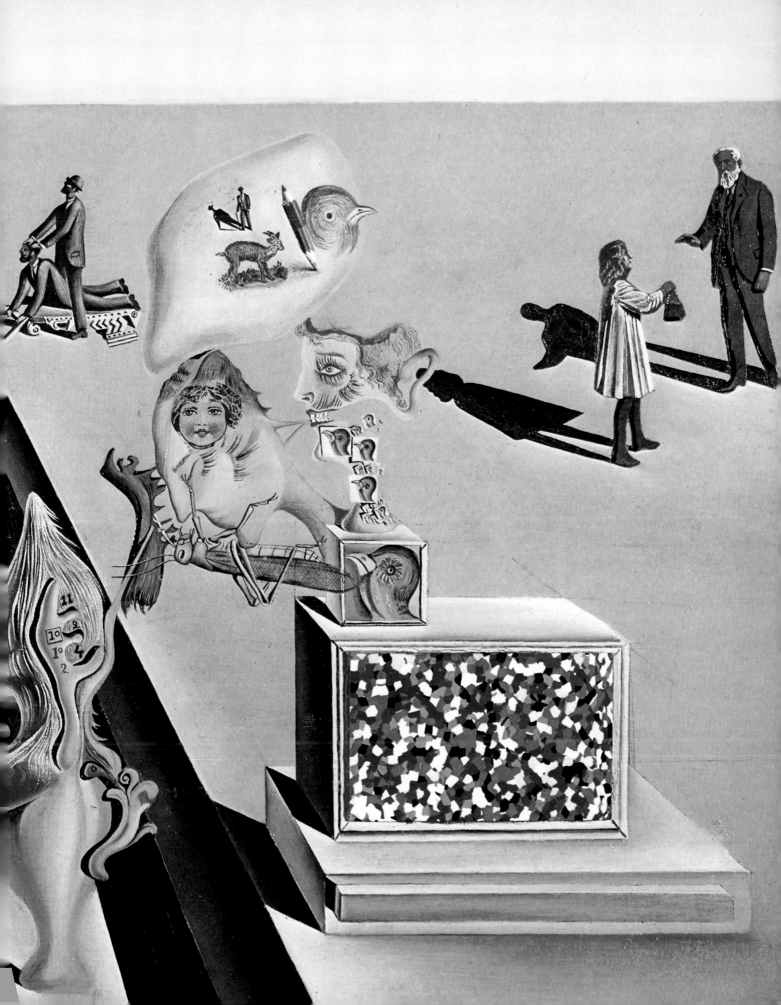

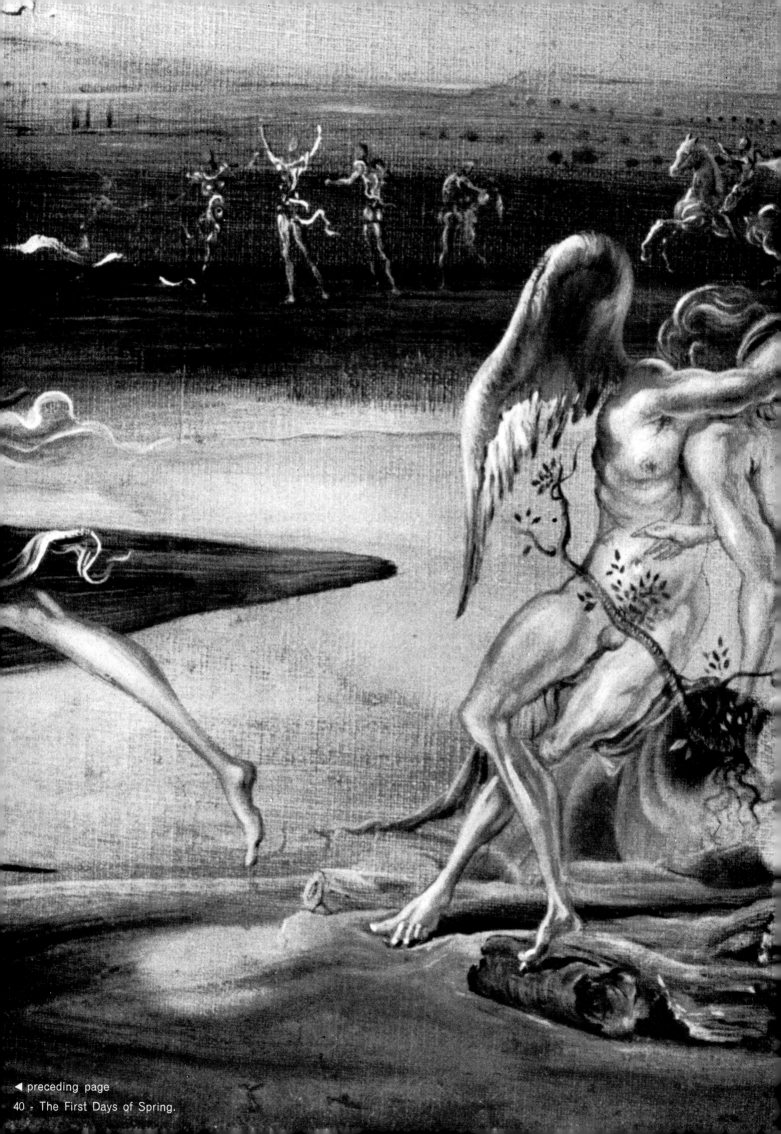

◄ preceding page
40 · The First Days of Spring.

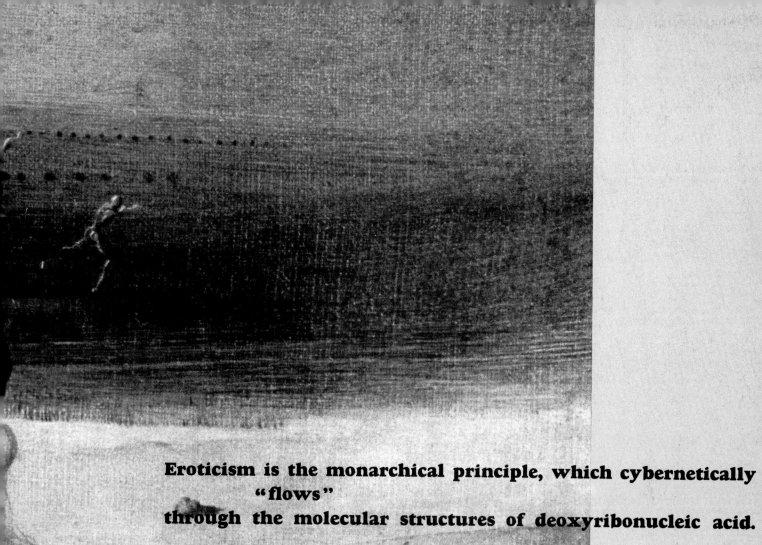

Eroticism is the monarchical principle, which cybernetically "flows"
through the molecular structures of deoxyribonucleic acid.

◀ 41 - The Broken Bridge
and the Dream (detail).

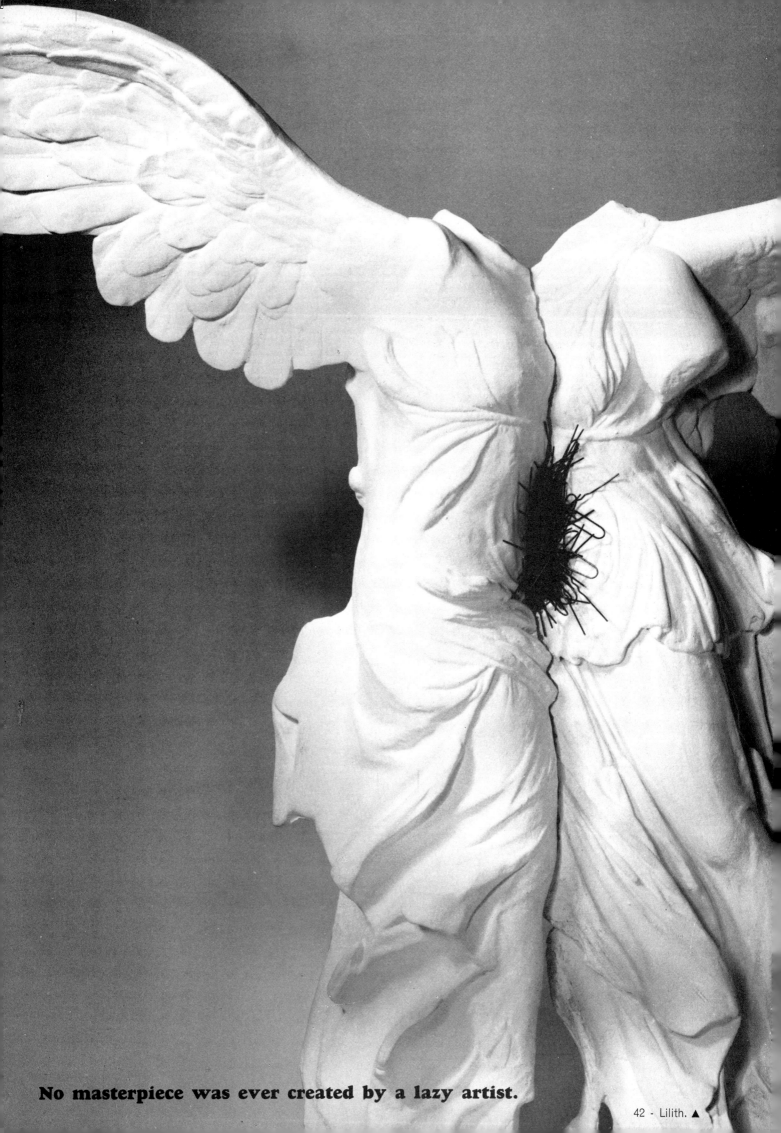

No masterpiece was ever created by a lazy artist.

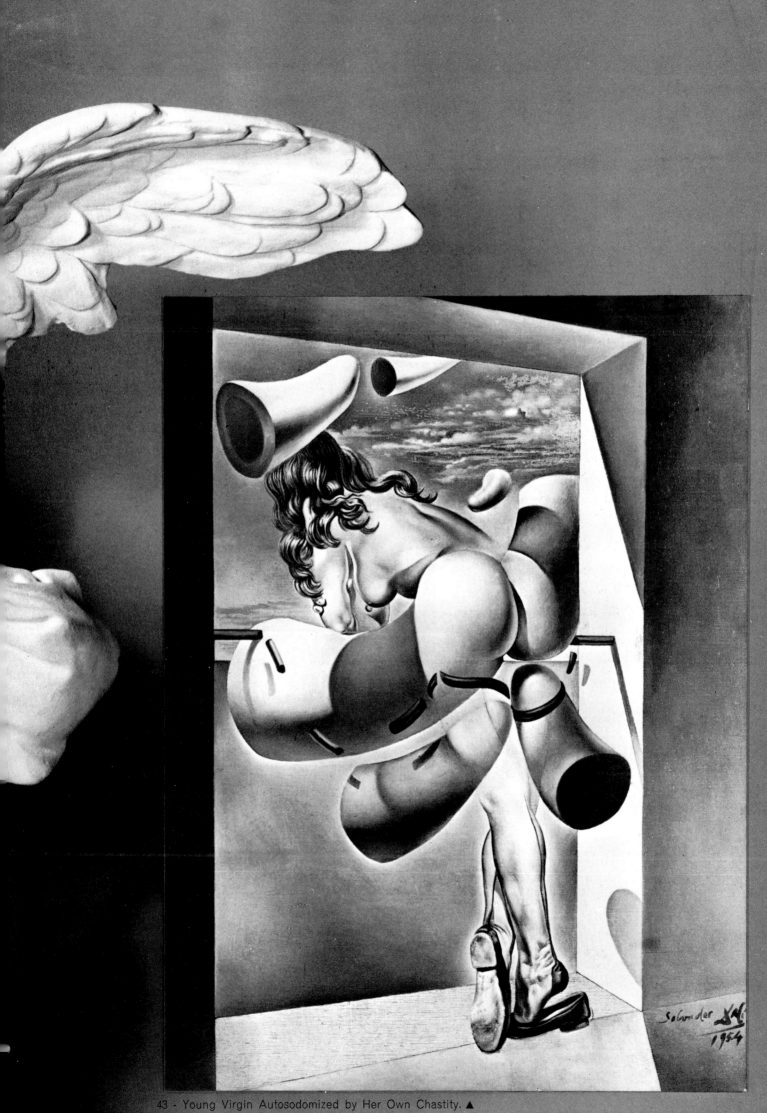

43 - Young Virgin Autosodomized by Her Own Chastity. ▲

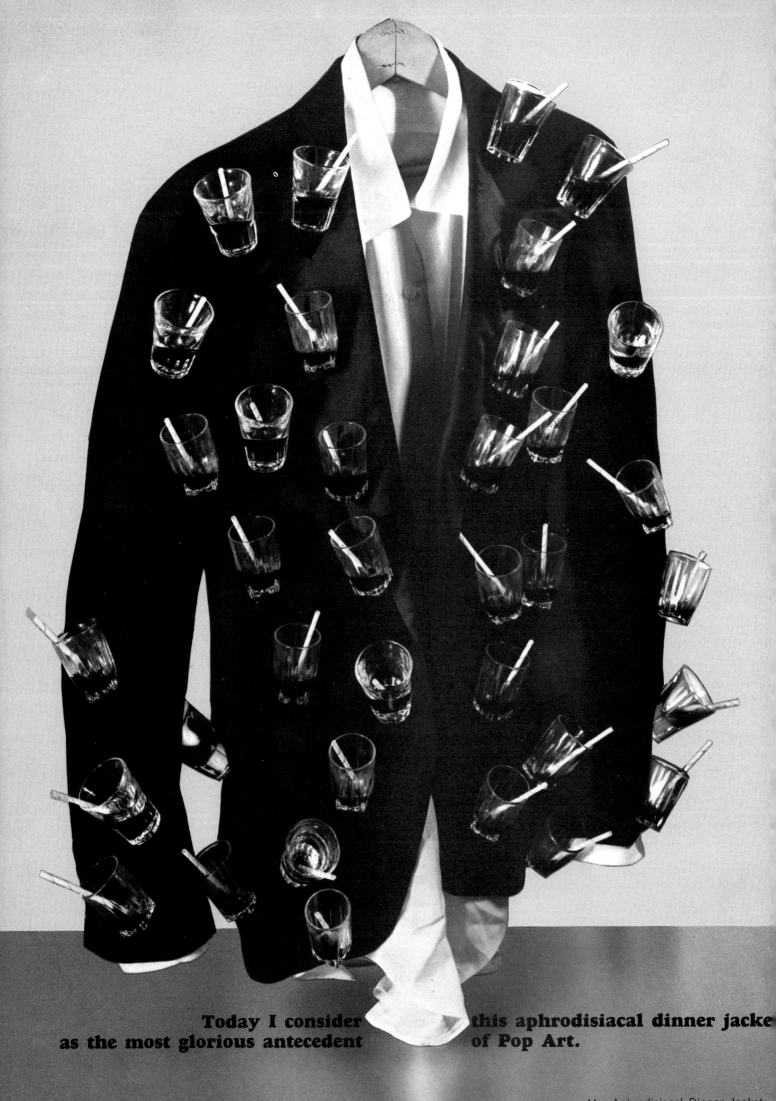

Today I consider this aphrodisiacal dinner jacket
as the most glorious antecedent of Pop Art.

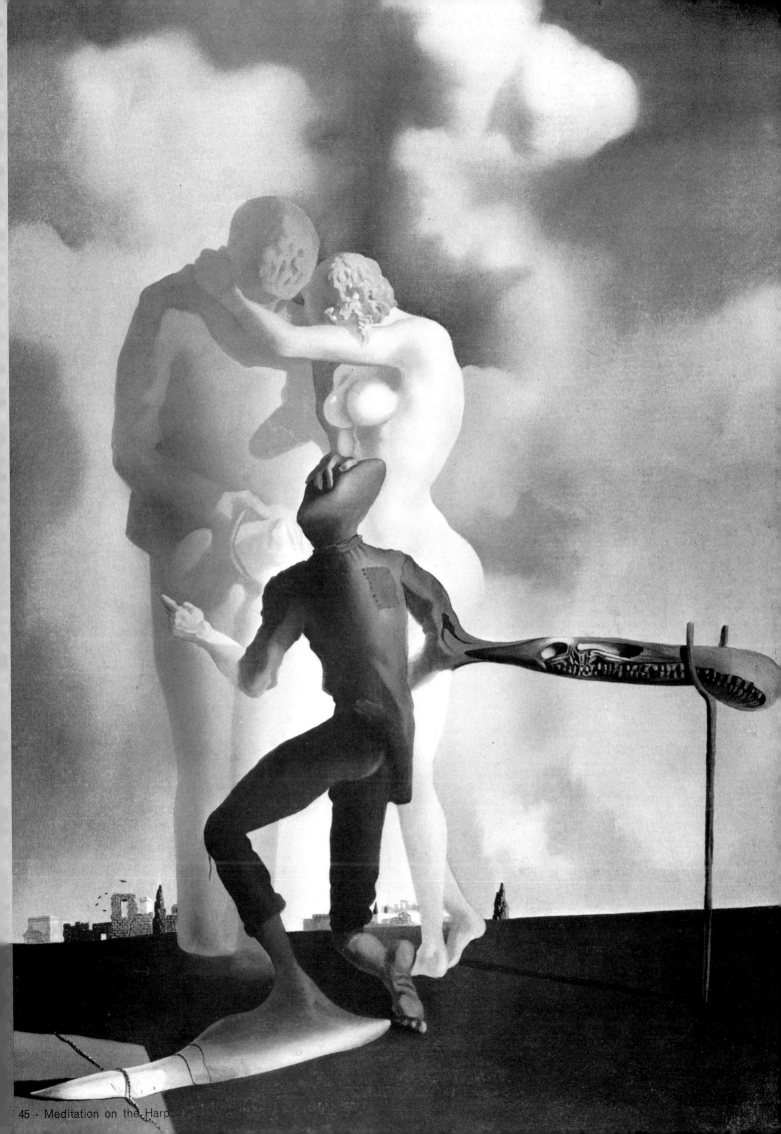

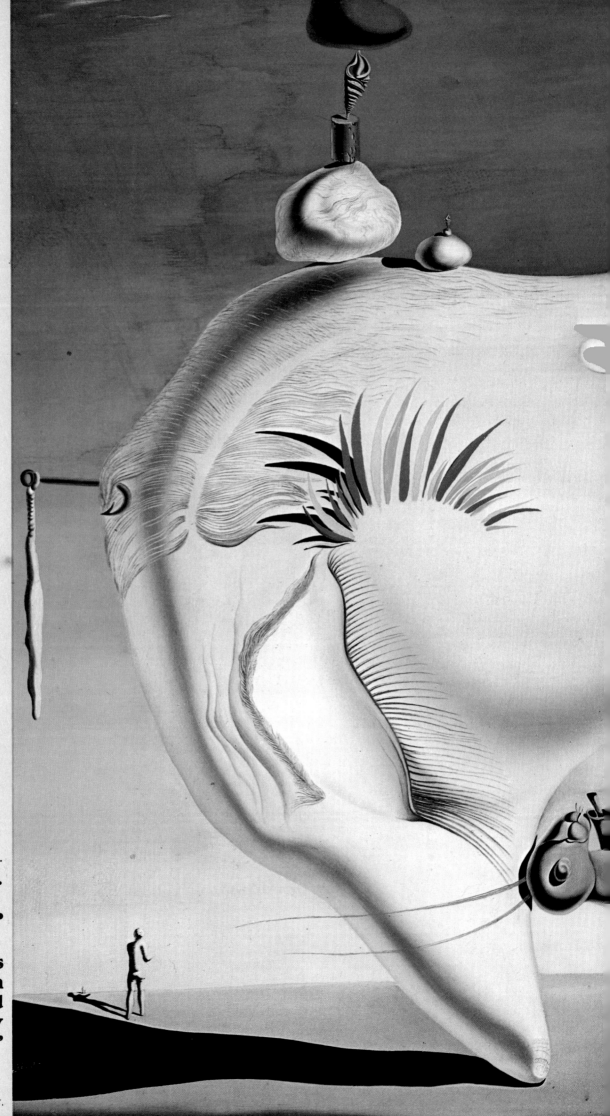

DALI...

DALI...

DALI...

signifies
in Catalan
" possessed
by
desire. "

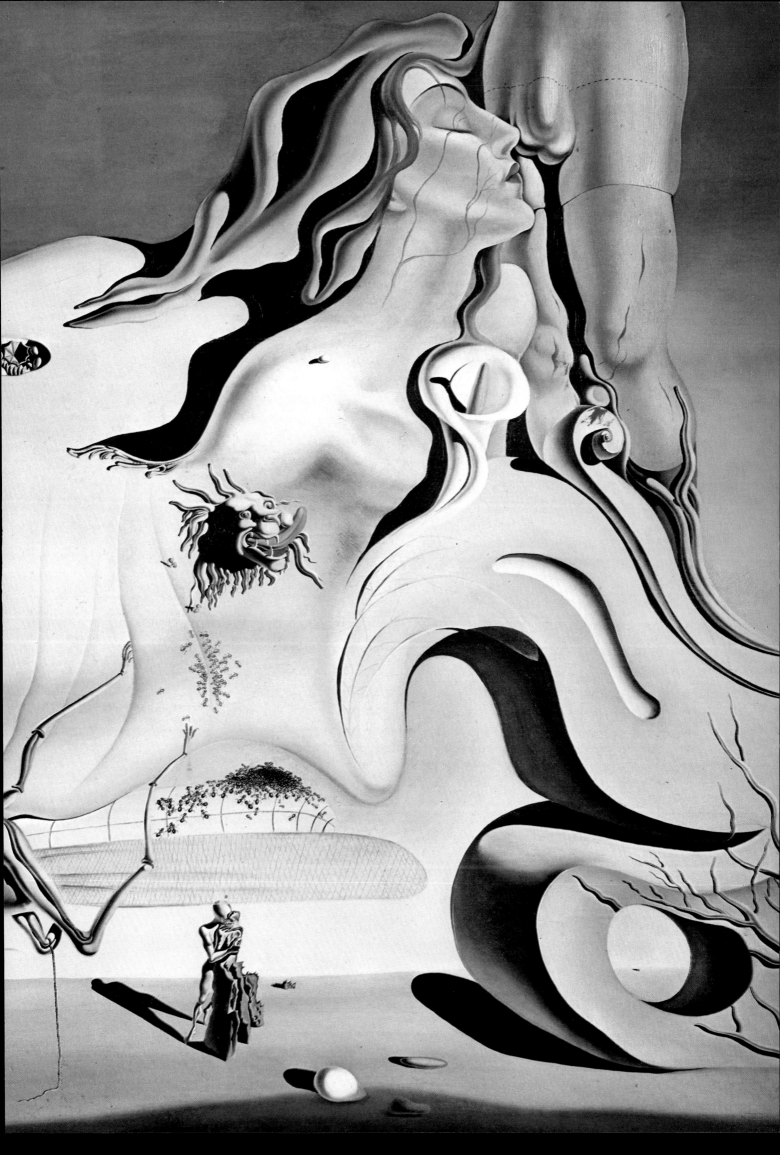

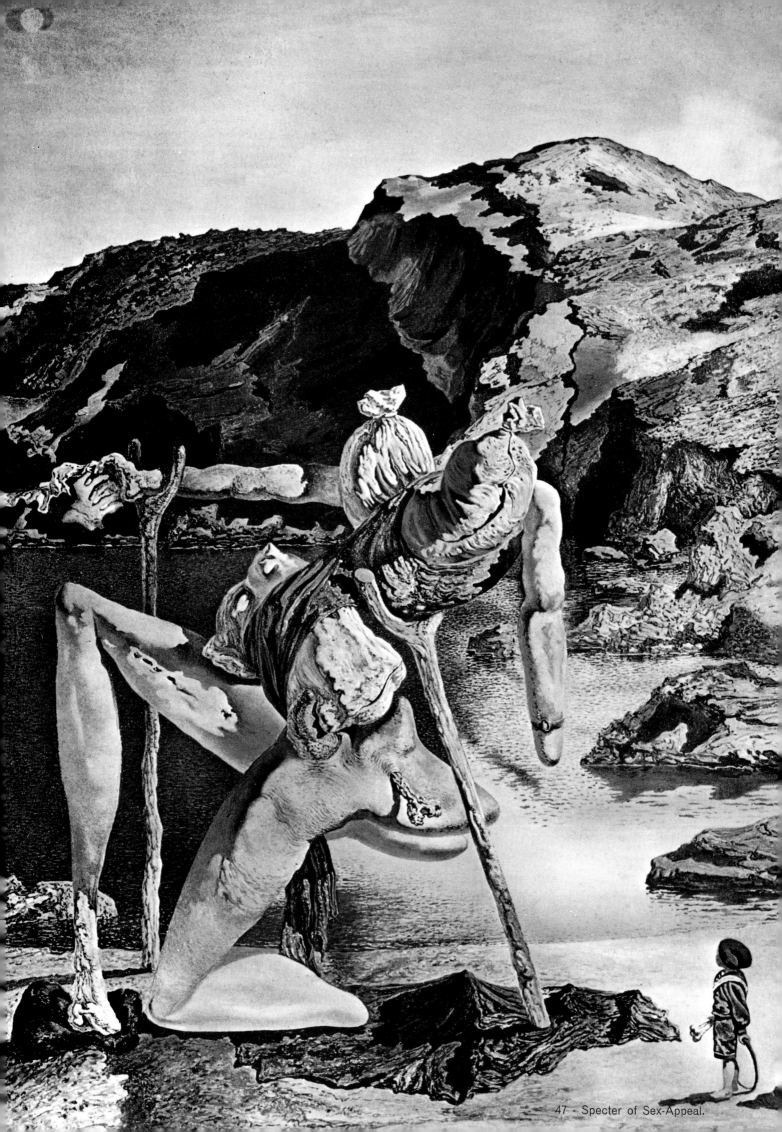

47 - Specter of Sex-Appeal.

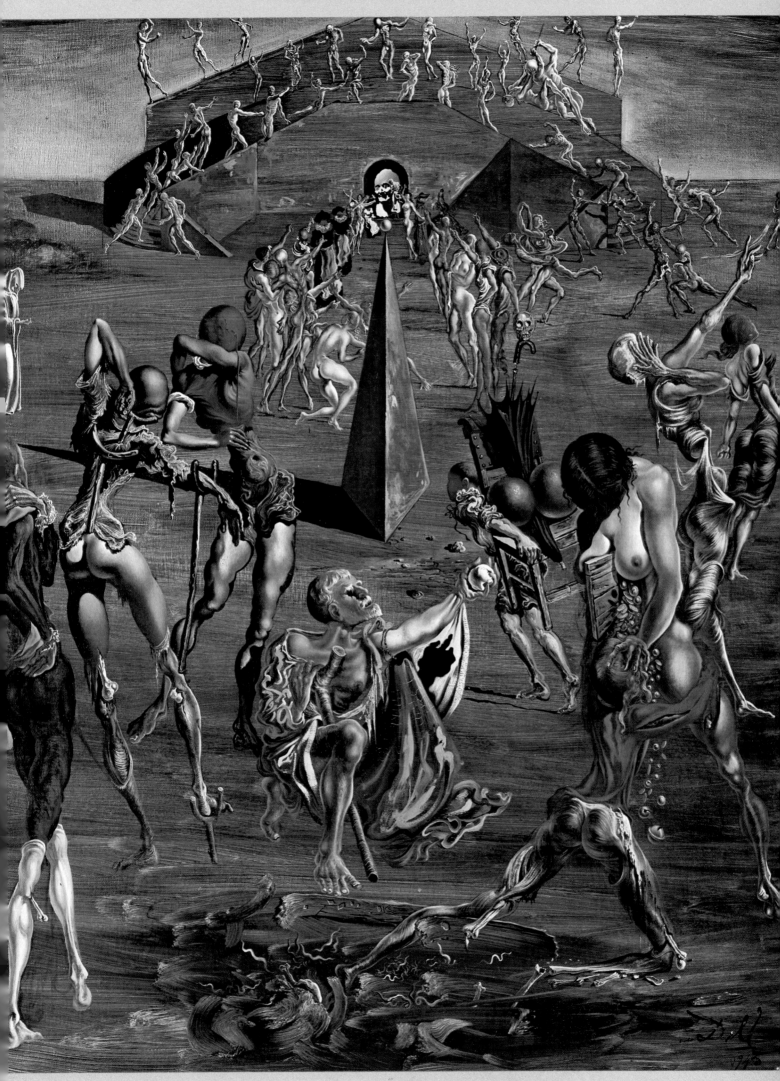

78 - Resurrection of the Flesh.

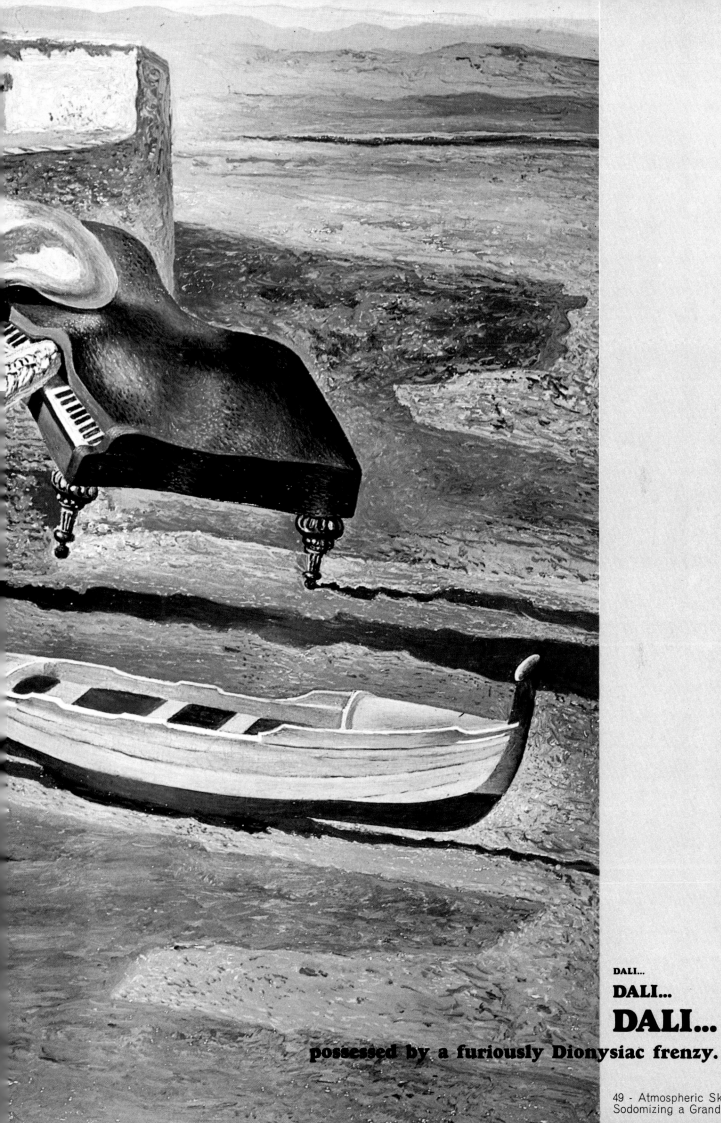

Mysticism

Mystic by his Spanish atavism,
mystic by the beauty of gesture,
mystic by tradition,
mystic in the face of material success,
whether it be of power or of money,
Dali's mysticism
serves some very strange adventures,
especially when to the mysticism of the religious man
he adds that of the wizard,
or that of the atomic scientist
whose means encroach upon the mystery of creation.
Then why should Dali stop on such a fruitful path,
when he is seized by the desire to annex hallucinogenic mysticism,
the mysticism of gothic cubism,
the mysticism of gold so vital to his actions,
the mystical quality of the Perpignan Railway Station,
thanks to which he materializes a painting
even more capable of moving into the third dimension,
finally the mysticism of soft watches,
of integrated time,
of a new opportunity for Dali
to annex for himself the mysticism of time.

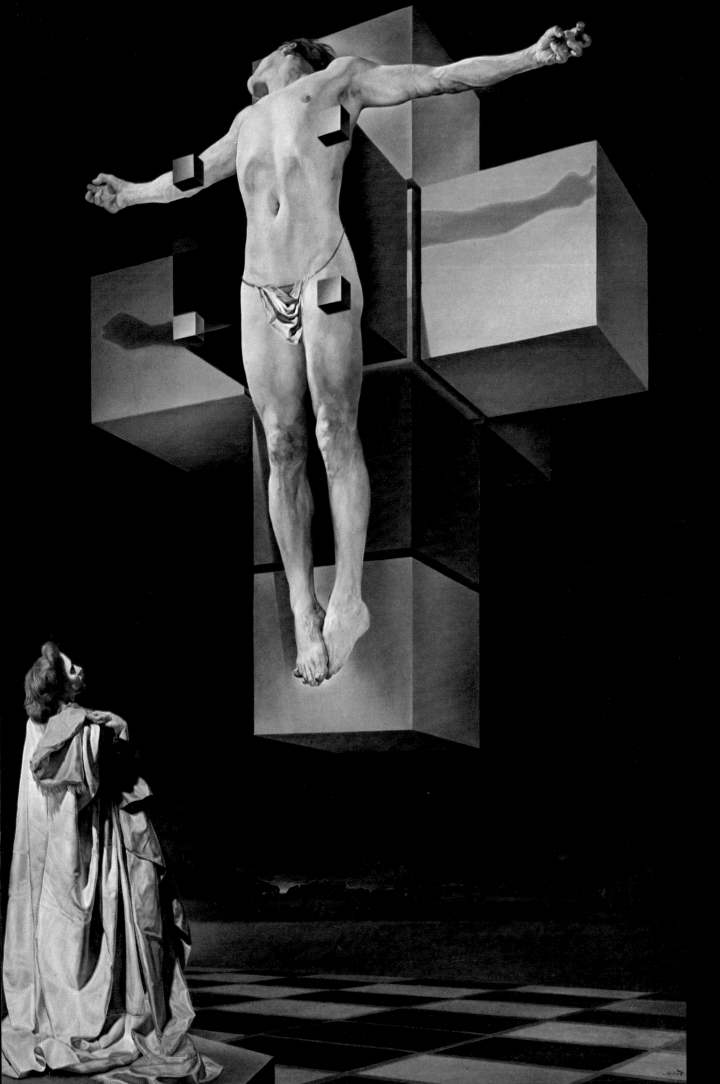

by th

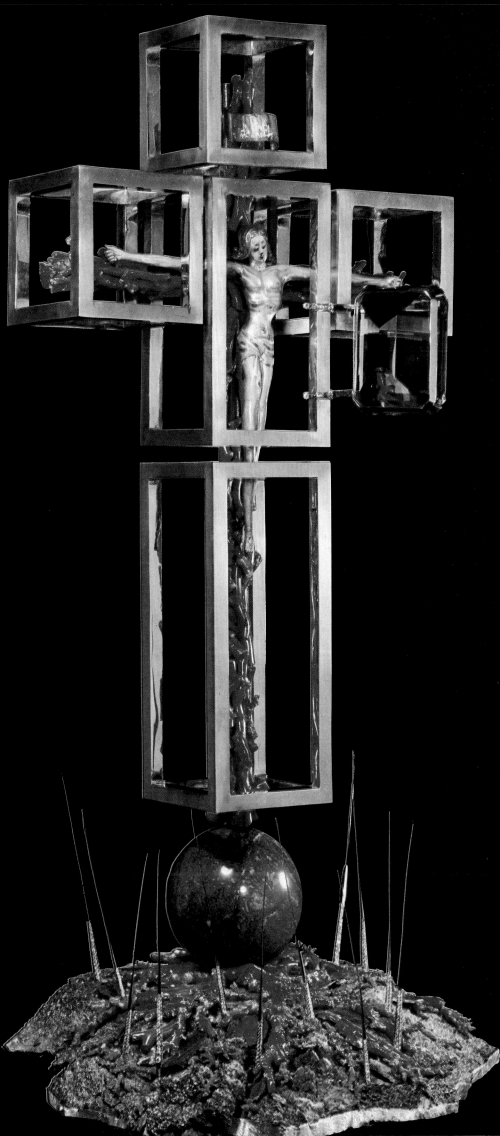

Marveling at the virtues of tradition, repeat that everything which does not proceed from this tradition plagiarism.

The Annunciation.

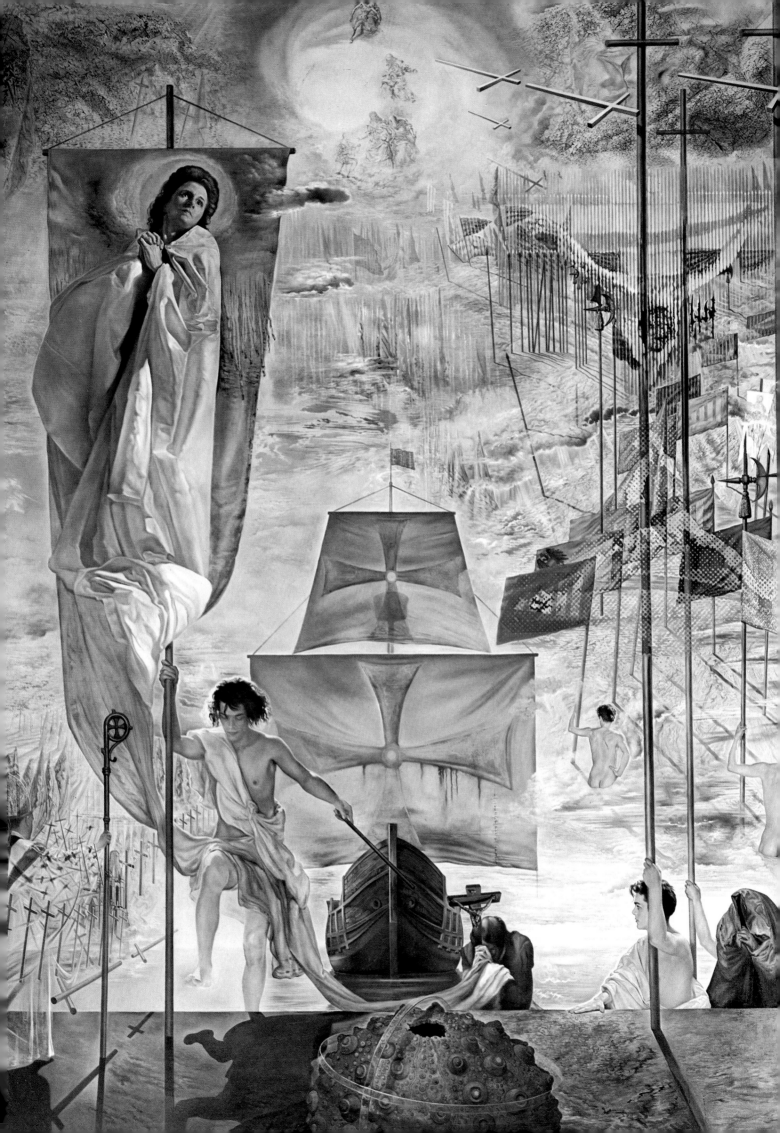

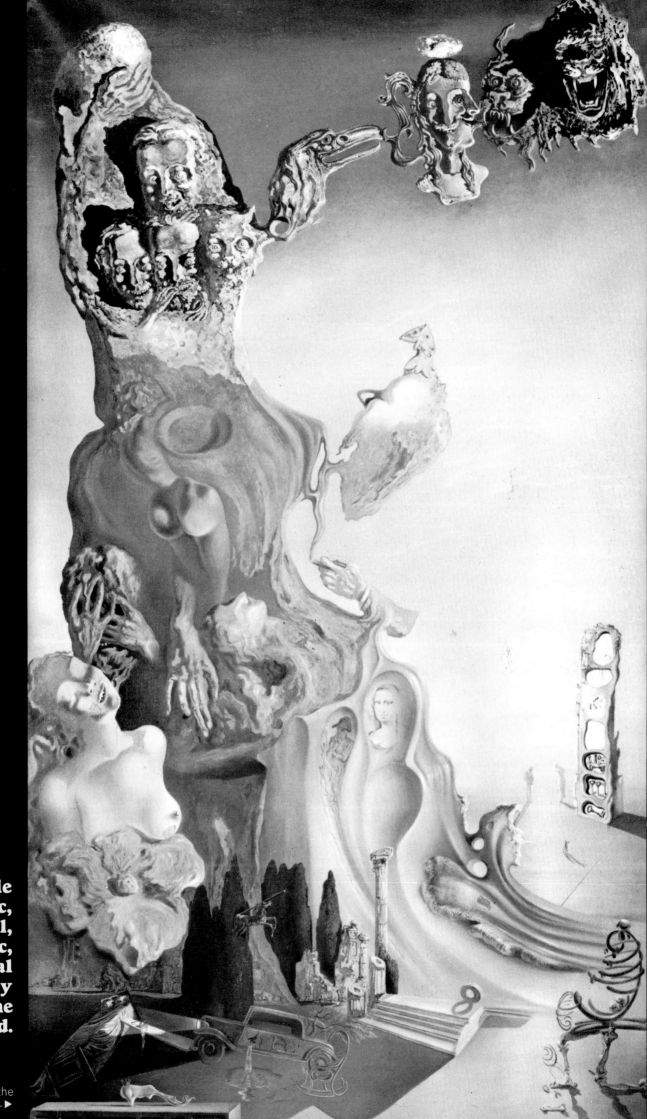

Not a single philosophic, moral, aesthetic, or biological discovery allows the denial of God.

54 - The Dream of Christopher Columbus.

- Imperial Monument to the Child-Woman (unfinished). ▶

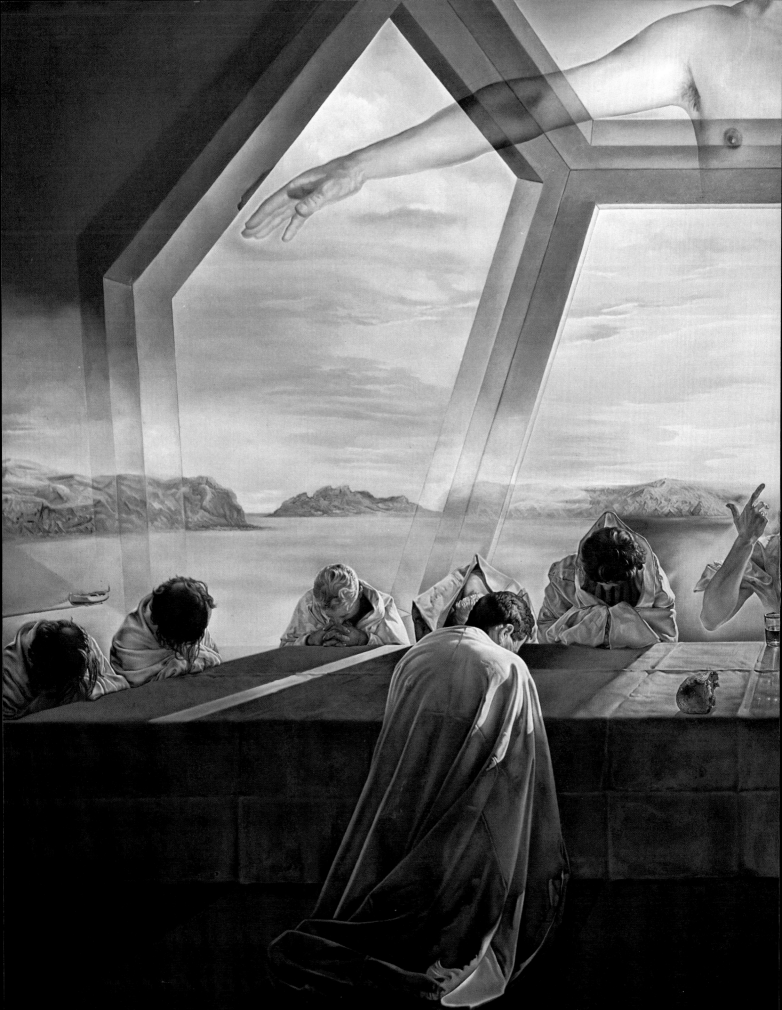

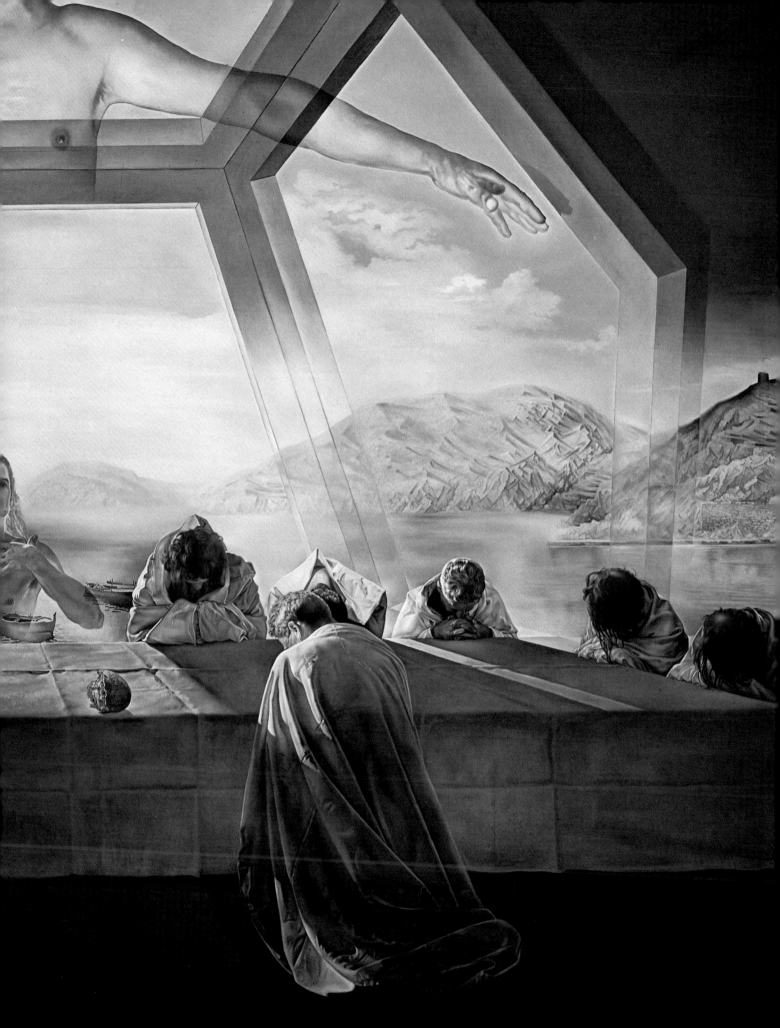

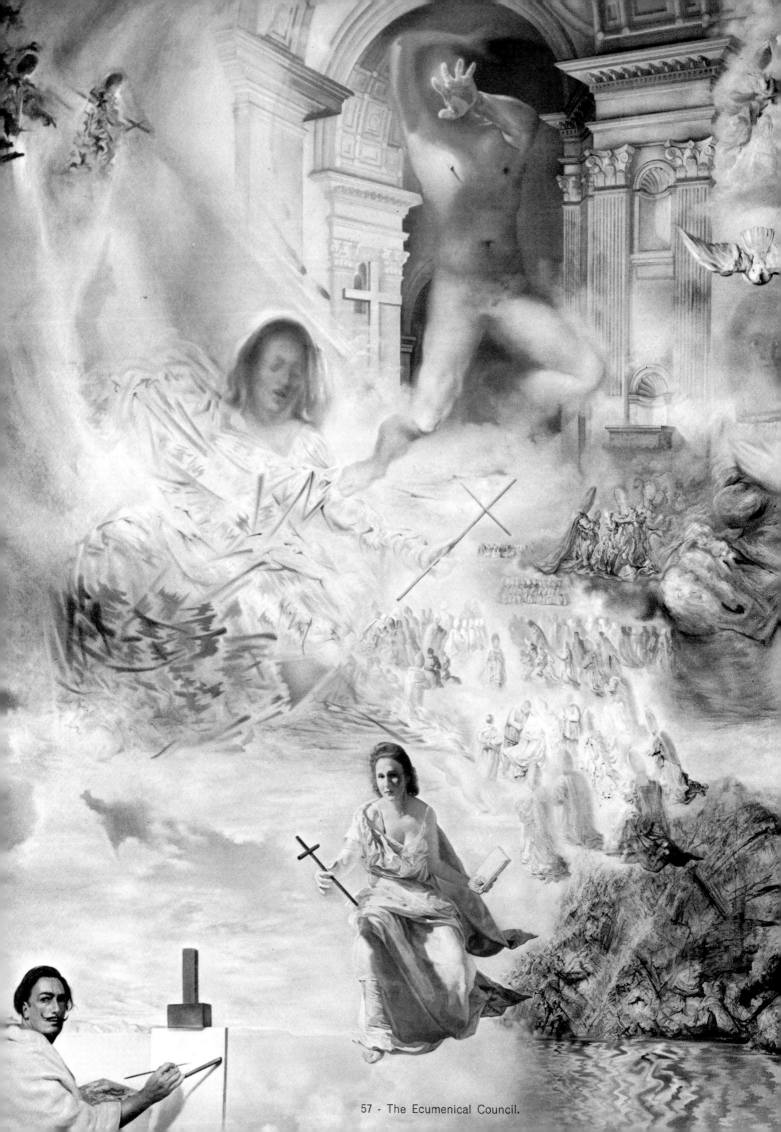

57 - The Ecumenical Council.

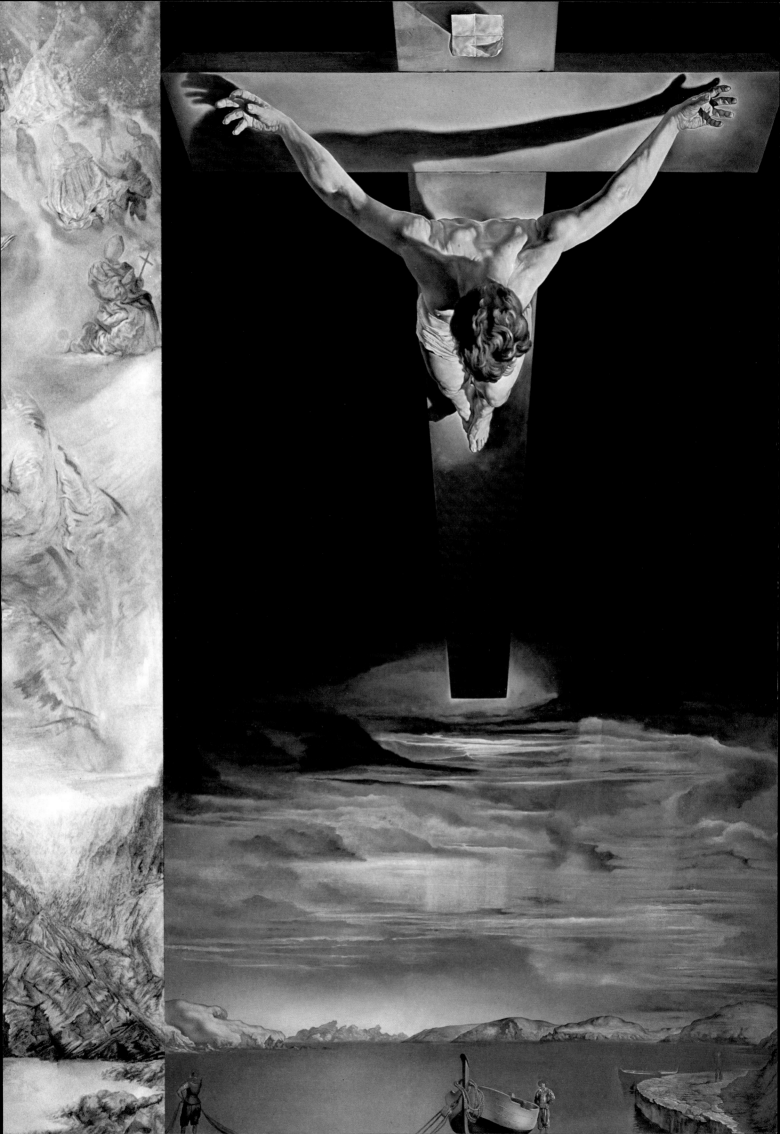

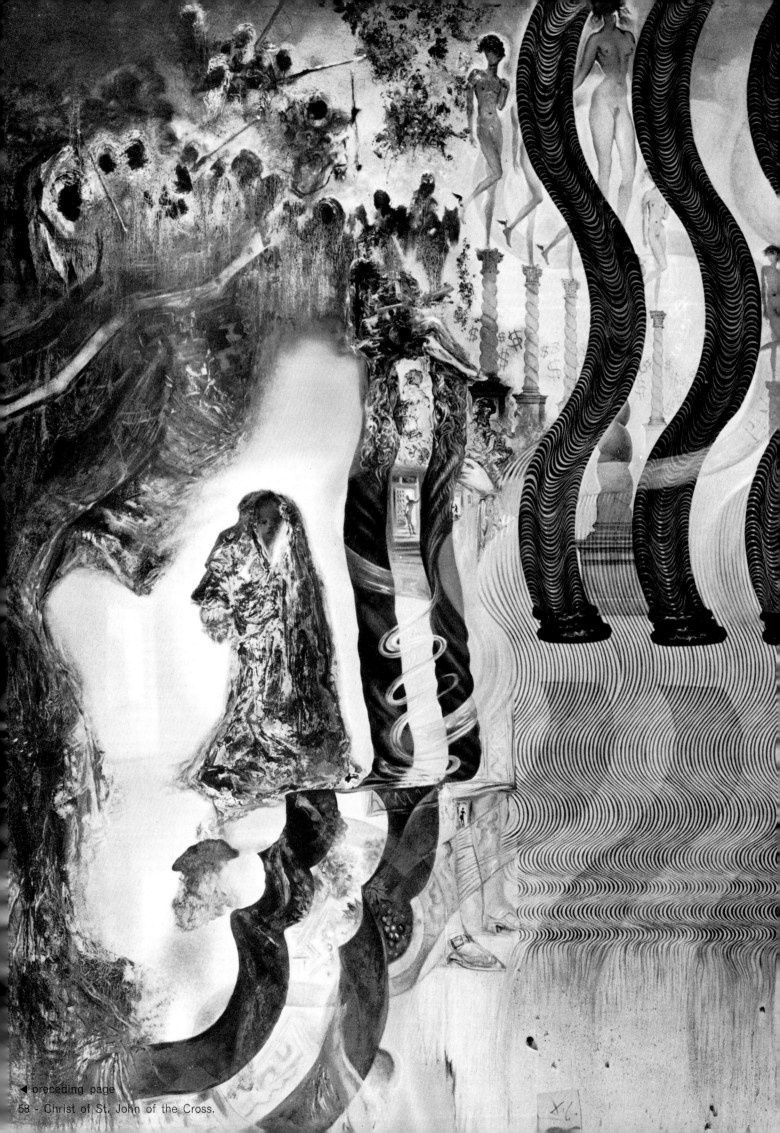

◀ preceding page
58 - Christ of St. John of the Cross.

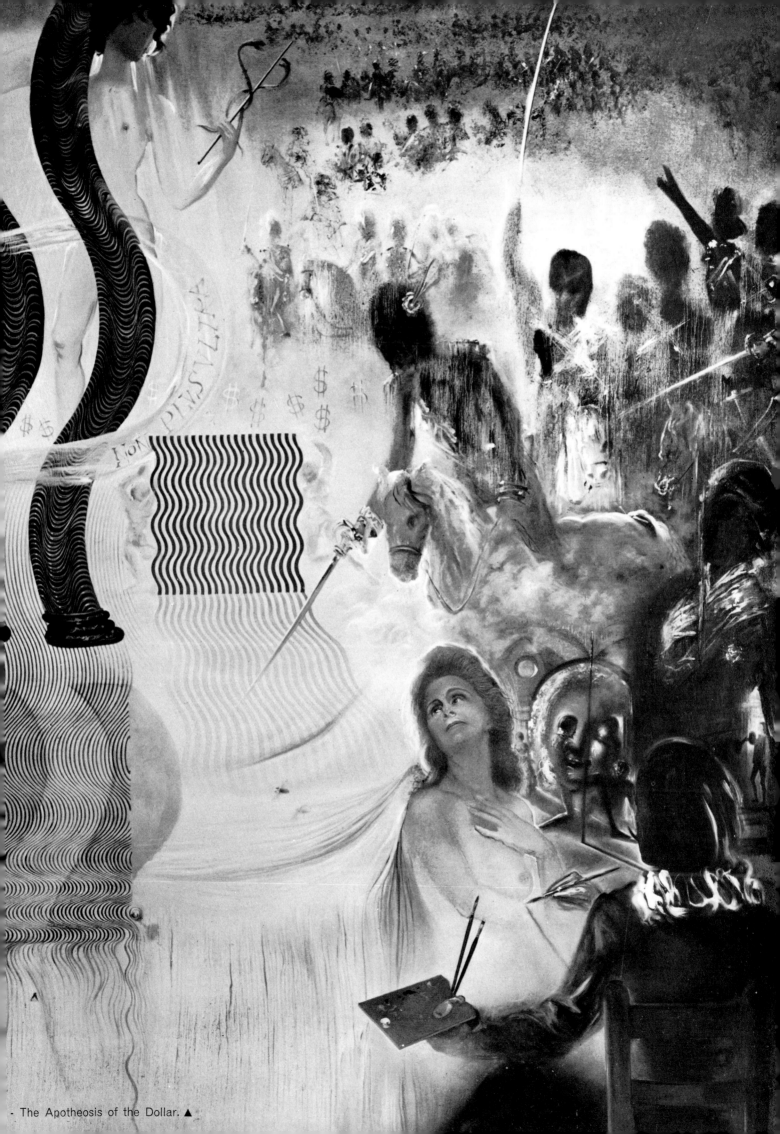

- The Apotheosis of the Dollar. ▲

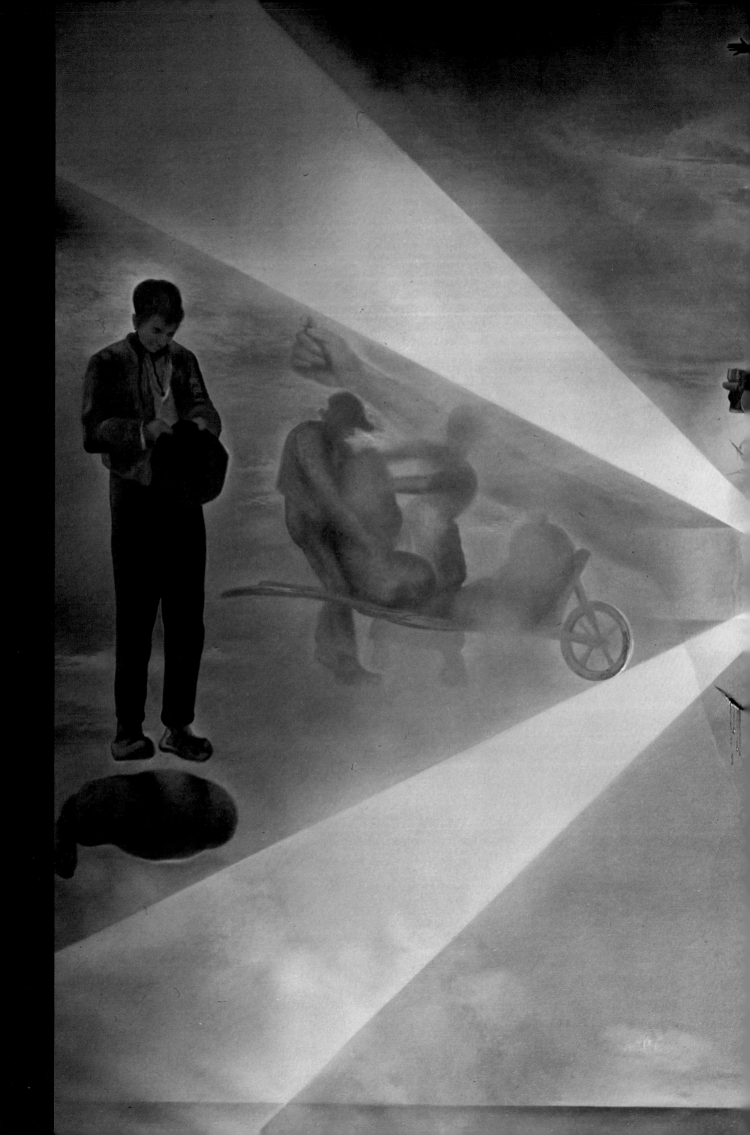

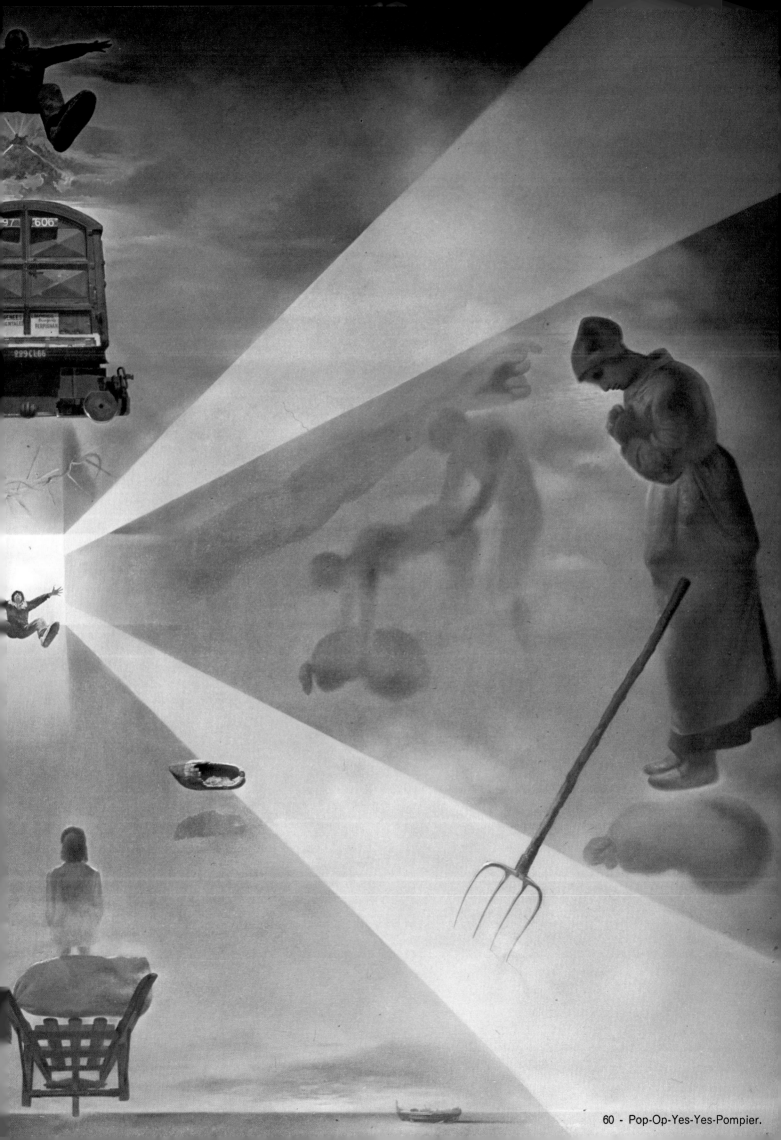

60 - Pop-Op-Yes-Yes-Pompier.

Space

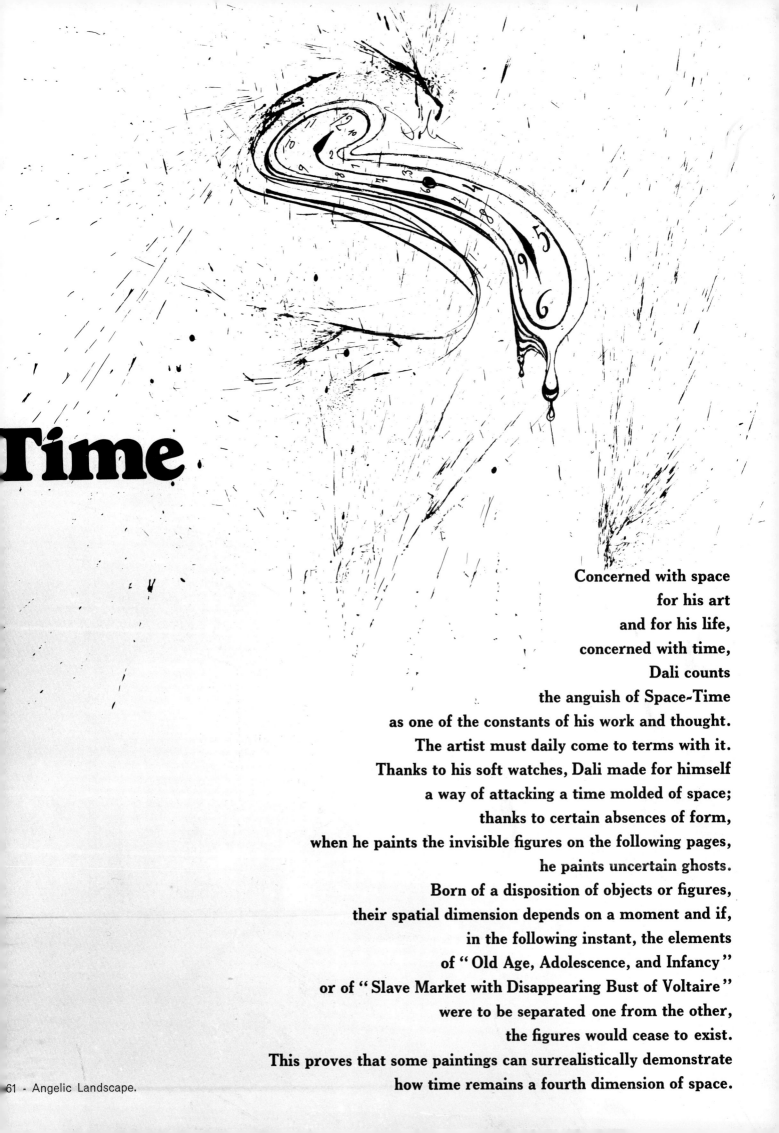

Time

Concerned with space
for his art
and for his life,
concerned with time,
Dali counts
the anguish of Space-Time
as one of the constants of his work and thought.
The artist must daily come to terms with it.
Thanks to his soft watches, Dali made for himself
a way of attacking a time molded of space;
thanks to certain absences of form,
when he paints the invisible figures on the following pages,
he paints uncertain ghosts.
Born of a disposition of objects or figures,
their spatial dimension depends on a moment and if,
in the following instant, the elements
of " Old Age, Adolescence, and Infancy "
or of " Slave Market with Disappearing Bust of Voltaire "
were to be separated one from the other,
the figures would cease to exist.
This proves that some paintings can surrealistically demonstrate
how time remains a fourth dimension of space.

61 - Angelic Landscape.

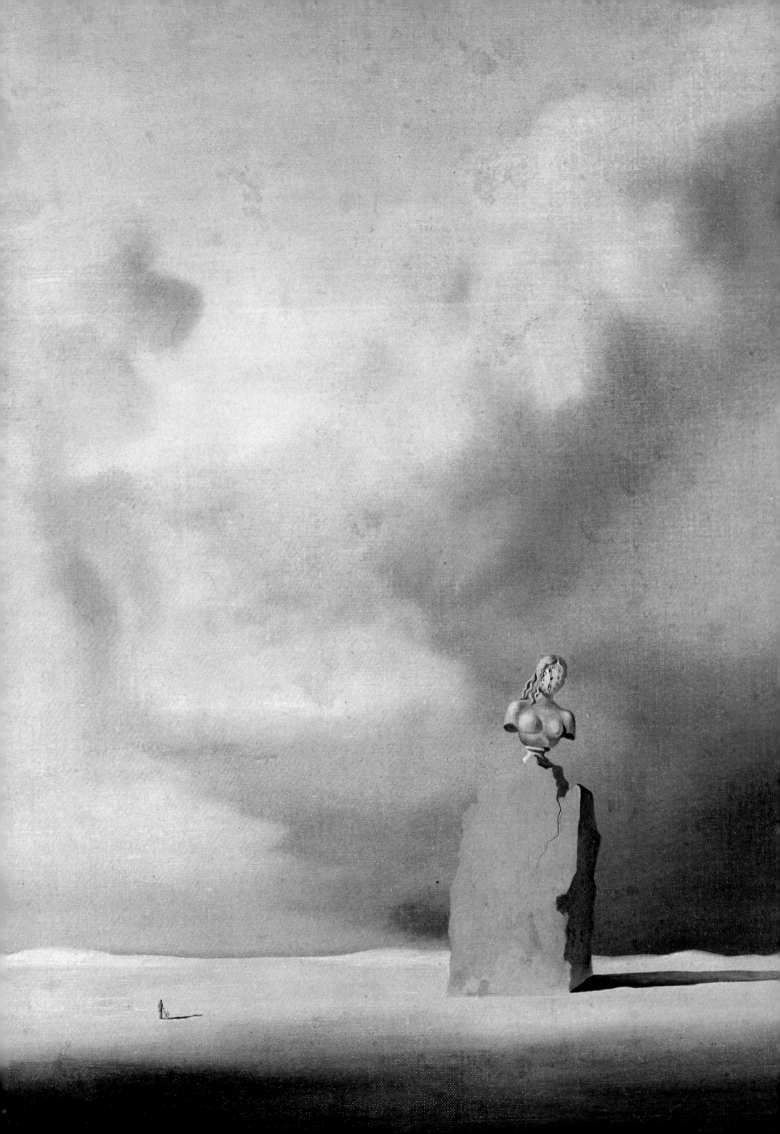

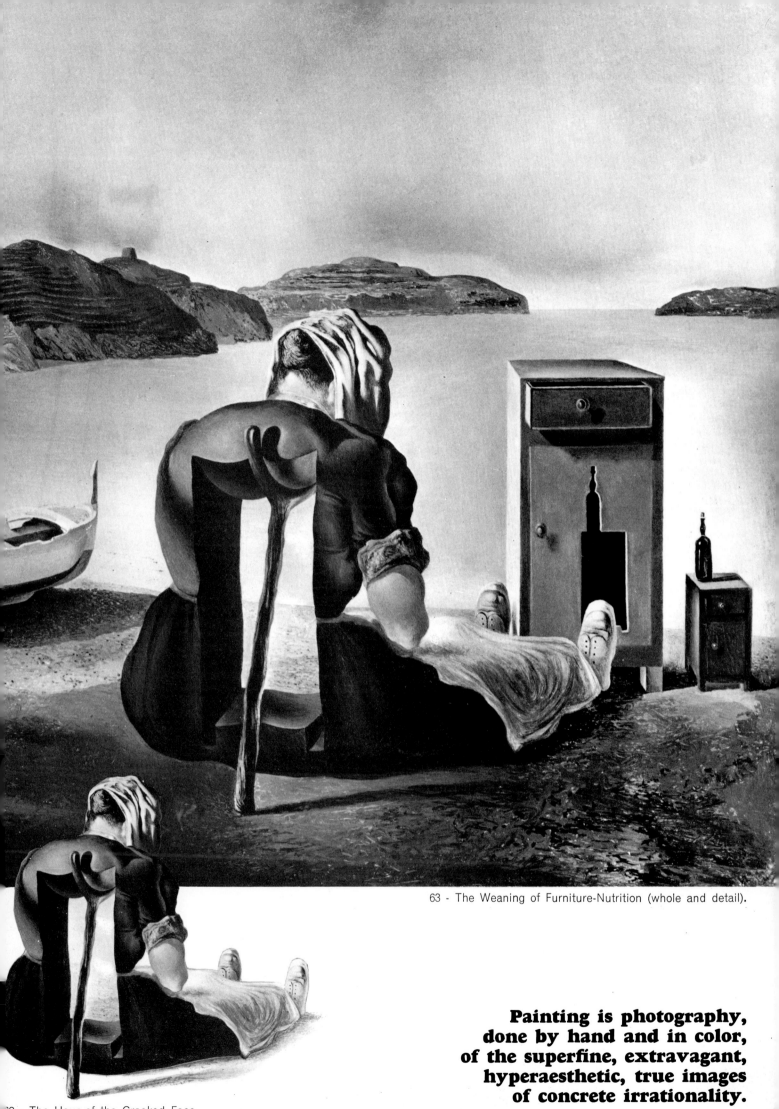

63 - The Weaning of Furniture-Nutrition (whole and detail).

52 - The Hour of the Cracked Face.

Painting is photography, done by hand and in color, of the superfine, extravagant, hyperaesthetic, true images of concrete irrationality.

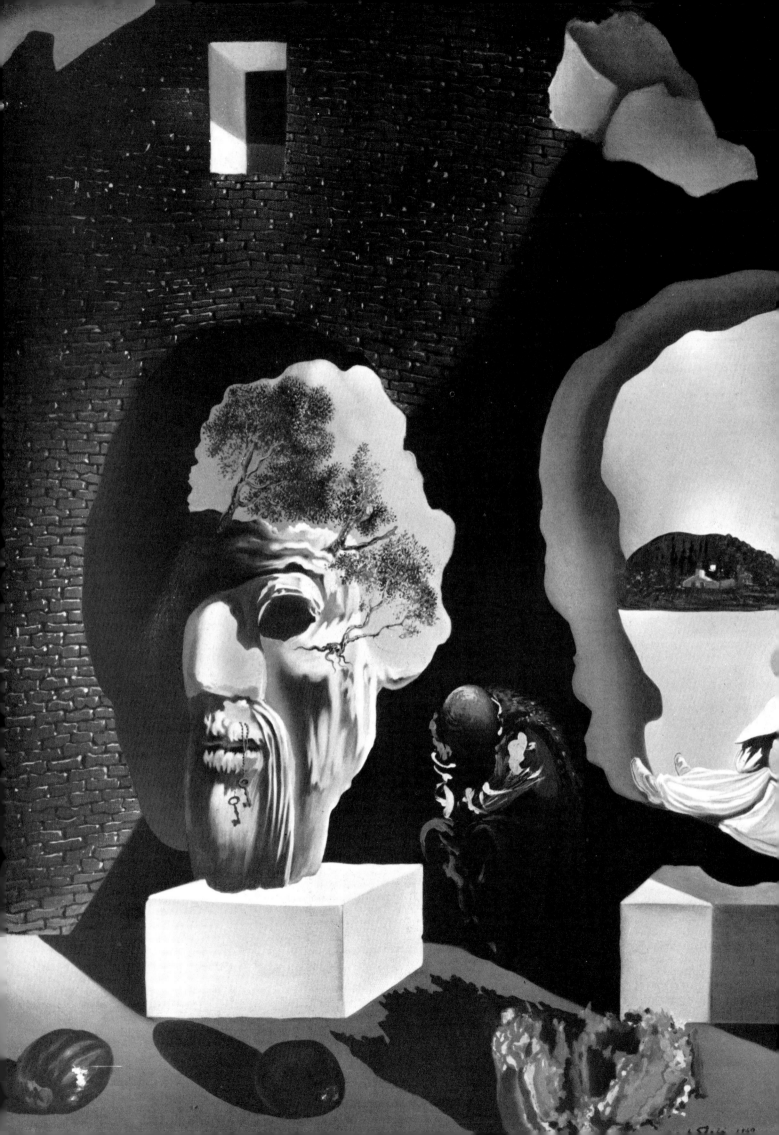

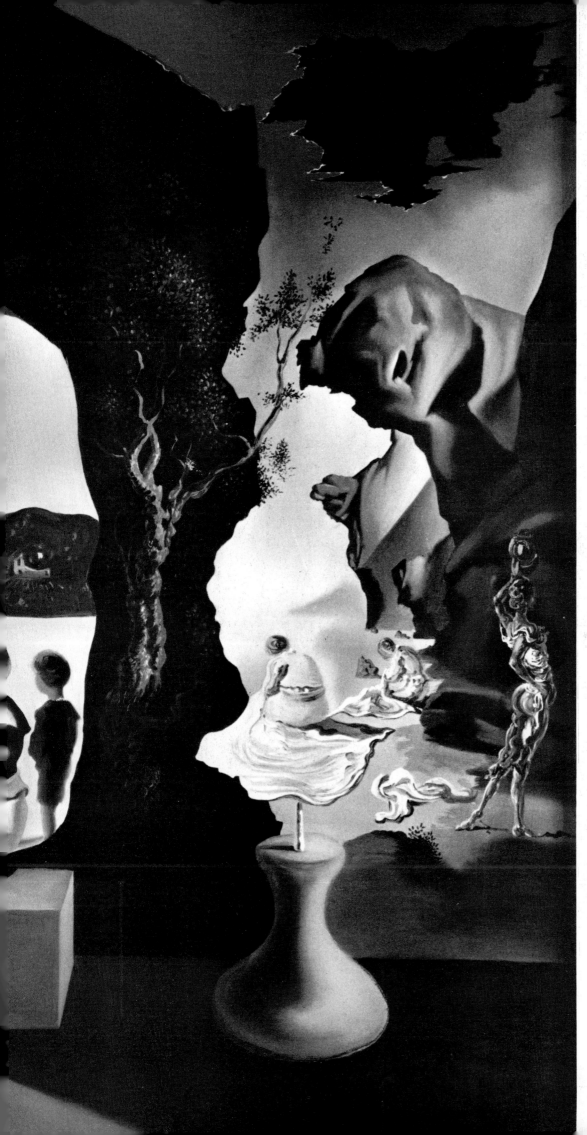

◄ 64 - Old Age, Adolescence, and Infancy (The Three Ages).

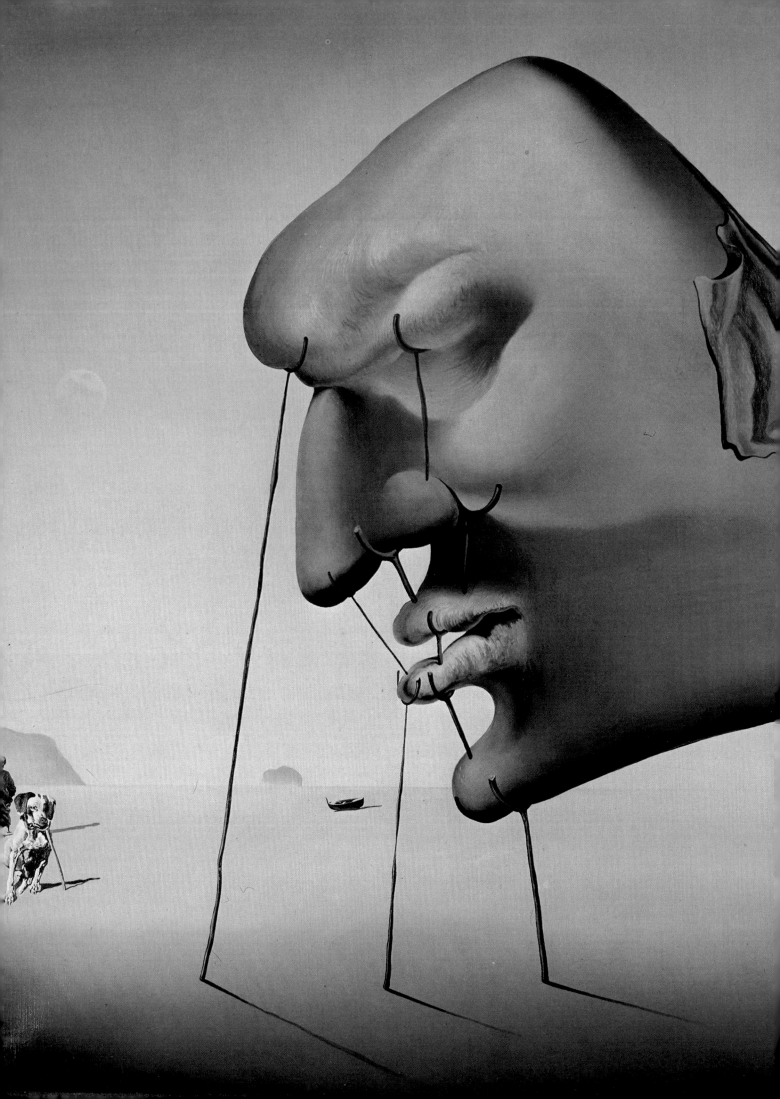

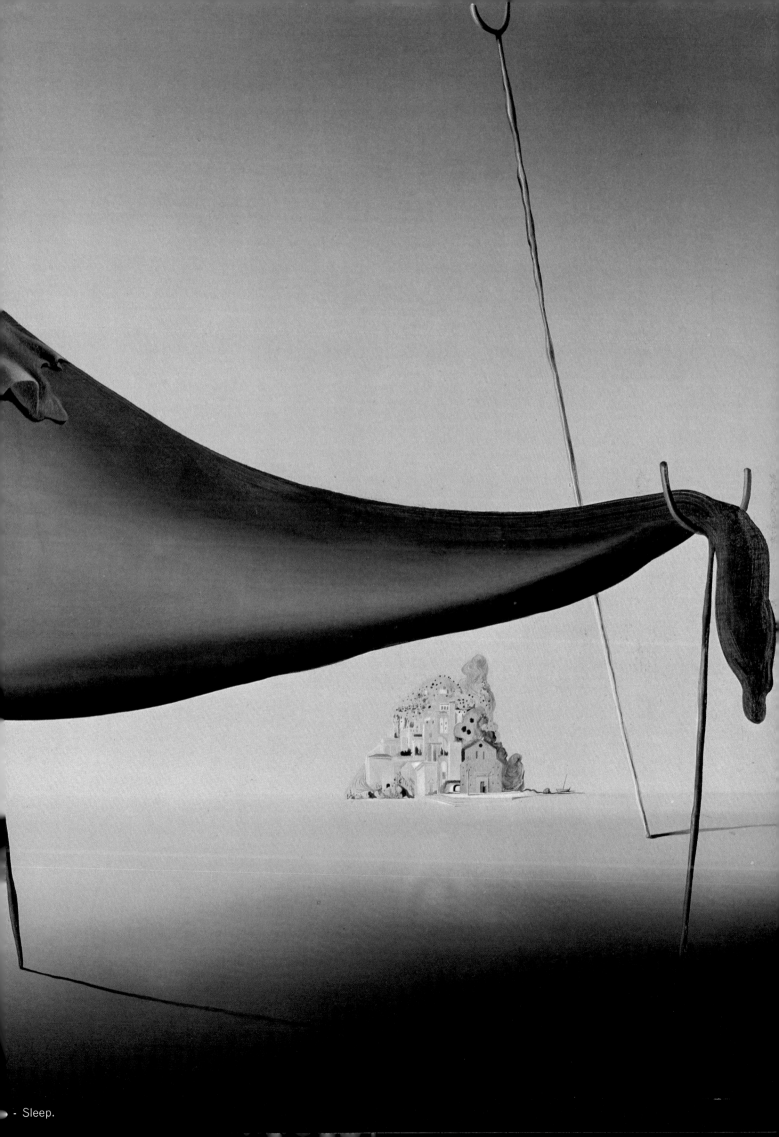

- Sleep.

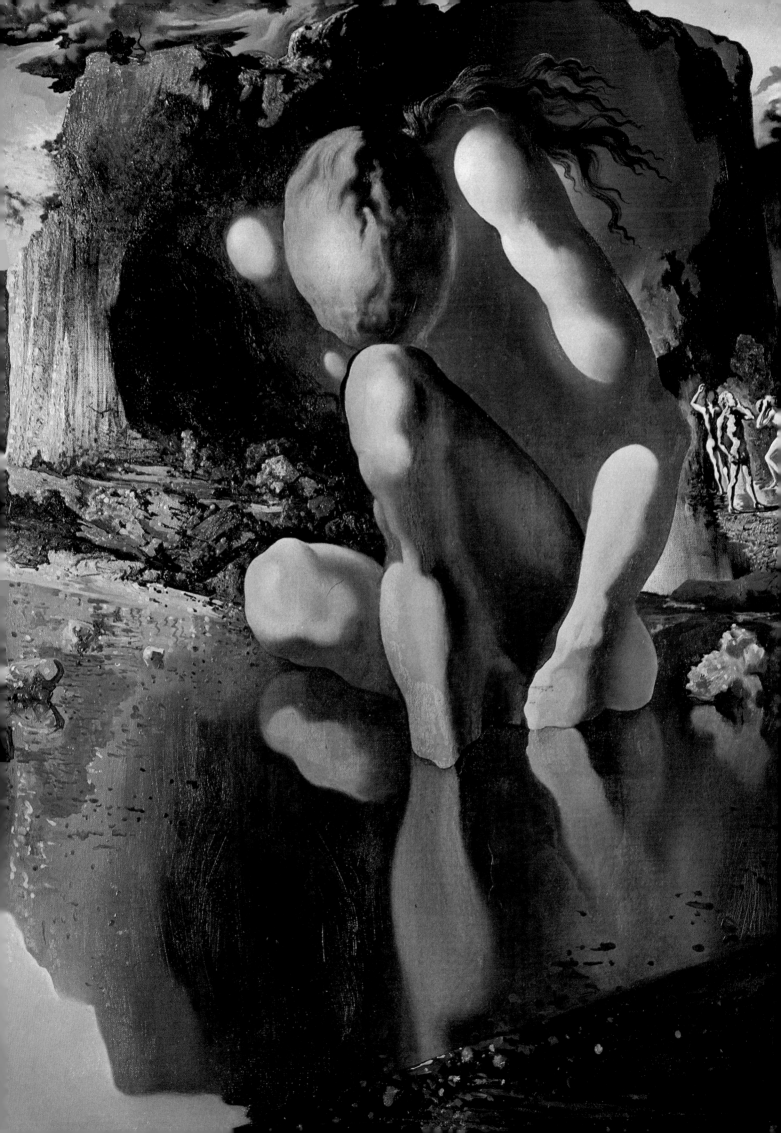

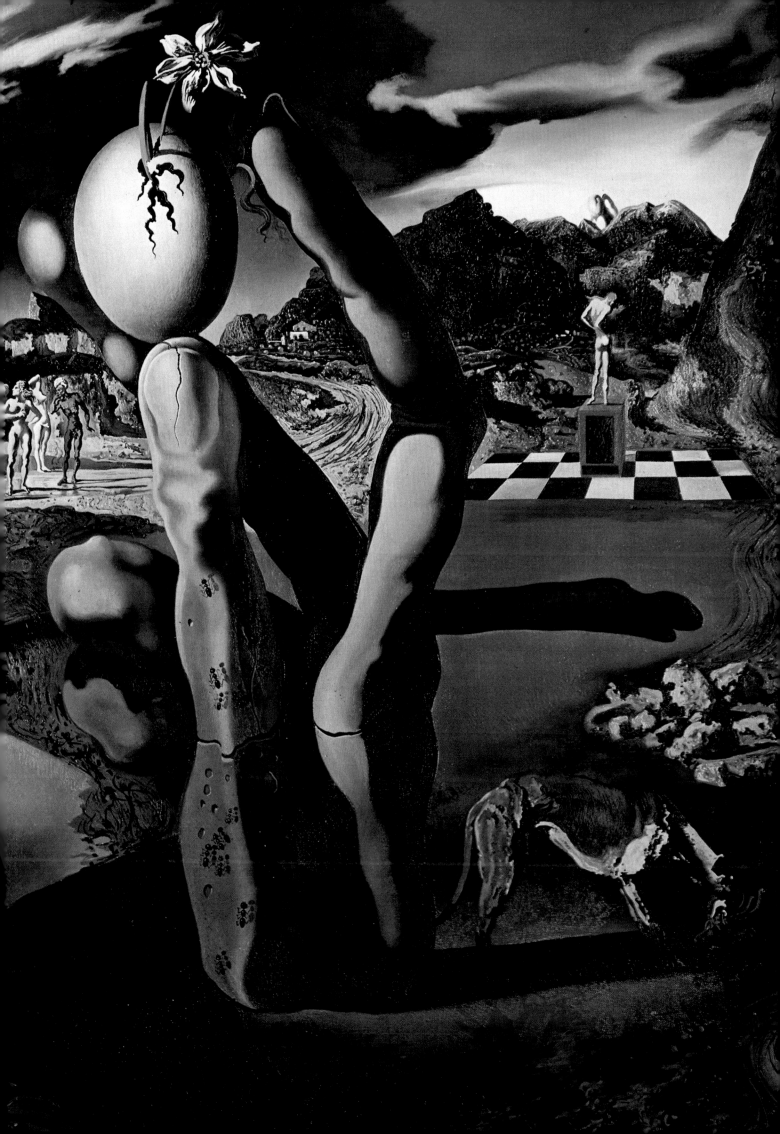

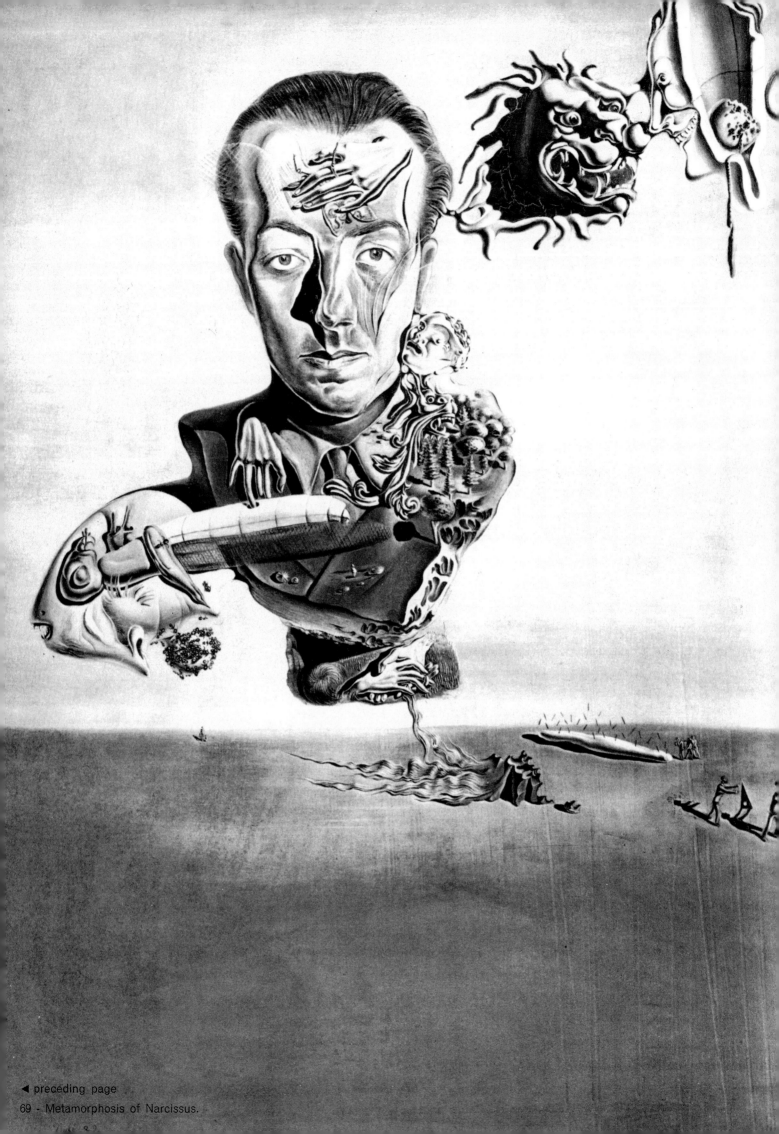

◄ preceding page
69 - Metamorphosis of Narcissus.

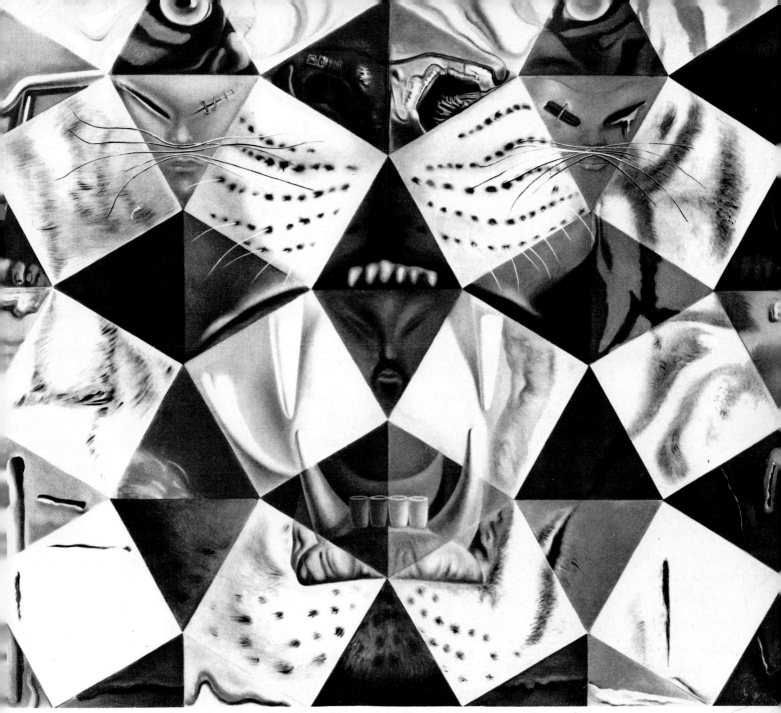

1 - Fifty Abstract Pictures Which as Seen from Two Yards Change into Three Lenins Masquerading as Chinese ▲
nd as Seen from Six Yards Appear as the Head of a Royal Bengal Tiger.

DALI...

DALI...

DALI...

**the only one who can sublimate,
integrate, and rationalize
in an imperial manner and with beauty,
all the revolutionary experiences
of modern times.**

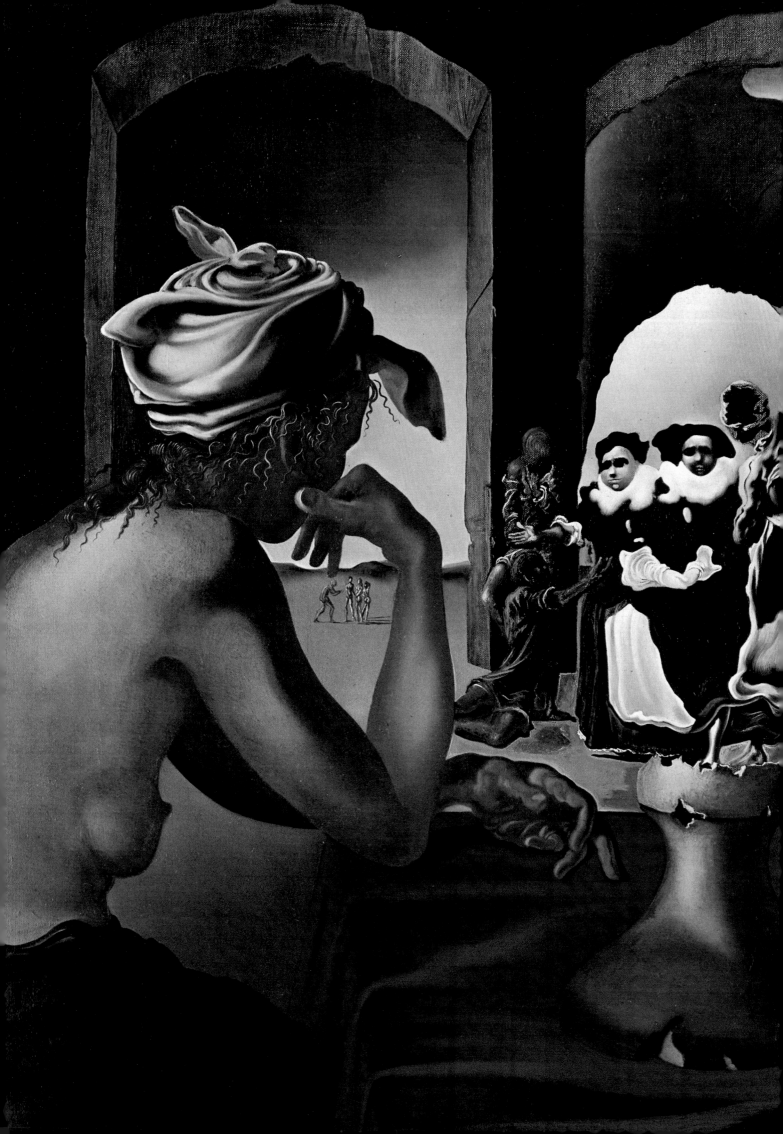

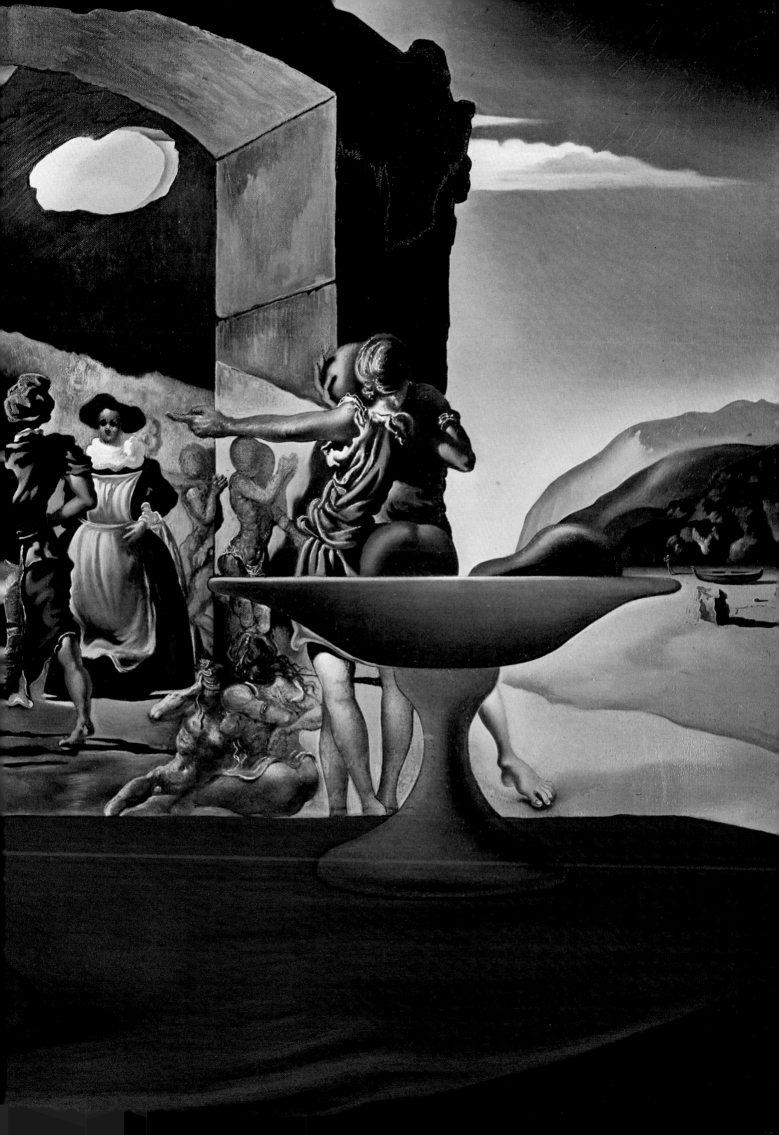

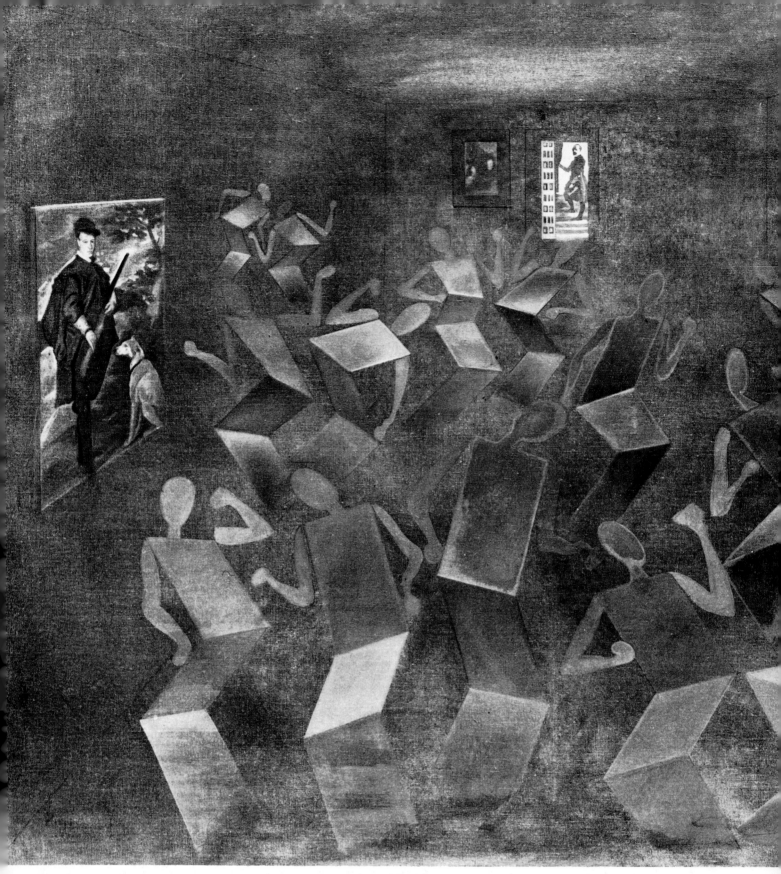

Close and open your eyes, the dancers change position, thus producing the kinet

◀ preceding page

72 - Slave Market
with Disappearing Bust of Voltaire.

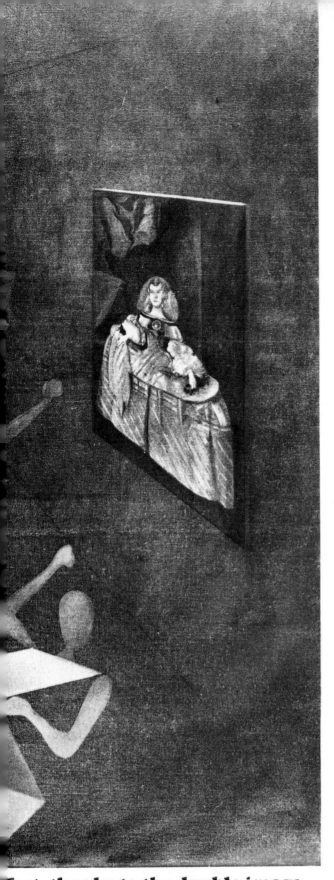

74 - Las Meninas. (▼ A and B ▲)

fect, thanks to the double image.

73 - Twist in the Studio of Velázquez (first version). ▲

**Velázquez teaches me more
about light
than tons of scientific treatises.
He is an inexhaustible treasure
of mathematics
and the exact sciences.**

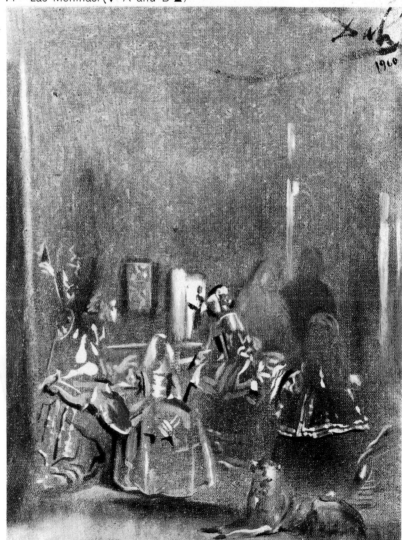

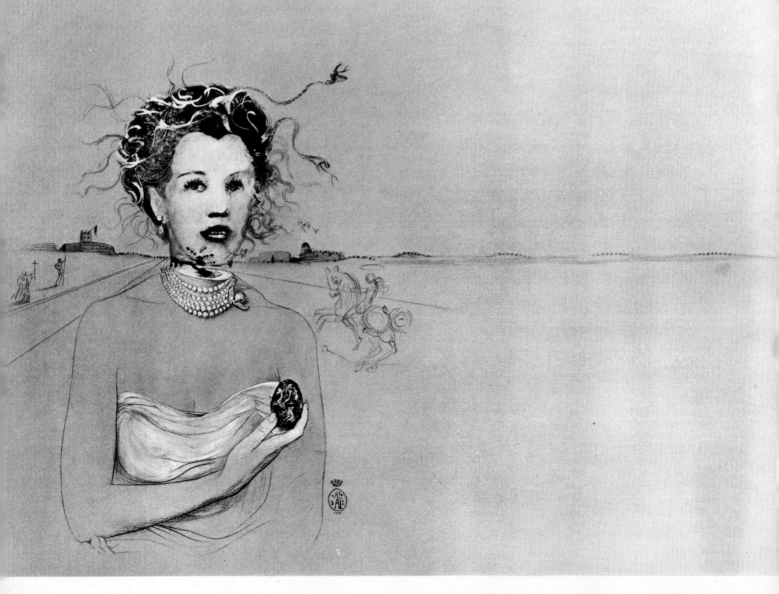

Oneiros

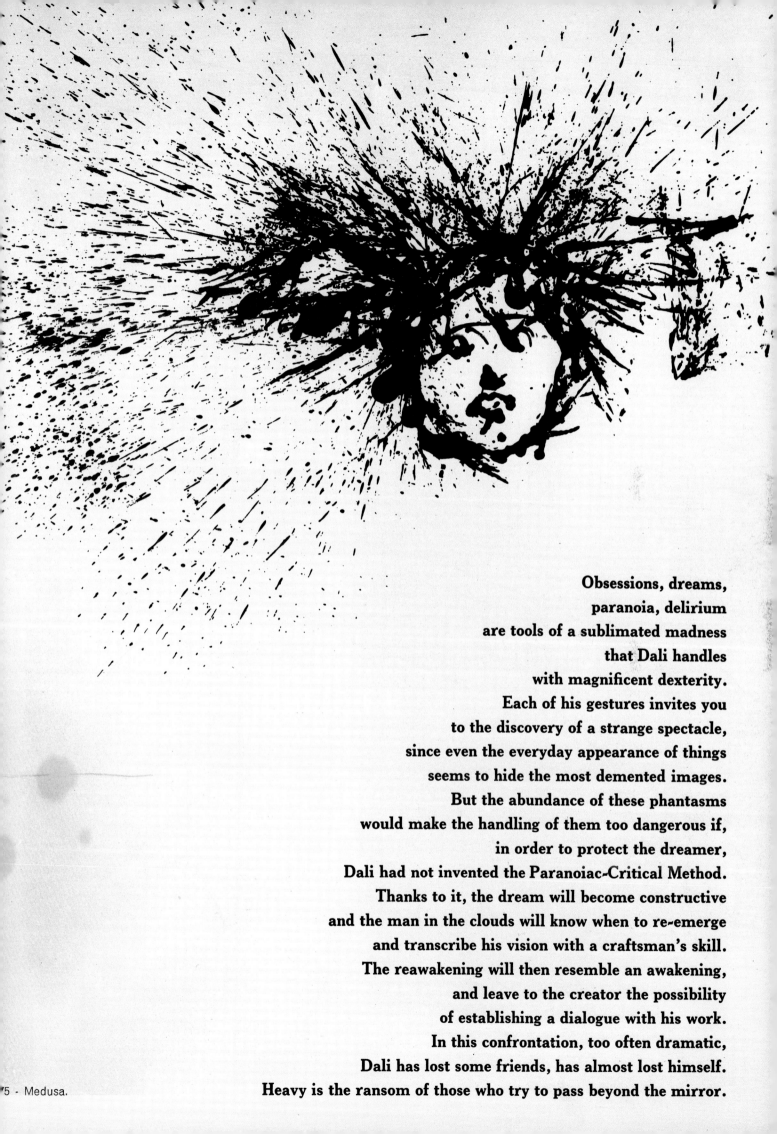

Obsessions, dreams,
paranoia, delirium
are tools of a sublimated madness
that Dali handles
with magnificent dexterity.
Each of his gestures invites you
to the discovery of a strange spectacle,
since even the everyday appearance of things
seems to hide the most demented images.
But the abundance of these phantasms
would make the handling of them too dangerous if,
in order to protect the dreamer,
Dali had not invented the Paranoiac-Critical Method.
Thanks to it, the dream will become constructive
and the man in the clouds will know when to re-emerge
and transcribe his vision with a craftsman's skill.
The reawakening will then resemble an awakening,
and leave to the creator the possibility
of establishing a dialogue with his work.
In this confrontation, too often dramatic,
Dali has lost some friends, has almost lost himself.
Heavy is the ransom of those who try to pass beyond the mirror.

5 - Medusa.

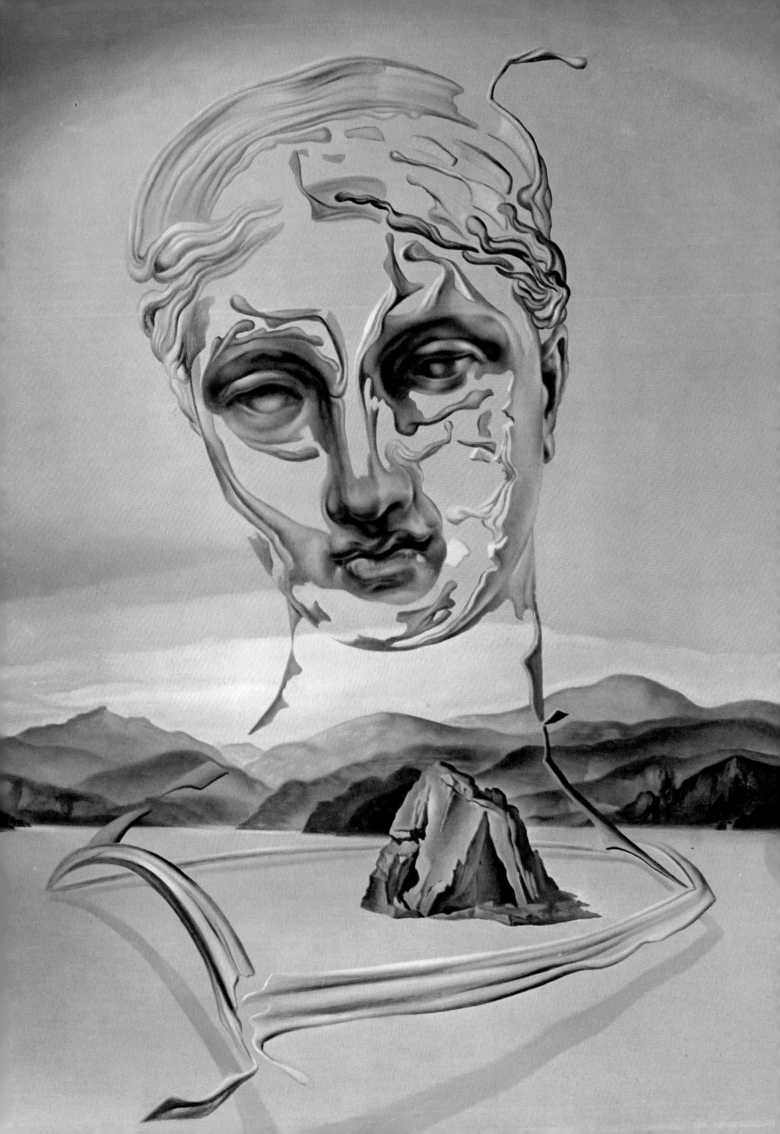

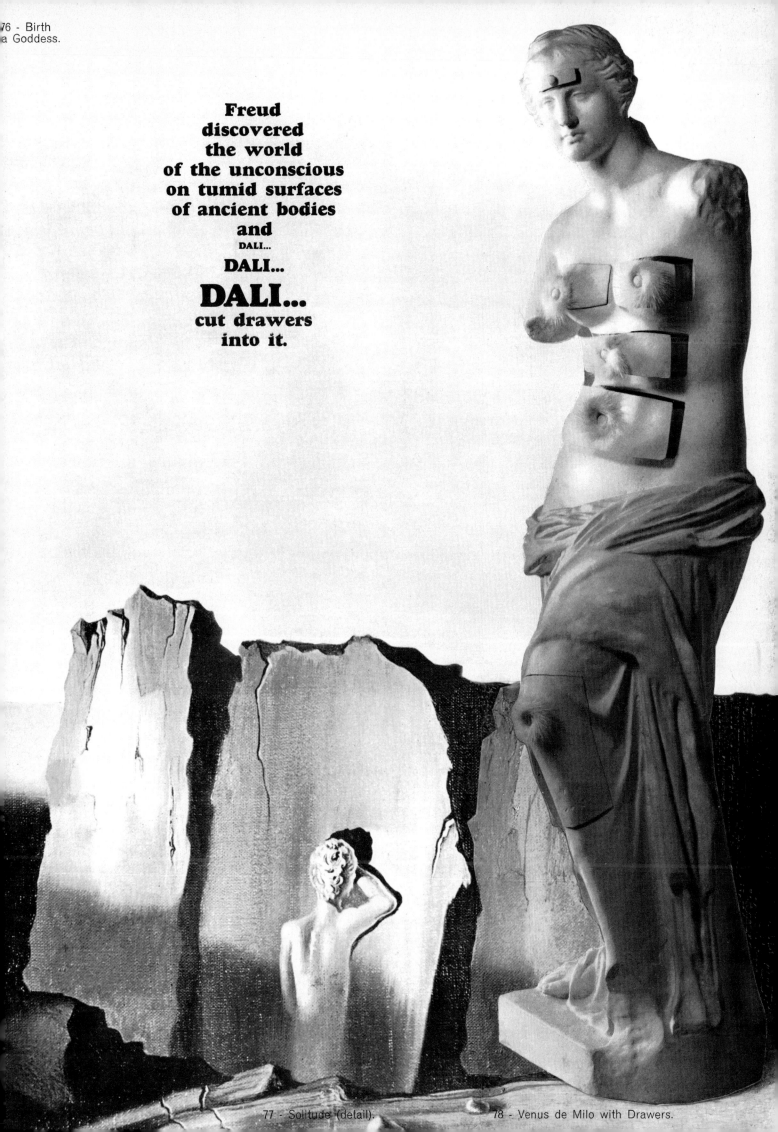

Freud
discovered
the world
of the unconscious
on tumid surfaces
of ancient bodies
and
DALI...
DALI...
DALI...
cut drawers
into it.

77 - Solitude (detail). 78 - Venus de Milo with Drawers.

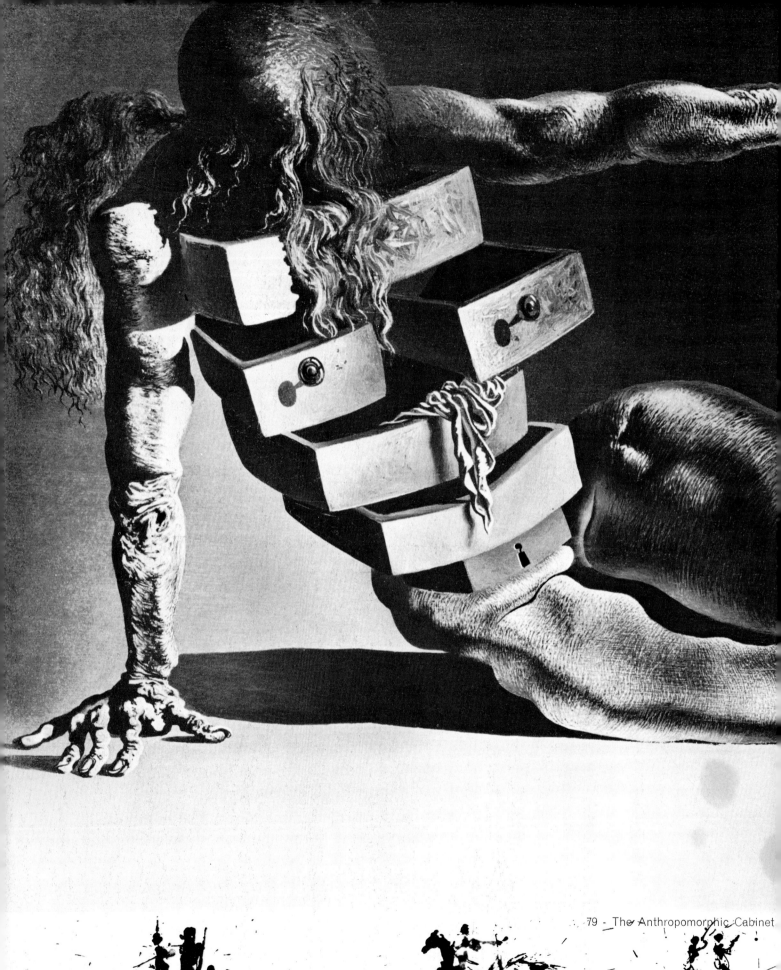

**How
do you expect
the public
to understand the meaning of the images I transcribe**

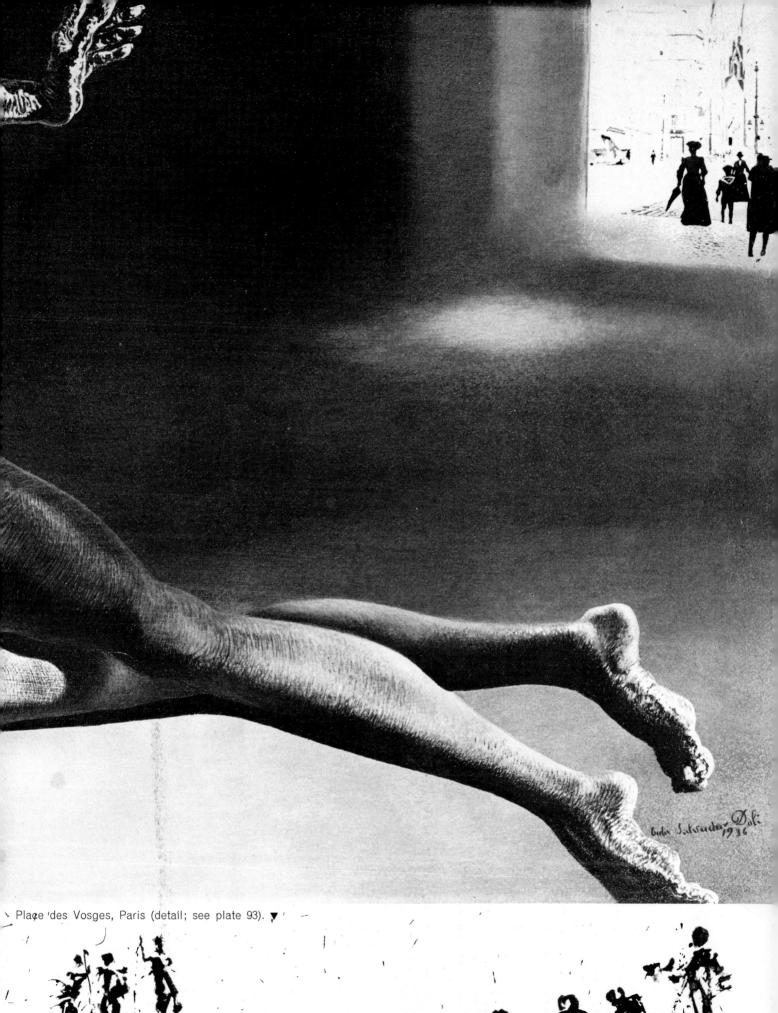

Place des Vosges, Paris (detail; see plate 93). ▼

when I myself,
who am the one
who makes them, I don't understand them
y longer when they appear in my pictures?

◄ preceding page
81 - Accommodations of Desire. 82 - The Hand (The Remorse of Conscience). ▲

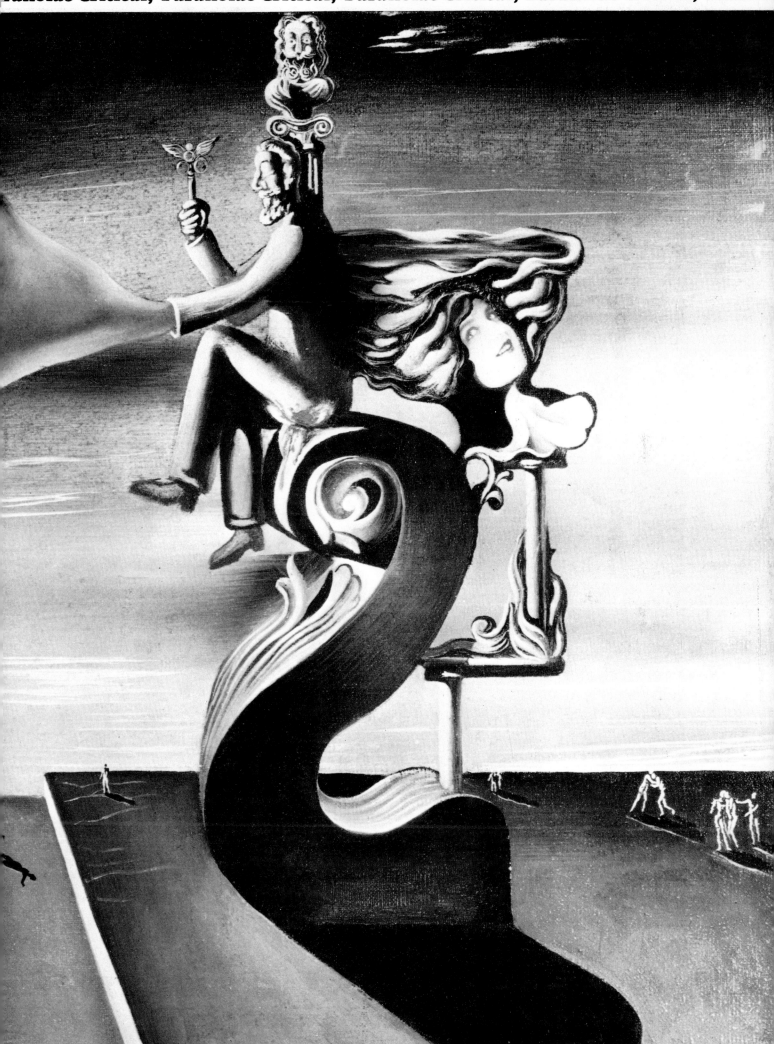

ased on the interpretive critical association of delirious phenomena.

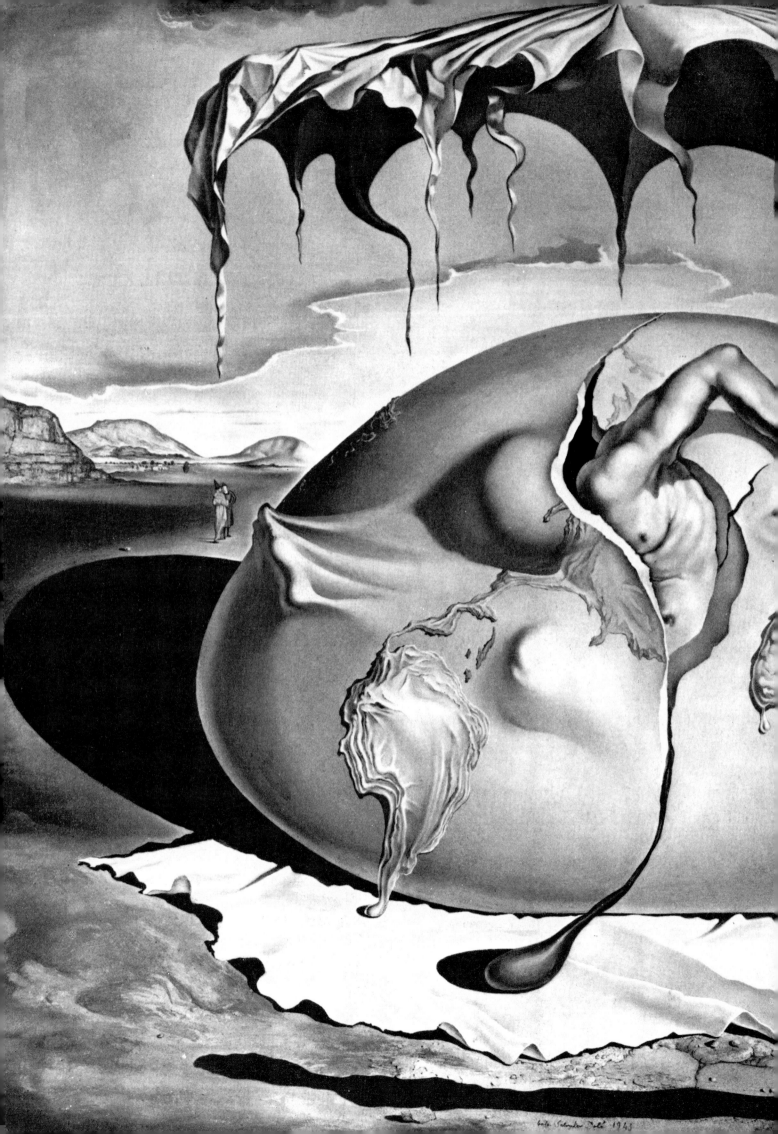

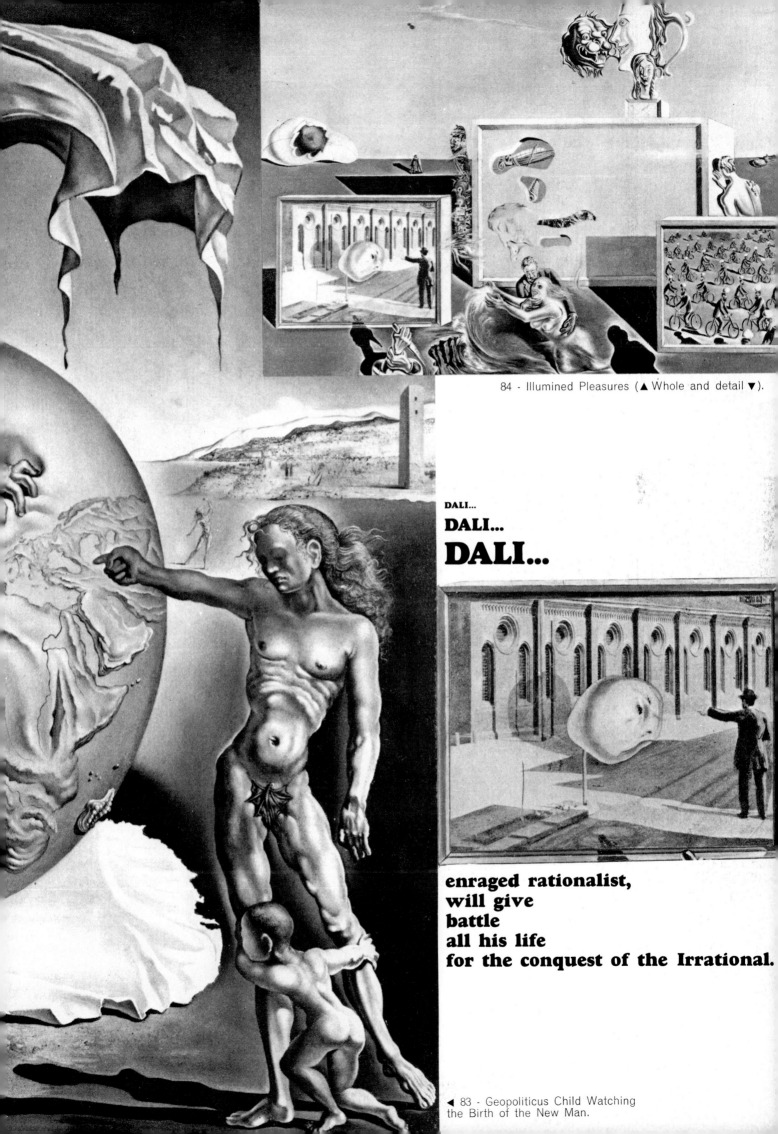

84 - Illumined Pleasures (▲ Whole and detail ▼).

DALI...

DALI...

DALI...

enraged rationalist,
will give
battle
all his life
for the conquest of the Irrational.

◄ 83 - Geopoliticus Child Watching
the Birth of the New Man.

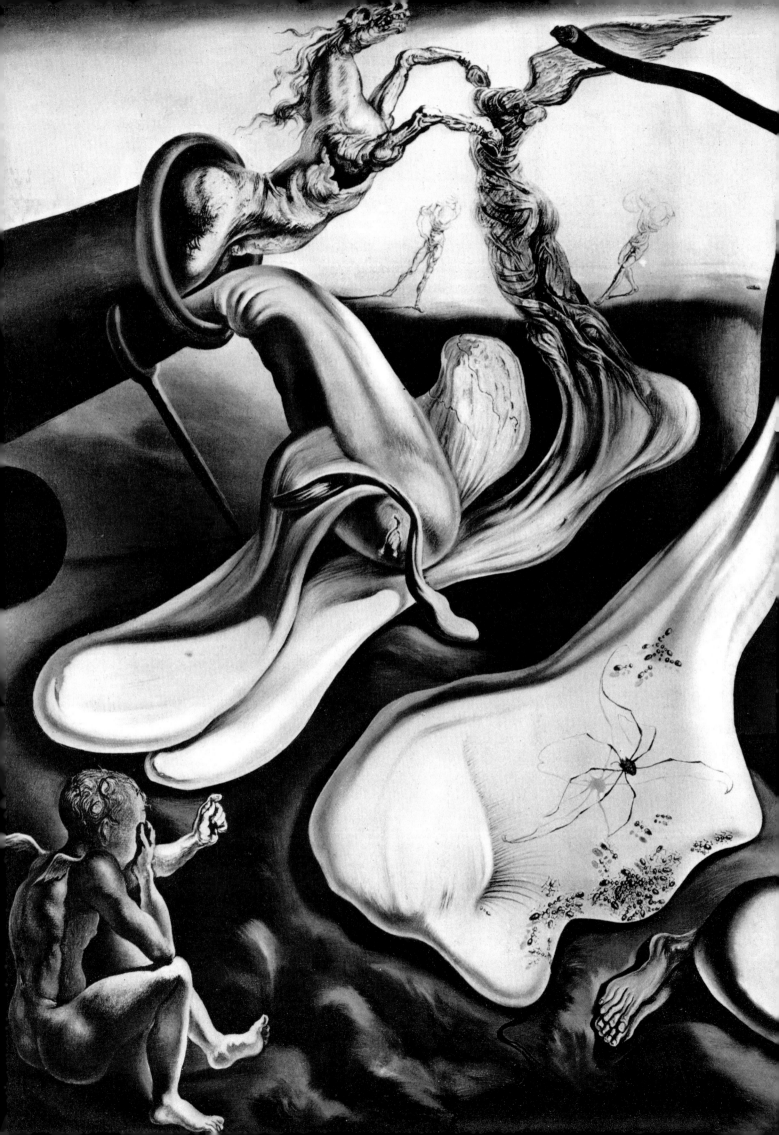

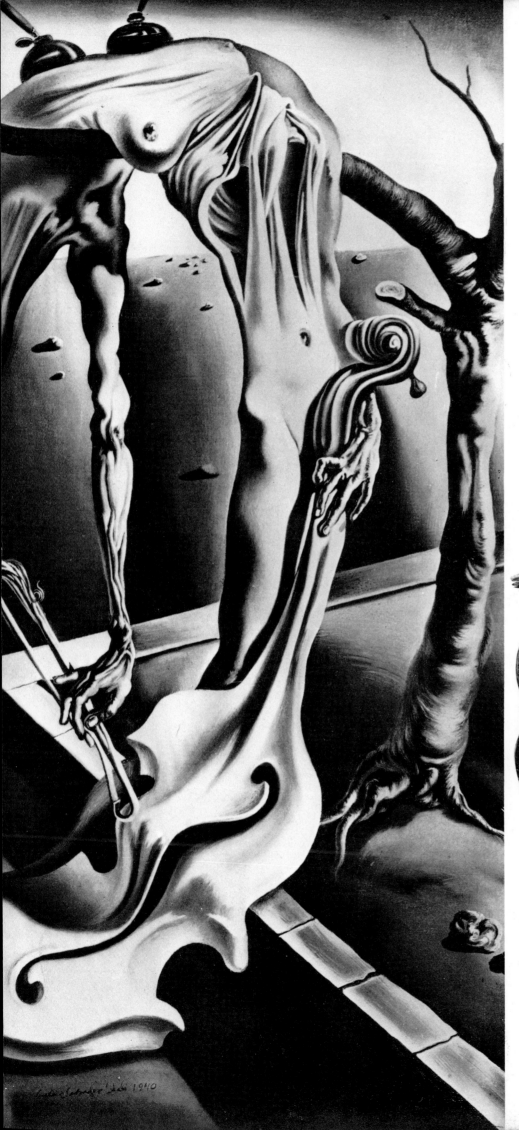

DALI...

DALI...

DALI...

whose buffoonery
may be substantial
and whose deep
substance
pure humbug

"I do not know
when I start
to pretend
or when I tell
the truth!"

85 - Daddy Long Legs of the Evening — Hope!
(◄ Whole and detail ▲).

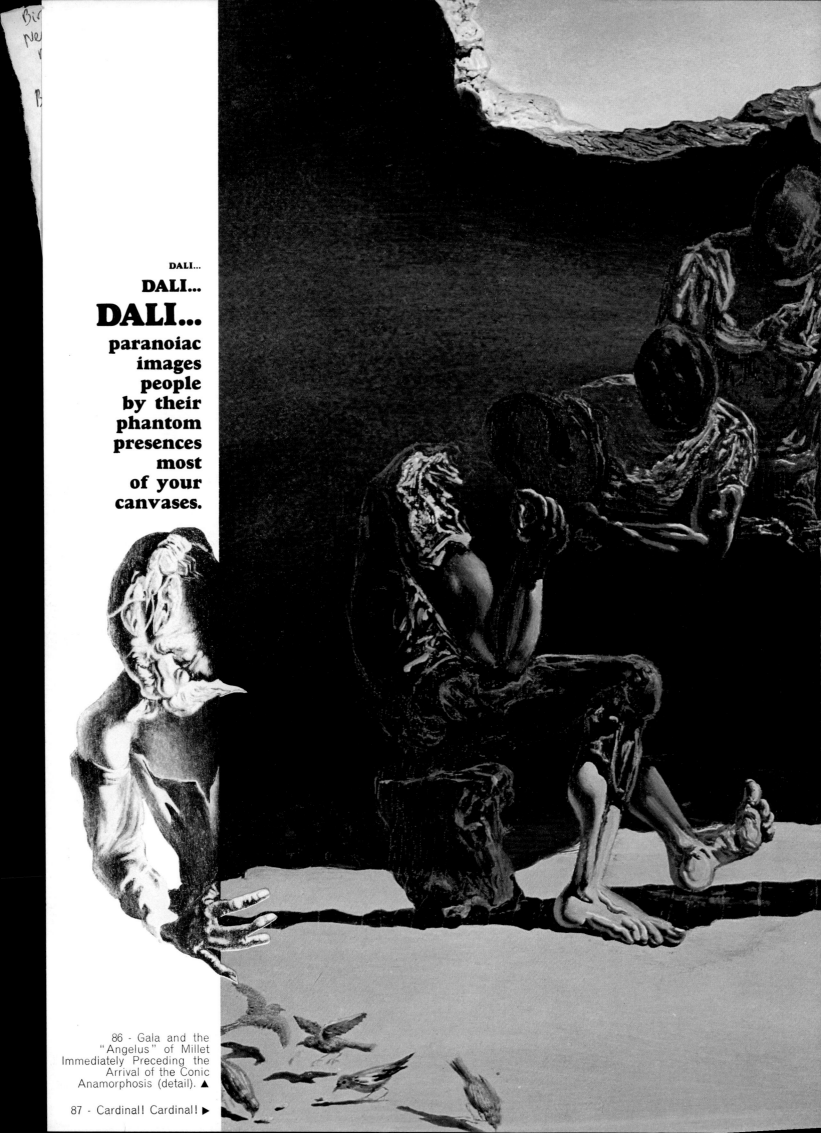

DALI...

DALI...
DALI...
DALI...

paranoiac images people by their phantom presences most of your canvases.

86 - Gala and the "Angelus" of Millet Immediately Preceding the Arrival of the Conic Anamorphosis (detail). ▲

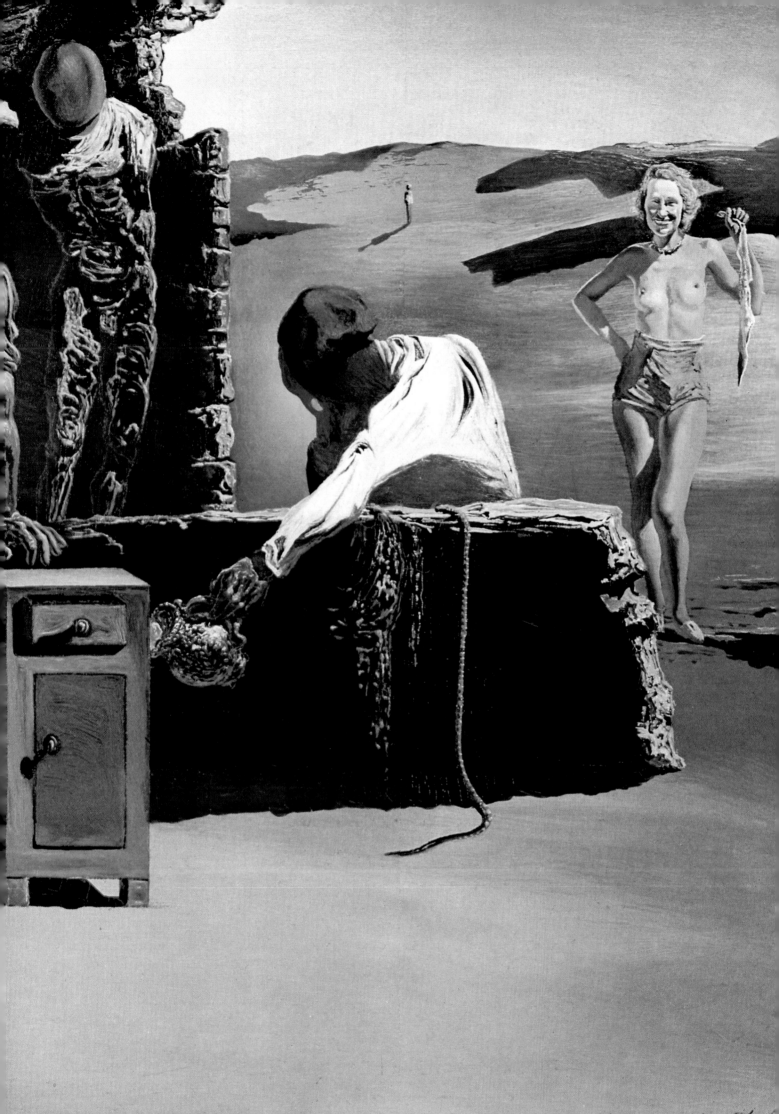

Toward an Imperial

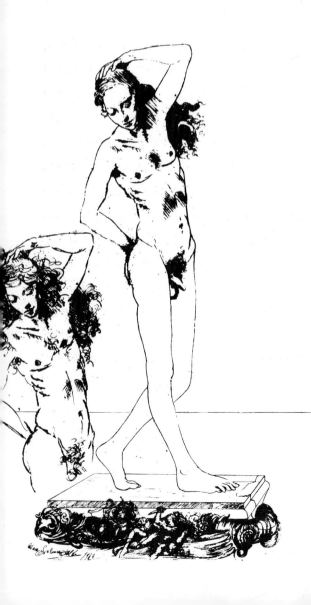

Classicism

Chronologically of our time,
Dali wished to terminate
the synthesis of his cause
with this chapter.
He grafts a classical discipline
onto his world of delirium.
If he devotes himself with joy
to the ease of the gesture that surprises, shocks,
or simply captures the public's attention for a moment,
Dali forgives others nothing,
especially not their "insulting lack of craftsmanship."
Classical in a breathless society,
maniac for detail
in a civilization that seeks to absorb everything,
to the limits of suffocation,
Dali passes,
excessive and wise, iconoclastic and respectful.
He goes to war clinging to Gala's hand,
bows to the powerful while refusing any constraints,
smashes space, nibbles time, sprinkles himself with tinsel,
and while still alive tries to erect a monument
capable of conferring on him the immortality that haunts him.

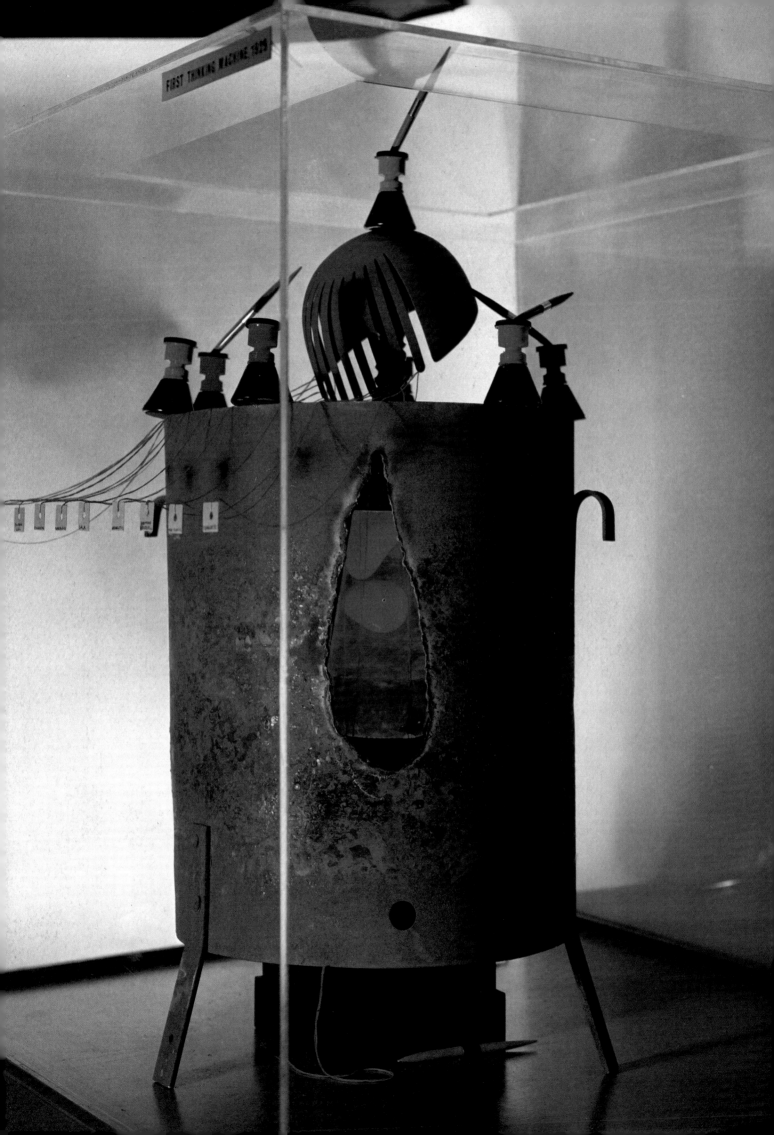

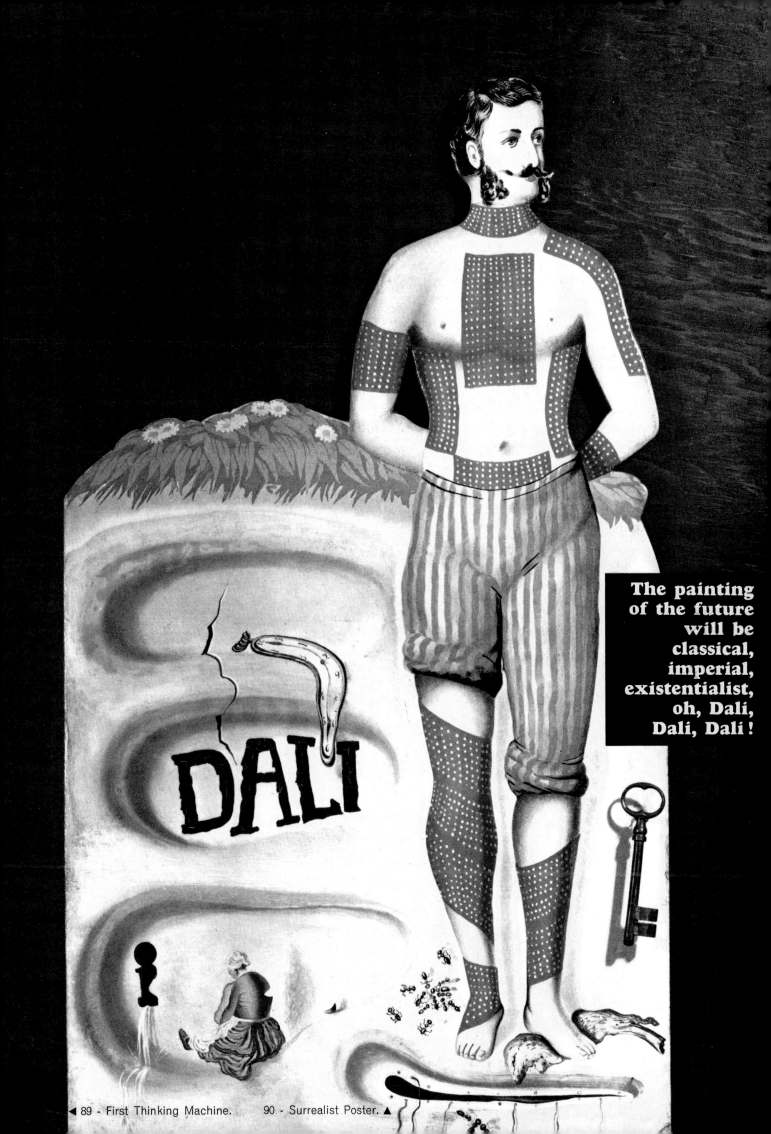

The painting
of the future
will be
classical,
imperial,
existentialist,
oh, Dali,
Dali, Dali !

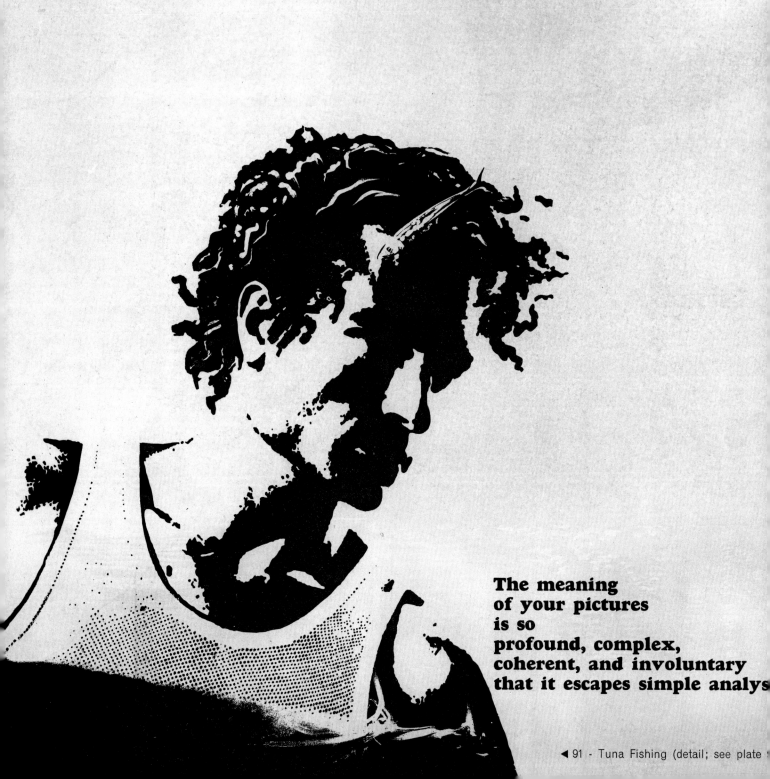

The meaning
of your pictures
is so
profound, complex,
coherent, and involuntary
that it escapes simple analys

◀ 91 - Tuna Fishing (detail; see plate

logical intuition, oh, Dali, Dali, Dali!

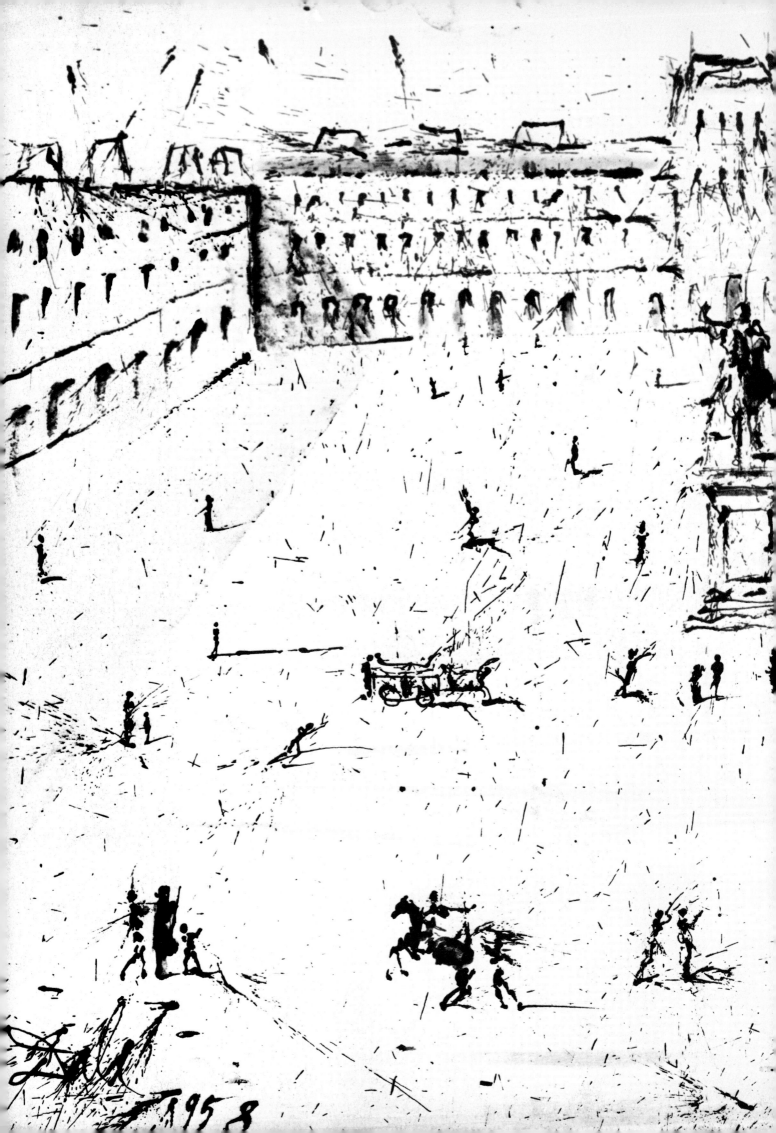

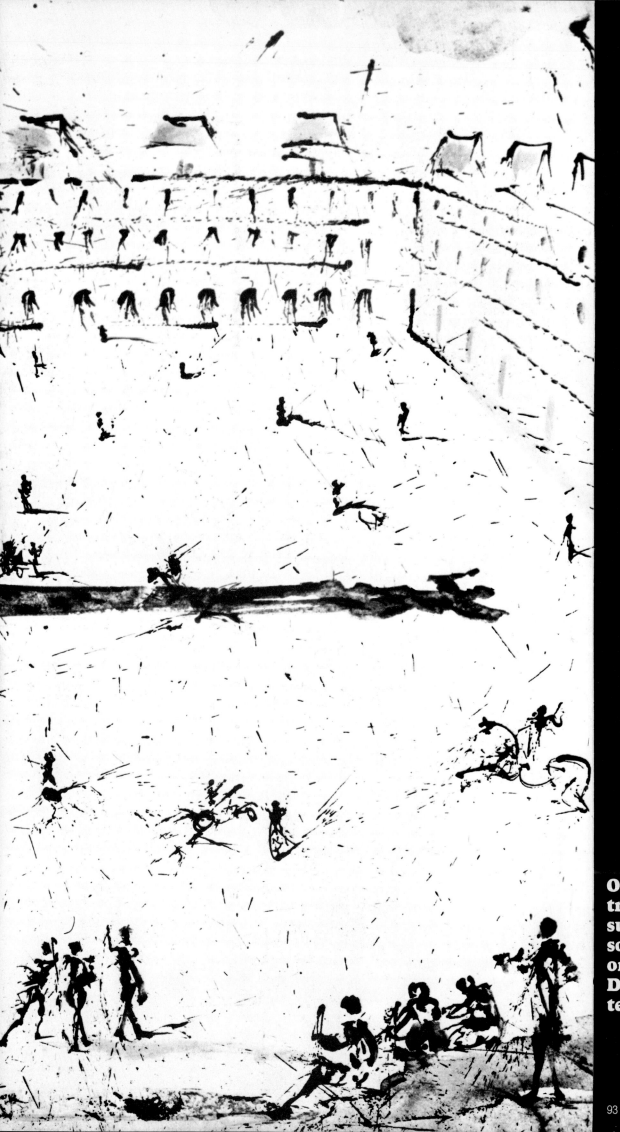

Only
tradition
suggests
something
original,
Dali, Dali, Dali
tells you!

93 - Place des Vosges, Paris

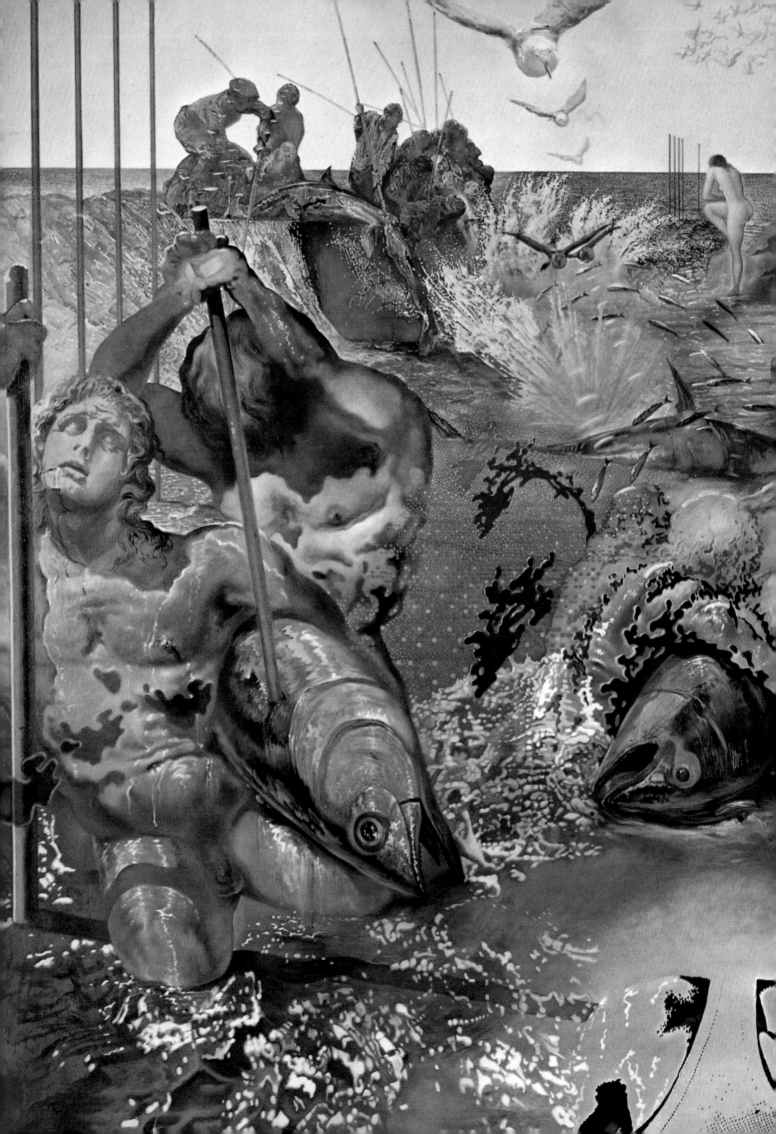

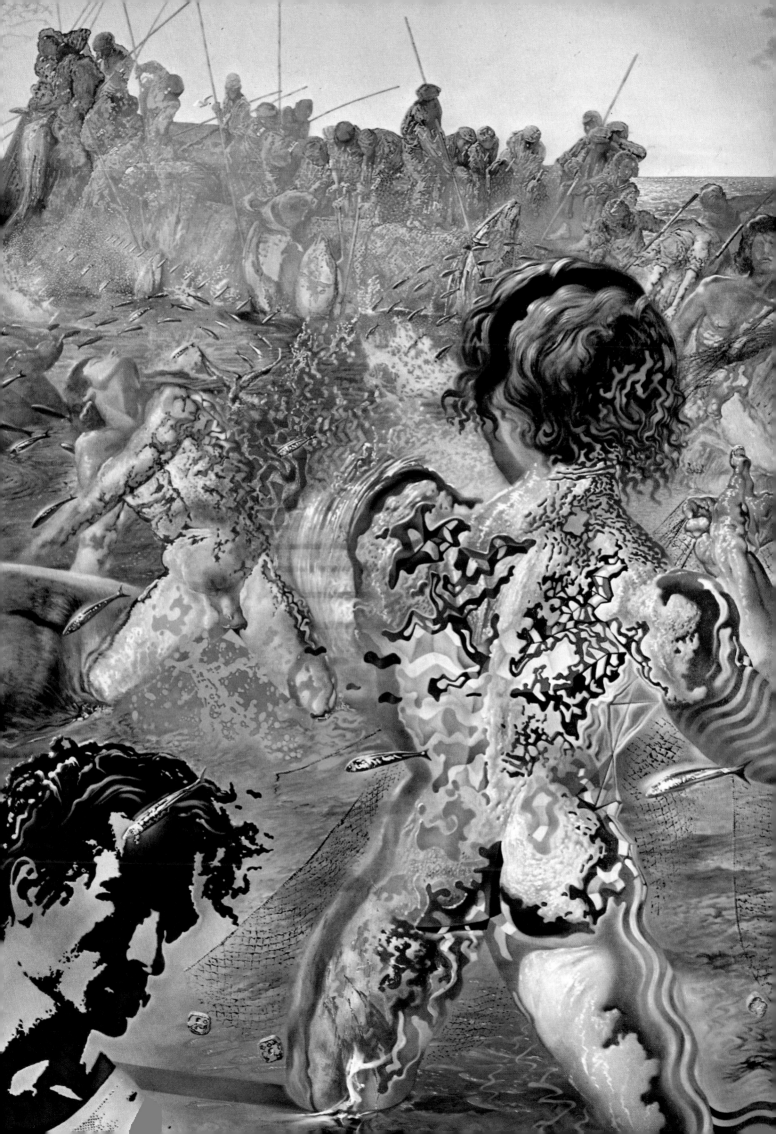

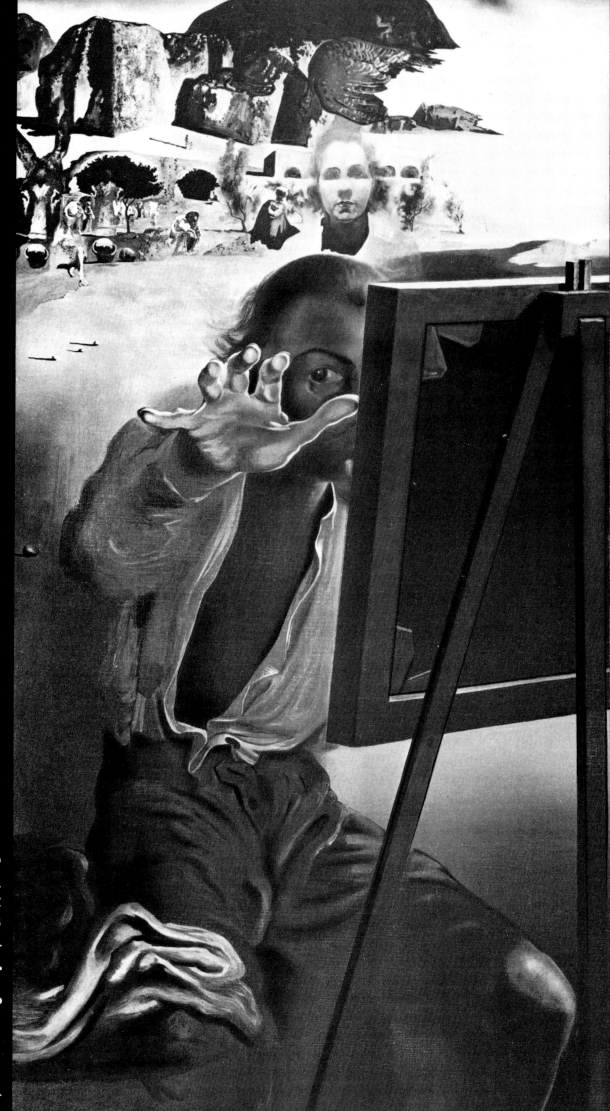

The saviour
of modern
art
is
DALI...
DALI...
DALI...

preceding page

- Tuna Fishing.

- Impressions of Africa. ▶

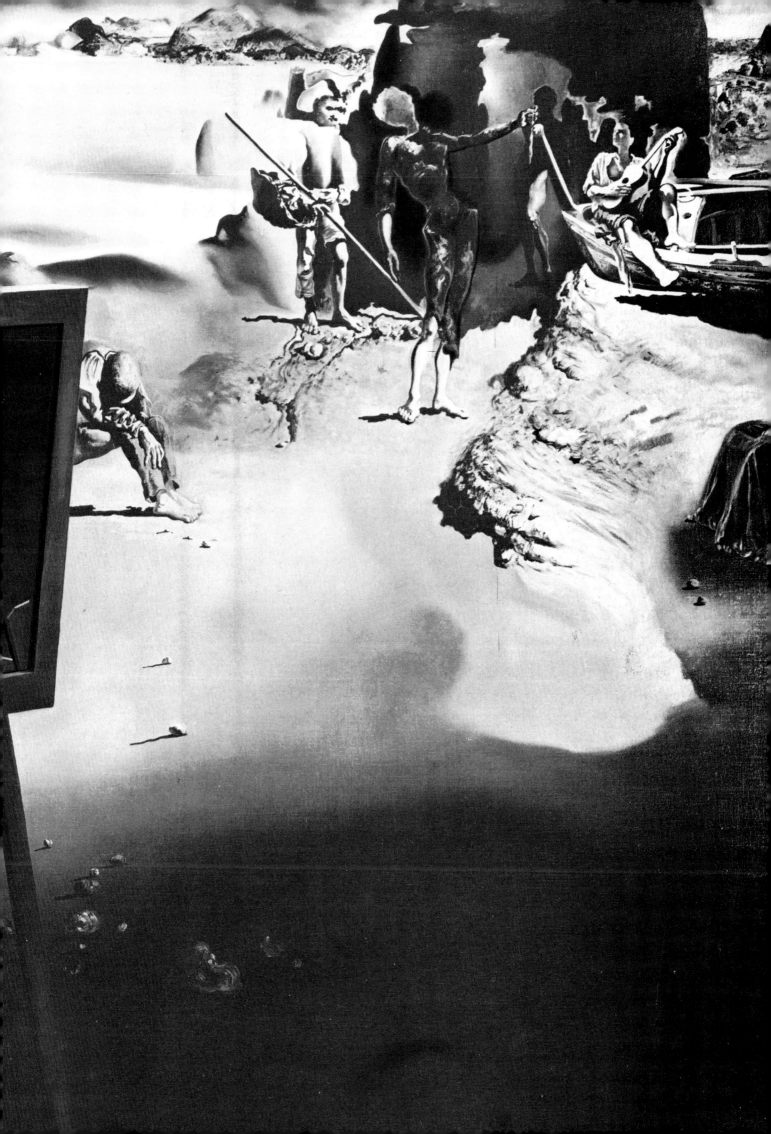

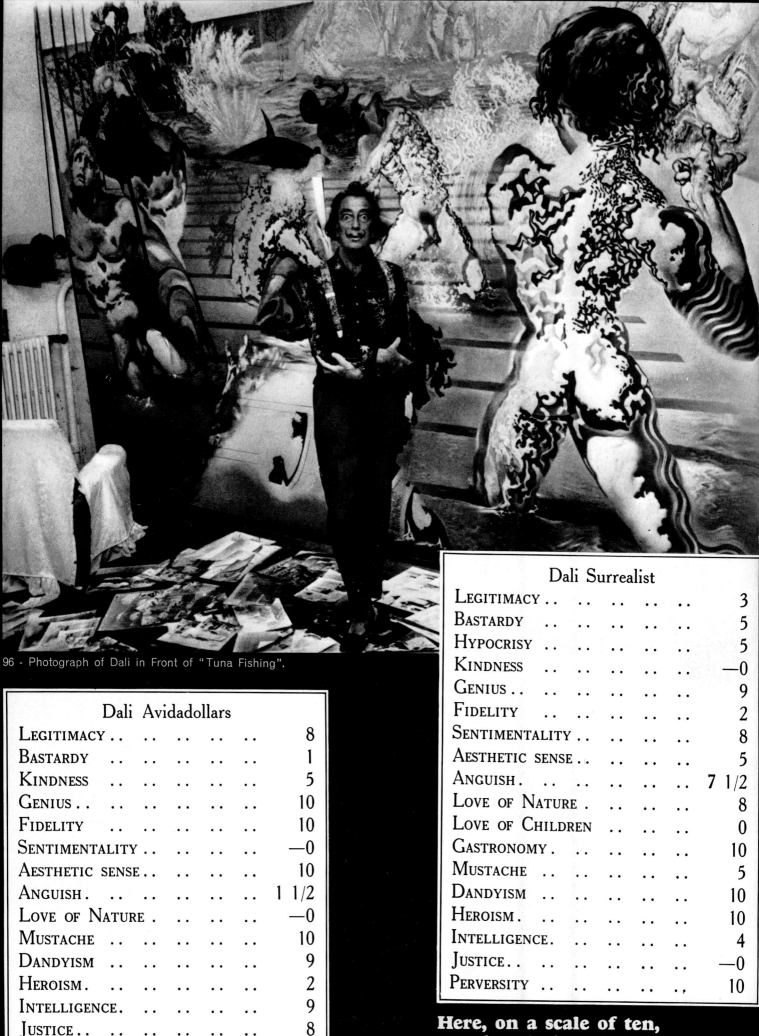

96 - Photograph of Dali in Front of "Tuna Fishing".

Dali Surrealist

LEGITIMACY	3
BASTARDY	5
HYPOCRISY	5
KINDNESS	—0
GENIUS	9
FIDELITY	2
SENTIMENTALITY	8
AESTHETIC SENSE	5
ANGUISH	7 1/2
LOVE OF NATURE	8
LOVE OF CHILDREN	0
GASTRONOMY	10
MUSTACHE	5
DANDYISM	10
HEROISM	10
INTELLIGENCE	4
JUSTICE	—0
PERVERSITY	10

Dali Avidadollars

LEGITIMACY	8
BASTARDY	1
KINDNESS	5
GENIUS	10
FIDELITY	10
SENTIMENTALITY	—0
AESTHETIC SENSE	10
ANGUISH	1 1/2
LOVE OF NATURE	—0
MUSTACHE	10
DANDYISM	9
HEROISM	2
INTELLIGENCE	9
JUSTICE	8
PERVERSITY	10

Here, on a scale of ten, are the vital statistics of the two Dalis,

Dali !

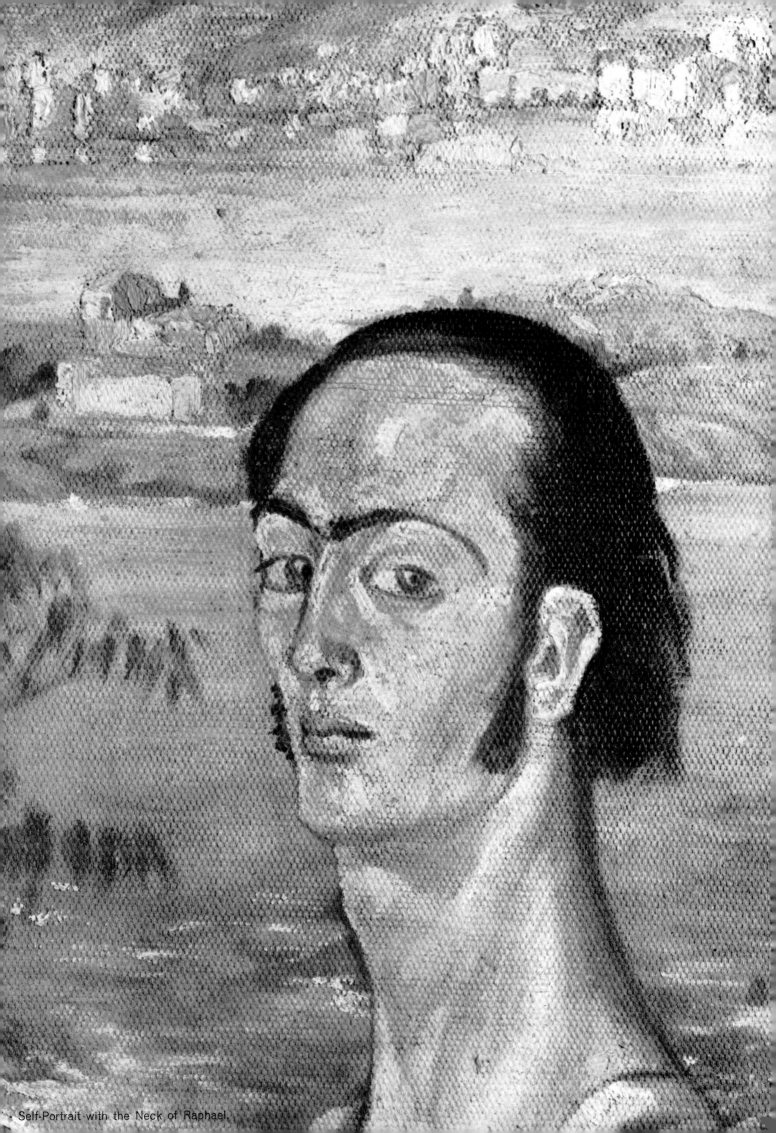

Self-Portrait with the Neck of Raphael.

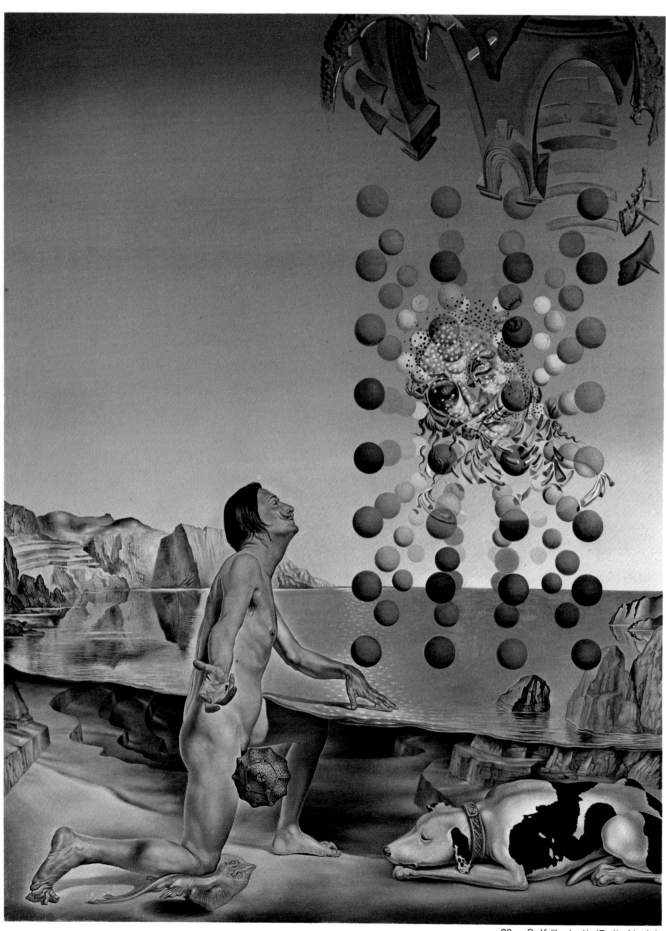

98 - Self-Portrait (Dali, Nude).

Biography

Dali, Dali, Dali readily discovered his existence with his intra-uterine memories, but Salvador, Domenech, Felipe, Jacinto Dali was legally born on May 11, 1904, at 20 Calle Monturiol in Figueras, in the province of Gerona. His father was a notary, and Salvador's middle-class background accounts for his desire to achieve an important position in life and for the sense of order at the core of even his worst excesses. Setting out in search of his vocation, Dali developed a mythomania that perfectly suited his megalomania—at seven he wanted to be Napoleon. He took lessons—apparently rather vague—from a drawing teacher. At about this time he discovered Cadaqués and its bay, which became a life-long love.

Salvador now became passionately addicted to painting; he discovered Impressionism and painted with rich colors and thick impasto. But he especially applied himself to inventing a profile: long hair, sideburns, reefer jacket, loosely flowing necktie. He seems to have divined that he would be not only a painter but an unusual character as well.

The reception accorded Salvador's canvases at an exhibition in Figueras, in 1918, convinced his father to send him to the School of Fine Arts in Madrid. There the boy discovered with astonishment, then rapture, a life totally different from that of the provinces. He made the acquaintance of Federico García Lorca and Luis Buñuel.

But political upheaval broke out in Catalonia, and Dali, mistakenly considered a ringleader, was twice expelled from the School of Fine Arts, and even imprisoned. The troubles did not, however, prevent him from painting. He extended his Cubist experience and discovered the Italian Metaphysical School of Giorgio de Chirico. Surrealism was flirting with Dali.

In 1927 Dali went to Paris, as he had long wished to do. He paid a visit to Picasso, joined the Surrealist group the following year, and made the acquaintance of Paul Éluard. Above all, he met Gala.

Returning to Spain, Dali floundered in psychical excess. He said himself that he wanted to go mad. Fortunately, Gala arrived in Cadaqués and calmed the young painter, whom she was never to leave again. Thanks to her, he became a full-fledged member of the Surrealist group and collaborated in the filming of *Un Chien andalou*. The showing of Luis Buñuel's film created a scandal; meanwhile Gala and Dali eloped to the French Riviera. In the same year, 1929, they bought a house at Port Lligat, which from then on they would never leave, even if sometimes they seemed to be away from it.

Relations between Salvador and the Surrealist group did not run smoothly. He invented his famous soft watches, devoted himself to lectures that more often degenerated into riots, and in 1933 became involved in the Catalan uprising. The Julien Levy Gallery in New York and the Zwemmer Gallery in London exhibited his work; Albert Skira commissioned him to illustrate Lautréamont's *Les Chants de Maldoror;* and in 1934 the Surrealists expelled him from their group. In that same year he landed in the United States, where he finally found the ideal terrain on which to develop his taste for exhibitionism.

In 1936 the Spanish Civil War broke out. Dali painted a series of violent, tortured canvases before returning to New York. He totally seduced the Americans, who bought all his paintings on the very day of the opening of his exhibition. But he could not withstand the impact of success, and fled to Port Lligat, where he underwent the most serious crisis of his life. Fortunately, Gala was there.

Later, as the war began in Europe, Gala and Dali fled to the United States, where, in 1941, the Museum of Modern Art in New York organized a Dali retrospective consisting of forty-three paintings and seventeen drawings. Salvador worked on lithographs, canvases, books, illustrations, and ballets before returning in 1948 to Spain and Port Lligat. The Spanish government, in order to protect it from new construction, declared Port Lligat " a picturesque site of national interest. "

Now Dali's fascination for religion was revived. He was granted an audience by Pope Pius XII and turned more and more toward classicism, even toward conformism, except when it came to organizing the frenzy of his public spectacles. His book *Les Cocus du vieil art moderne*, published in 1956, remains a reactionary pamphlet against almost all recent painting.

From now on the life of this *enfant terrible* was to be arranged with scrupulous care : Port Lligat, Paris, New York — Dali rotated annually and punctually among them. Whether working at home or putting on a public spectacle in the two capitals, he always managed to be involved with those in the limelight, from the Pope to Marilyn Monroe, from Lenin to Mao Tse-tung. He painted very large canvases; splendidly illustrated *Don Quixote*, as he had the *Divine Comedy;* and developed new obsessions such as Millet's *Angelus* and the Perpignan Railway Station. He became interested in creating jewels and Pop objects.

In a period when artistic schools and styles jostle each other in their efforts to prevail, Dali remains faithful to his own standards. He prefers style to automatism, hierarchy to collectivism, tradition to experimentation, and Meissonier to Cézanne. He knows that his work must face the battles of centuries to come, and therefore ceaselessly fashions new weapons with the point of his pencil, the precision of his brush, the play of his attitudes when he puts on a public performance.

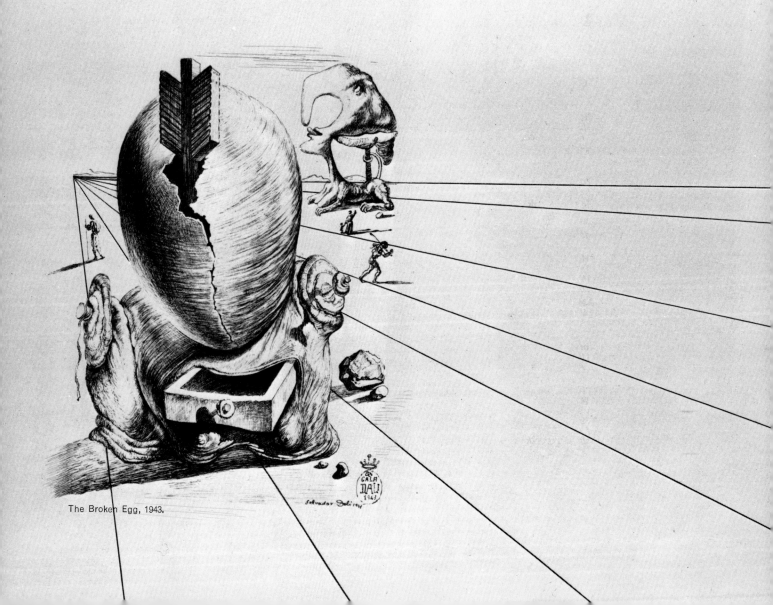

The Broken Egg, 1943.

List of Illustrations

When a painting has two titles, the second is indicated between ().

The first dimension is always that of the vertical measurement.

Note : All works listed as in the collection of Mr. and Mrs. A. Reynolds Morse may be seen in the Dali Museum in Cleveland.

Dust Jacket :
1 **THE PERSISTENCE OF MEMORY - 1931 (detail)**
Oil on canvas
The Museum of Modern Art, New York.

2 **SOFT SELF-PORTRAIT WITH FRIED BACON - 1941 (detail)**
Oil on canvas
Private collection, New York.

WAR

3 **SAINT GEORGE AND THE DRAGON - 1962**
Ink, 22 1/2×30 3/8"
Collection Dr. and Mrs. Giuseppe Albaretto, Turin.

4 **ARABS - 1963 (Death of Ramón Lullio)**
Oil on panel, 4 1/2×11 1/2"
Collection Mrs. Abel E. Fagan, Chicago.

5 **SKETCH FOR " BATTLE OF TETUÁN " - 1962**
Gouache, 4 7/8×8 1/4"
Private collection, New York.

6 **FUTURISTIC WAR - 1935 (What the Countryside Will Look Like in 1987)**
Ink, 11 3/8×14 1/4"
Collection John U. Sturdevant, New York.

7 **ATOMICA MELANCHOLICA 1945 (whole and detail)**
Oil on canvas, 26 1/8×34 1/8"
Private collection, New York.

8 **BATTLE OF TETUÁN - 1962**
Oil on canvas, 10′×13′ 4″
Private collection, Italy.

9 **COMBAT - 1955 (Microphysical Warriors)**
Ink and wash, 6 1/4×9 1/4"
Collection Mr. and Mrs. A. Reynolds Morse, Cleveland.

10 **SOFT CONSTRUCTION WITH BOILED BEANS - 1936 (Premonition of Civil War)**
Oil on canvas, 39 3/8×39"
Philadelphia Museum of Art. The Louise and Walter Arensberg Collection.

THE LANDSCAPE

11 **PARANOIAC-ASTRAL IMAGE 1934**
Oil on panel, 6 1/4×8 3/4"
Wadsworth Atheneum, Hartford, Connecticut. The Ella Gallup Sumner and Mary Catlin Sumner Collection.

12 **PHARMACIST OF AMPURDAN IN SEARCH OF ABSOLUTELY NOTHING - 1936**
Oil on panel, 11 3/4×20 3/8"
Collection Edward F.W. James, Sussex, England.

13 **LANDSCAPE OF PORT LLIGAT - 1950**
Oil on canvas, 23×31"
Collection Mr. and Mrs. A. Reynolds Morse, Cleveland.

14 **IMPERIAL VIOLETS - 1938**
Oil on canvas, 39 1/4×56"
Museum of Modern Art, New York. Gift of Edward F.W. James.

15 **FIGURE ON THE ROCKS - 1926**
Oil on canvas, 10 1/4×15 3/4"
Collection Mrs. Marianna Minola de Gallotti, Milan.

GALA

16 **GALA GRADIVA - 1938**
Pencil, 16 5/8×10 5/8"
Private collection, New York.

17 **COUPLE WITH THEIR HEADS FULL OF CLOUDS - 1934**
Oil on panel, 36×24"
Collection Edward F.W. James, Sussex, England.

18 **OVOCIPEDE - 1959**
Transparent plastic sphere
Diameter 55"
Accidentally destroyed.

19 **AUTOMATIC BEGINNING OF A PORTRAIT OF GALA - 1932**
Oil on panel, 6 1/4×5 1/4"
Private collection, New York.

20 **LEDA ATOMICA - 1949**
Oil on canvas, 23 5/8×17 1/2"
Private collection, New York.

21 **STUDY FOR " LEDA ATOMICA " - 1947**
Ink and gouache, 23 3/4×19 1/2"
Collection Mr. and Mrs. Ernest Byfield, New York.

GALA (continued)

22 **GALA - 1936 (First Architectural Drawing)**
Pencil, 15×13"
Collection Lockwood Thompson, Cleveland.

23 **GALA, NAKED AT THE WINDOW - 1963**
Pencil, 30 3/8×20 1/2"
Collection Dr. and Mrs. Giuseppe Albaretto, Turin.

24 **STUDY FOR " GALARINA " 1945 (detail), Pencil.**
Private collection, New York.

25 **THE FLESH OF THE DÉCOLLETÉ OF MY WIFE, CLOTHED, OUTSTRIPPING LIGHT AT FULL SPEED - 1954**
Oil on canvas, 15 1/2×12 1/4"
Private collection, New York.

26 **GALA LOOKING AT THE HYPERCUBUS CHRIST (study for " Crucifixion ") - 1954**
Oil on canvas, 12 1/4×10 3/4"
Private collection, New York.

27 **GALARINA - 1945**
Oil, 25 1/2×19 3/4"
Private collection, New York.

28 **GALA WITH TWO LAMBCHOPS IN EQUILIBRIUM ON HER SHOULDER - c. 1933**
Oil on panel, 2 3/8×3 1/4"
Private collection, New York.

29 **APOTHEOSIS OF THE DOLLAR 1965 (detail; see plate 59)**
Oil on canvas
Private collection, New York.

30 **PORTRAIT OF GALA IN CIRCLES - 1952**
Oil on canvas, 25 5/8×21 3/8"
Private collection, New York.

31 **PORTRAIT OF GALA - 1931**
Oil on cardboard, 5 1/2×3 5/8"
Collection Albert Field, New York.

NATURE MORTE (STILL LIFE)

32 STILL LIFE OF A ROSE - 1958
Oil on canvas, 14×11″
Collection Mr. and Mrs. Arnold Grant,
New York.

**33 THE SLAVE
OF MICHELANGELO - 1966**
Plaster with old painted tires
Length 8′
Private collection.

**33a THE WEANING
OF FURNITURE-NUTRITION
1934 (detail; see plate 63)**
Oil on panel
Collection Mr. and Mrs. A. Reynolds
Morse, Cleveland.

**34 NATURE MORTE VIVANTE
(Still Life, Fast Moving) - 1956**
Oil on canvas, 49 1/4×63″
Collection Mr. and Mrs. A. Reynolds
Morse, Cleveland.

35 BASKET OF BREAD, II - 1945
Oil on canvas
Private collection, New York.

36 EUCHARISTIC STILL LIFE - 1952
Oil on canvas, 21 1/2×34 1/4″
Collection Mr. and Mrs. A. Reynolds
Morse, Cleveland.

**37 DALI, AT THE AGE OF SIX
WHEN HE BELIEVED HIMSELF
TO BE A YOUNG GIRL,
LIFTING THE SKIN OF THE
WATER TO OBSERVE A DOG
SLEEPING IN THE SHADOW
OF THE SEA - 1950**
Oil on canvas, 10 3/4×13 3/8″
Collection Comte François de
Vallombreuse, Paris.

38 THE SUBLIME MOMENT - 1938
Oil on canvas, 15 1/2×18 1/2″
Collection T.W. Braasch, New York.

EROTICISM

**39 THE GREAT MASTURBATOR
1929 (detail; see plate 46)**
Oil on canvas
Private collection, Paris.

**40 THE FIRST DAYS OF SPRING
1929**
Oil and collage on panel
19 3/4×25 5/8″
Collection Mr. and Mrs. A. Reynolds
Morse, Cleveland.

**41 THE BROKEN BRIDGE
AND THE DREAM - 1945 (detail)**
Oil on canvas
Collection Mr. and Mrs. A. Reynolds
Morse, Cleveland.

42 LILITH - 1966
Plaster with hairpins
Height 6″
Private collection.

**43 YOUNG VIRGIN
AUTOSODOMIZED BY HER
OWN CHASTITY - 1954**
Oil on canvas, 16×12″
Collection Carlos B. Alemany,
New York.

**44 APHRODISIACAL DINNER
JACKET**
Original 1936; replica 1966
Dinner jacket, shirt, hanger, shot
glasses, liqueur, and straws
Height 36″
Private collection.

**45 MEDITATION ON THE HARP
1932-1933**
Oil on canvas, 26 1/4×18 1/2″
Collection Mr. and Mrs. A. Reynolds
Morse, Cleveland.

**46 THE GREAT MASTURBATOR
1929**
Oil on canvas, 43 1/4×59 1/8″
Private collection, Paris.

47 SPECTER OF SEX-APPEAL - 1934
Oil on panel, 6 5/8×5 1/8″
Private collection, New York.

**48 RESURRECTION OF THE FLESH
1940-1945**
Oil on canvas, 35 1/2×28 1/2″
Collection Mr. and Mrs. Bruno Pagliai,
Mexico, D.F., and Beverly Hills.

**49 ATMOSPHERIC SKULL
SODOMIZING A GRAND
PIANO - 1934**
Oil on panel, 5 1/2×7″
Collection Mr. and Mrs. A. Reynolds
Morse, Cleveland.

MYSTICISM

**50 RAPHAELESQUE HEAD
EXPLODING - 1951**
Oil on canvas, 26 1/2×22 1/2″
Collection Stead H. Stead-Ellis,
Somerset, England.

**51 CRUCIFIXION (CORPUS
HYPERCUBUS) - 1954**
Oil on canvas, 76 1/2×48 3/4″
The Metropolitan Museum of Art,
New York. Gift of the Chester Dale
Collection, 1955.

52 ANGELIC CRUCIFIXION
Designed 1959, executed 1960
Gold, platinum needles with diamonds
and motor, lapis-lazuli, coral,
and topaz, height 30″
The Owen Cheatham Foundation,
New York.

53 THE ANNUNCIATION - 1956
Ink, 17×22″
Collection Mr. and Mrs. A. Reynolds
Morse, Cleveland. © 1967.

**54 THE DREAM OF
CHRISTOPHER COLUMBUS
1959**
Oil on canvas, 13′ 5″×10′ 2″
Collection Mr. and Mrs. A Reynolds
Morse, Cleveland.

**55 IMPERIAL MONUMENT
TO THE CHILD-WOMAN - c. 1929
(unfinished)**
Oil on canvas, 56×32″
Private collection, Paris.

**56 THE SACRAMENT OF THE
LAST SUPPER - 1955**
Oil on canvas, 65 5/8×105 1/8″
The National Gallery of Art,
Washington, D.C. The Chester Dale
Collection.

57 THE ECUMENICAL COUNCIL - 1960
Oil on canvas, 9′10″×8′4″
Collection Mr. and Mrs. A. Reynolds
Morse, Cleveland.

**58 CHRIST OF ST. JOHN
OF THE CROSS - 1951**
Oil on canvas, 80 5/8×45 5/8″
Glasgow Art Gallery and Museum.

**59 SALVADOR DALI IN THE
ACT OF PAINTING GALA
IN THE APOTHEOSIS OF THE
DOLLAR IN WHICH YOU CAN
SEE ON THE LEFT MARCEL
DUCHAMP MASQUERADING
AS LOUIS XIV BEHIND A
VERMEERIAN CURTAIN
WHICH ACTUALLY IS THE
INVISIBLE BUT MONUMENTAL
FACE OF "HERMES"
BY PRAXITELES - 1965**
Oil on canvas, 13′×16′ 4″
Private collection, New York.

**60 GALA LOOKING AT DALI IN A
STATE OF ANTI-GRAVITATION
IN HIS WORK OF ART "POP-
OP-YES-YES-POMPIER" IN
WHICH ONE CAN CONTEM-
PLATE THE TWO ANGUISHING
CHARACTERS FROM
MILLET'S "ANGELUS" IN A
STATE OF ATAVISTIC
HIBERNATION STANDING
OUT OF A SKY WHICH CAN
SUDDENLY BURST INTO A
GIGANTIC MALTESE CROSS
RIGHT IN THE HEART OF
THE PERPIGNAN RAILWAY
STATION WHERE THE WHOLE
UNIVERSE MUST BEGIN
TO CONVERGE - 1965**
Oil on canvas, 9′ 8″×13′ 4″
Private collection, New York.

SPACE-TIME

61 **ANGELIC LANDSCAPE - 1958**
Watercolor, 20×30″
Collection James Henry Grady, Atlanta.

62 **THE HOUR OF THE CRACKED FACE - 1934**
Oil on canvas, 24×18″
Collection Barnet Hodes, Chicago.

63 **THE WEANING OF FURNITURE-NUTRITION**
1934 (detail and whole)
Oil on panel, 7×9 1/2″
Collection Mr. and Mrs. A. Reynolds Morse, Cleveland.

64 **OLD AGE, ADOLESCENCE, AND INFANCY - 1940**
(The Three Ages)
Oil on canvas, 19 5/8×25 5/8″
Collection Mr. and Mrs. A. Reynolds Morse, Cleveland.

65 **DALI AS A CHILD - 1929**
(detail of " The First Days of Spring "; see plate 40)
Oil and collage on panel
Collection Mr. and Mrs. A. Reynolds Morse, Cleveland.

66 **DALI AT THE AGE OF TEN - 1936**
(detail of " The Anthropomorphic Cabinet "; see plate 79)
Oil on panel, 10×17″
Collection James Henry Grady, Atlanta.

67 **DALI AT THE AGE OF TWENTY-FIVE WITH GALA - 1937**
(detail of " The Inventions of Monsters ")
Oil on canvas, 20×30 7/8″
The Art Institute of Chicago, Illinois.
Joseph Winterbotham Collection.

68 **SLEEP - 1937**
Oil on canvas, 20×30 3/4″
Collection Edward F.W. James, Sussex, England.

69 **METAMORPHOSIS OF NARCISSUS - 1936-1937**
Oil on canvas, 20×30″
Collection Edward F.W. James, Sussex, England.
Courtesy Tate Gallery, London.

70 **PORTRAIT OF PAUL ÉLUARD**
1929
Oil on cardboard, 13×9 7/8″
Private collection, Paris.

71 **FIFTY ABSTRACT PICTURES WHICH AS SEEN FROM TWO YARDS CHANGE INTO THREE LENINS MASQUERADING AS CHINESE AND AS SEEN FROM SIX YARDS APPEAR AS THE HEAD OF A ROYAL BENGAL TIGER - 1963**
Oil on canvas, 79×90″
Private collection, New York.

72 **SLAVE MARKET WITH DISAPPEARING BUST OF VOLTAIRE - 1940**
Oil on canvas, 18 1/4×25 3/4″
Collection Eleanor R. Morse, Cleveland.

73 **TWIST IN THE STUDIO OF VELÁZQUEZ - 1962**
(first version)
Oil on canvas, 50×70″
Private collection, New York.

74 **LAS MENINAS (A) - 1960**
Oil on canvas, 7×6″
Collection Mr. and Mrs. Julien Levy, Bridgewater, Connecticut.

LAS MENINAS (B) - 1960
Gouache, 9×7″
Collection Mr. and Mrs. Julien Levy, Bridgewater, Connecticut.

ONEIROS

75 **MEDUSA - 1950**
Ink and watercolor, 24×18″
Private collection, New York.

76 **BIRTH OF A GODDESS - 1960**
Oil on panel, 13 1/8×10 3/8″
Collection Mrs. Henry J. Heinz II, New York.

77 **SOLITUDE - 1931 (detail)**
Oil on canvas, 13 7/8×10 11/16″
Wadsworth Atheneum, Hartford, Connecticut.

78 **VENUS DE MILO WITH DRAWERS - 1936**
Bronze, height 39 3/8″
Collection Max Clarac Serou, Paris.

79 **THE ANTHROPOMORPHIC CABINET - 1936**
Oil on panel, 10×17″
Collection James Henry Grady, Atlanta.

80 **PLACE DES VOSGES, PARIS**
1958 (detail; see plate 93)
Engraving
17 1/2×23 1/2″.

81 **ACCOMMODATIONS OF DESIRE - 1929**
Oil on panel, 8 5/8×13 3/4″
Julien Levy Gallery Inc., Bridgewater, Connecticut.

82 **THE HAND - 1930**
(The Remorse of Conscience)
Oil and collage on canvas
16 1/4×26″
Collection Mr. and Mrs. A. Reynolds Morse, Cleveland.

83 **GEOPOLITICUS CHILD WATCHING THE BIRTH OF THE NEW MAN - 1943**
Oil on canvas, 18×20 1/2″
Collection Mr. and Mrs. A. Reynolds Morse, Cleveland.

84 **ILLUMINED PLEASURES - 1929**
(detail and whole)
Oil and collage on panel
9 3/8×13 5/8″
The Museum of Modern Art, New York.
The Sidney and Harriet Janis Collection.

85 **DADDY LONG LEGS OF THE EVENING—HOPE! - 1940**
(detail and whole)
Oil on canvas, 16×20″
Collection Mr. and Mrs. A. Reynolds Morse, Cleveland.

86 **GALA AND THE "ANGELUS" OF MILLET IMMEDIATELY PRECEDING THE ARRIVAL OF THE CONIC ANAMORPHOSIS - 1933**
(detail)
Oil on panel, 9 3/8×7 3/8″
Collection Henry P. MacIllhenny, Philadelphia.

87 **CARDINAL! CARDINAL! - 1934**
Oil on panel, 6 3/8×8 5/8″
Munson-Williams-Proctor Institute, Utica, New York.

TOWARD AN IMPERIAL CLASSICISM

88 **THE AESTHETIC IS THE GREATEST OF EARTHLY ENIGMAS - 1943**
Ink, 11×8 1/4″
Collection Mr. and Mrs. A. Reynolds Morse, Cleveland. © 1967.

89 **FIRST THINKING MACHINE**
1966, after a project illustrated in " The Secret Life of Salvador Dali " - 1942
Bronze, ink bottles, pens, and electric lights, height 38″
Private collection.

90 **SURREALIST POSTER - 1934**
Oil on chromolithographic poster with key, 27×18″
Collection Mr. and Mrs. A. Reynolds Morse, Cleveland.

91 **TUNA FISHING - 1966-1967**
(detail; see plate 94)
Oil on canvas
Paul Ricard Foundation, Paris.

92 **FUTURE MARTYR OF SUPERSONIC WAVES**
1949-1950 (study for " The Madonna of Port Lligat ")
Gouache and pencil, 5 1/2×10 3/4″
Collection Mr. and Mrs. A. Reynolds Morse, Cleveland. © 1967.

93 **PLACE DES VOSGES, PARIS**
1958
Engraving, 17 1/2×23 1/2″.

94 **TUNA FISHING - 1966-1967**
Oil on canvas, 11′ 2″×14′ 5″
Paul Ricard Foundation, Paris.

95 **IMPRESSIONS OF AFRICA**
1938
Oil on canvas, 36×46 1/4″
Collection Edward F.W. James.
Courtesy Tate Gallery, London.

96 **PHOTOGRAPH OF DALI IN FRONT OF "TUNA FISHING" - Port Lligat, 1967.**

97 **SELF-PORTRAIT WITH THE NECK OF RAPHAËL**
1922-1923
Oil on canvas, 16 3/8×20 7/8″
Private collection, Paris.

98 **SELF-PORTRAIT - 1954**
(Dali, Nude)
Oil on canvas, 24×18″
Private collection, Memphis.